Vision, Illusion and Perception

Volume 2

Series editor

Nicholas Wade, University of Dundee, Department of Psychology,
Dundee, DD1 4HN, Scotland, UK
e-mail: n.j.wade@dundee.ac.uk

Editorial Board

Benjamin W. Tatler, University of Dundee, Dundee, UK
e-mail: b.w.tatler@activevisionlab.org

Frans Verstraten, School of Psychology, The University of Sydney, Australia
e-mail: frans.verstraten@sydney.edu.au

Thomas Ditzinger, Springer-Verlag, Heidelberg, Germany
e-mail: thomas.ditzinger@springer.com

About this Series

The Vision, Illusion and Perception (VIP) book series publishes new developments and advances in the fields of Vision and Perception research, rapidly and informally and with a high quality. The series publishes fundamental principles as well as state-of-the-art theories, methods and applications in the highly interdisciplinary field of Vision Science, Perception and multisensory processes related to vision. It covers all the technical contents, applications, and multidisciplinary aspects of fields such as Cognitive Science, Computational and Artificial Intelligence, Machine Vision, Psychology, Physics, Eye Research, Ophthalmology, and Neuroscience. In addition, the series will embrace the growing interplay between the art and science of vision. Within the scope of the series are monographs, popular science books, and selected contributions from specialized conferences and workshops.

More information about this series at http://www.springer.com/series/13864

Marco Bertamini

Library & Media Center
Carroll Community College
1601 Washington Road
Westminster MD 21157

Programming Visual Illusions for Everyone

Springer

Library & Media Center
Carroll Community College
1601 Washington Road
Westminster MD 21157

Marco Bertamini
Institute of Psychology, Health and Society
University of Liverpool
1 Waverley Drive
Prescot L341PU
United Kingdom
e-mail: m.bertamini@liv.ac.uk

ISSN 2365-7472 ISSN 2365-7480 (electronic)
Vision, Illusion and Perception
ISBN 978-3-319-64065-5 ISBN 978-3-319-64066-2 (eBook)
DOI 10.1007/978-3-319-64066-2

Library of Congress Control Number: 2017950041

Springer Cham Heidelberg New York Dordrecht London

© Springer International Publishing AG 2018
This work is subject to copyright. All rights are reserved by the Publisher, whether the whole or part of the material is concerned, specifically the rights of translation, reprinting, reuse of illustrations, recitation, broadcasting, reproduction on microfilms or in any other physical way, and transmission or information storage and retrieval, electronic adaptation, computer software, or by similar or dissimilar methodology now known or hereafter developed.
The use of general descriptive names, registered names, trademarks, service marks, etc. in this publication does not imply, even in the absence of a specific statement, that such names are exempt from the relevant protective laws and regulations and therefore free for general use.
The publisher, the authors and the editors are safe to assume that the advice and information in this book are believed to be true and accurate at the date of publication. Neither the publisher nor the authors or the editors give a warranty, express or implied, with respect to the material contained herein or for any errors or omissions that may have been made.

Production: Armin Stasch and Scientific Publishing Services Pvt. Ltd. Chennai, India
Typesetting and layout: Stasch · Bayreuth (stasch@stasch.com)

Printed on acid-free paper

This Springer imprint is published by Springer Nature
The registered company is Springer International Publishing AG
The registered company address is: Gewerbestrasse 11, 6330 Cham, Switzerland
Springer International Publishing AG Switzerland is part of Springer Science+Business Media
(www.springer.com)

Preface

A Book about Illusions and about Programming

Hello. If you find visual illusions fascinating this book is for you. I start by providing some background, some history and some theories about visual illusions, and I discuss in some detail twelve of my favourite illusions. Some are about surfaces, some are about apparent size of objects, some are about colour and some involve movement. But this is only one of the aims of the book. The other aim is to show you how you can create these effects on any computer.

The book includes a very brief introduction to a powerful programming language called **Python**®. No previous experience with programming is necessary. I will start from the basic concepts. I will also introduce a package called **PsychoPy** that makes it very easy to draw images on a computer screen. It is OK if you have never heard the names Python or PsychoPy before. I have chosen them because they are a great combination. Python is a modern and easy-to-read language, and PsychoPy takes care of all the graphical aspects of drawing on a screen and also interacting with a computer. By the way, both Python and PsychoPy are absolutely free, so you will not need to spend any money.

The structure of the book is simple. In Chapter 1 I discuss visual illusions, why they are more than just a curiosity, and how hard it is to classify them. I am an experimental psychology and in particular I study visual perception, therefore I have worked in this field for many years. In this chapter, however, I will not write an academic essay on illusions. Instead I will give a general introduction to the topic. Illusions are fun, and most people find them interesting and entertaining, I am sure that you will like them.

I have included many references in the text. The first example in Chapter 1 is "(Shepard 1990)". Each time that you will see a name and a year like this, the reference is in the Bibliography at the back of the book. They are not strictly necessary as you read the book. They are important for two reasons, one is that it is only fair to give credit to the people who wrote the original articles, and the other is because some readers may want to explore in more depth some illusions or some claims.

In Chapter 2 I talk about programming, and in particular about a language called Python. I have used Python as a tool extensively but I am not a professional programmer. This book is not a standard programming manual, it is a quick guide and it provides enough information to start using the language. It is a bit like one of those phrase books for when you go to a foreign country and you want to be able to say "I would like an ice cream please", and "let's go to the beach!".

Chapter 3 explains how to use PsychoPy to open a window, to set up the coordinates of a space in which to draw, and to show on the screen lines, rectangles and other shapes. We will use objects like windows, shapes, clocks and more. We will see how to create these objects and what properties they have. This approach is very powerful if you want to control the images on the screen, make them change in various ways, and it also allows the user to interact with the program for instance using the mouse.

Chapter 4 describes a program that draws a so-called **Kanizsa square**. This will be our first illusion. After that we will see several more. Many key references for these illusions are provided in a list of references at the back (if you would like to read more and delve into the science).

When I started on this project I was not sure whether I was going to teach programming with the excuse of looking at some visual illusions, or whether I was going to teach about visual illusions with the excuse of learning to program. I am still not sure.

The book has **figures** to illustrate both the illusions and some of the programming techniques, and **boxes** with information on specific topics. In addition, there are **messages** from twelve international scholars working on visual illusions in general, or on one in particular. They will introduce themselves and their work in a few sentences. I have included this feature so that you as the reader can meet some of the authors of the research that is discussed. They are from Belgium, England, France, Italy, Japan, Scotland and the USA.

There is, as you may have expected, a companion website to this book. The address has exactly the same name as the book:

www.programmingvisualillusionsforeveryone.online

Enjoy!

Marco Bertamini
Prescot, July 2017

Acknowledgments

Writing this book was a lot of fun. In the process I have also had help from a number of friends and colleagues. I would like to thank Stuart Anstis, Nicola Bruno, Floriana Grasso, Jacques Ninio, Jon Peirce, Alessandro Soranzo, Andrew Stewart, Nick Wade and Michele Zito.

I discussed my idea with Nick Wade in Aberlady, Scotland in May 2016, and he was immediately supportive. It is thanks to him that this book was included in the **Vision, Illusion and Perception (VIP)** series.

Thanks to the groups of experts who are featured in the book in individual boxes: Akiyoshi Kitaoka, Arthur Shapiro, Giorgio Vallortigara, Jacques Ninio, Jon Peirce, Michael Bach, Nicholas Wade, Nicola Bruno, Priscilla Heard, Stuart Anstis. It was not a conscious effort but it is nice to see how international the community is (with contributions from Belgium, England, France, Germany, Italy, Japan, Scotland, USA). Of all the resources I used, a special mention goes to Michael Bach's website, and to Giovanni Vicario's book.

In December 2016 I spent a week at the University of the Balearic Islands (**UIB**), and gave a series of workshops related to the book to the students in the Doctoral

Faculty and students from the Programme in Human Cognition and Evolution on a walk to the Castell d'Alarò (Tramuntana Range). Marco Bertamini is the fourth from the left, Enric Munar is the sixth. This castle is perched on top of a rocky mountain above the town of Alarò in Mallorca, Spain

Degree Programme in Human Cognition and Evolution. It was most enjoyable and I gained useful feedback as I was writing the book. Thanks to all of the staff and students at UIB, and to Enric Munar in particular. Thanks also to the EU Erasmus programme; just one of the countless ways in which the Erasmus programme has facilitated the exchange of people and ideas in Europe.

Contents

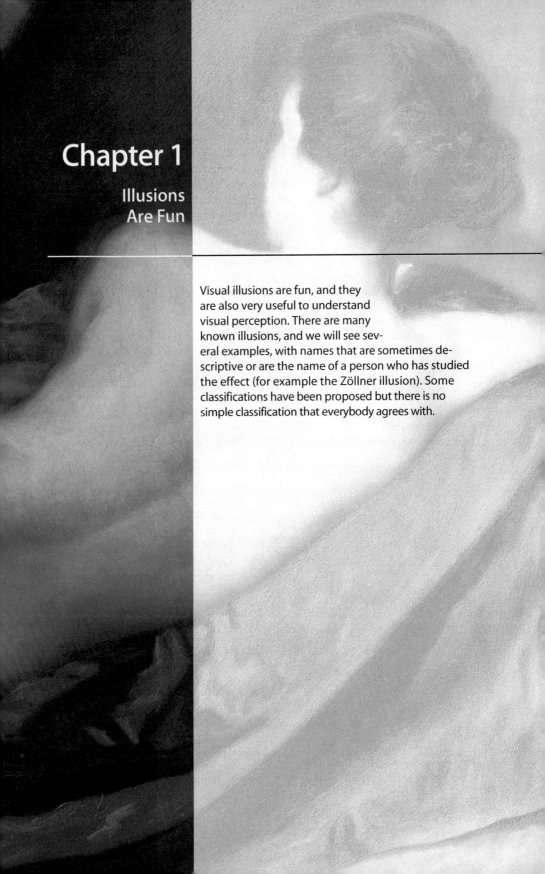

Chapter 1

Illusions Are Fun

Visual illusions are fun, and they are also very useful to understand visual perception. There are many known illusions, and we will see several examples, with names that are sometimes descriptive or are the name of a person who has studied the effect (for example the Zöllner illusion). Some classifications have been proposed but there is no simple classification that everybody agrees with.

Illusions are fun and they also challenge us to think about how perception works. Because they are fun they can make good tricks for parties and dinner conversation. Imagine that you have invited your friends for dinner and you use the picture in Fig. 1.1 to ask them a simple question: "which of the two tables should I use?" Some may prefer the square one and some the rectangular one, in any case you can then surprise them by showing that the two shapes are the same. This is illustrated in Fig. 1.1, which shows that the two rectangles (on a page or on a screen) differ only in orientation. You can put one on top of the other and they match, and if you print the image on paper you can cut out one rectangle and put it on top of the other. There is a technical word for this: *congruent*.

This is surprising because they do not **look** congruent. This is the essence of a visual illusion, our visual system organises images in certain ways, and we all see the same illusion (in most cases). Knowing that the two rectangles are identical will not change how they appear. The trick on your friends relies on the fact that you can be confident that they will not see the rectangles as identical in shape.

What we see in Fig. 1.1 is known as Shepard's illusion (Shepard 1990). Like many famous illusions it has taken the name of a researcher who has described the effect. Roger Shepard referred to it as *Turning the Tables*.

Visual illusions are helpful to counter what the psychologist Titchener called the **stimulus error** (Titchener 1909). That is what happens when we describe what we perceive in terms of what we **know**, instead of drawing on our perceptual experiences. To say I see a *rectangle* because there is a *rectangle*, or a *cat* because there is a *cat*, are examples of stimulus error.

Illusions make us also think about the nature of reality, and raise two types of questions. The first is why do we get it wrong; how is the trick working? The second is a more fundamental question about whether the senses tell us about some external reality, or whether our experience of the world is all an illusion. Let us briefly consider these two issues in turn.

Two tables Two rectangles

Moving one shape on top of the other

Figure 1.1. The two tables in the first image appear different in shape. On the right, the two rectangles are shown in isolation (not as tables). In the third image one shape is rotated on top of the other, something you can do with a piece of paper. If you cut out the two rectangles you can prove that they are identical

How Does It Work?

With respect to explanations, I will describe the best available theories as we will consider different visual illusions. In general, illusions have been useful in science exactly because they highlight some of the working of the sensory systems; we could even say that they tell us how our mind works (Kingdom 2015). A famous example is the fact that **colour afterimages** tell us about how colour vision works.

If you have never experienced an afterimage before, you should try. It's easy and there is no need for a computer. I have provided the necessary image in Fig. 1.2, and you can even make it with pen and paper. For instance, you can take a piece of paper and draw a red square on the left side. It is important that you fill in the square nicely with red ink. Next, place the page on the table in front of you, under normal illumination, and stare at the red square for 30 seconds. After that, move your gaze to the other side of the page, where there is a blank space. You will see something, and it is squarish, but it is not red. It is green. In Fig. 1.2 you should stare at the cross on the left for 30 seconds, and then look at the cross on the right. You will see four colours but again they are different from the colours that you have been looking at: red is replaced by green and green by red, blue is replaced by yellow and yellow by blue.

The explanation for the perception of a greenish shape after adaptation to red relies on the fact that the system **subtracts** red from the blank page and you see its complementary colour green. This is an important discovery. There is no law of physics that says that green is the complement of red, or yellow the complement of blue. This phenomenon is telling us something about the brain.

The illusion of colour afterimages played an important part in how scientists developed theories of colour. In the 19th century two main ideas were proposed and they were quite different. The Trichromatic theory was based on studies in which people

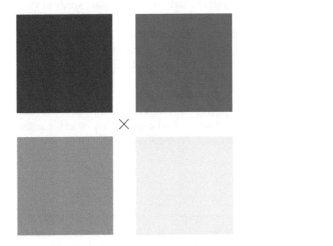

Figure 1.2. *Colour afterimages.* Fixate on the cross on the left for 30 seconds, then look at the blank page on the right. Notice the colours that you perceive around the cross. You will see that on the top right red is replaced by green, in the bottom left corner green is replaced by red, blue (top left) is replaced by yellow and yellow (bottom right) by blue

matched or mixed colours. By doing that, Thomas Young (1773–1829) and Hermann von Helmholtz (1821–1894) discovered that people needed three different unique colours (primaries) to match any other colour in the visible spectrum. Therefore the key idea was that there were three basic receptors. However, this theory could not explain colour afterimages like the ones you have just experienced.

In opposition to the proponents of the Trichromatic theory, Ewald Hering (1834–1918) proposed the Opponent-Process theory. The theory says that in the system there is a channel for black-white, one for red-green and one for yellow-blue. For example some cells increase their activity when stimulated with red light, and the same cells decrease their activity when stimulated with green light. We now know these cells exist and we call them red$^+$green$^-$ (other cells will do the opposite, and we call them red$^-$green$^+$). Which colour is perceived is the balance of the responses, and because of this common encoding of red-green we have complementary colours, and therefore afterimages. By staring at the red square, you have fatigued the red mechanism, and response to red will be depressed when staring at the blank page. Reduction in activity in the red$^+$green$^-$ channel is interpreted as the presence of green. What we have said about red and green applies also to blue and yellow.

Both theories had their strengths, and were based on careful observations. In fact they both were correct (but partial). The Trichromatic theory is more accurate in relation to receptors. Humans have indeed three different photoreceptors in the eye, identified more than a century later (that is, in the middle of the 20th century). The Opponent-Process theory captures something that takes place later, the way in which the information from the receptors is combined.

One may be tempted to say "well if this is the mechanism responsible for colour afterimages then it is not really an illusion. We perceive the output of a known mechanism in the brain". Whether we know the mechanism or not, however, it is reasonable to think that what we perceive is always the output of something that is going on inside our head. As you can see we are getting drawn into the fascinating study of perception, and some tricky questions about the relationship between mind and brain. At this point, if you are hooked, I will mention a few textbooks on visual perception that you can consult (see Box 1.1). Apart from this list, there will be many specific references that appear as names followed by a year. You can find a full list of references at the end of the book.

Although the example of colour afterimages shows that what we know about the visual system can explain some aspects of perception, and it can explain some illusions, this is not always the case. We do not have a good explanation even for some illusions that have been known for many years, or even centuries. There are still mysteries to solve.

Is Everything Just an Illusion?

Illusions may also lead us to ask a fundamental question about reality. Basically the question is whether we can ever trust our senses. At the very least illusions force us to accept the role of the observer in organising the incoming information and generate an interpretation. According to a constructivist view, any perception is a construction. Not everybody agrees with that view, however, because the term construction gives the impression that there is a very active role of the observer.

Box 1.1. Books on visual perception

Visual perception has a long history and it is the subject of many available books, including textbooks for university courses. Contributions have come and continue to come from a number of disciplines, including psychology, physiology, and neuroscience. This is a short personal selection (in alphabetical order).

- Bruce V, Green PR, Georgeson MA (2003) Visual perception: Physiology, psychology, and ecology, 4th ed. Psychology Press, Hove New York
 This is a textbook used in University courses, especially in Britain. As the title says research findings from three different approaches to visual perception are brought together.
- Goldstein EB (2013) Sensation and perception, 9th ed. Wadsworth Publishing
 If you want a standard textbook, very structured, and used in many University courses, this is an excellent one. It covers all the senses (not just vision) and it has been updated and revised over many editions.
- Gregory R (1966) Eye and brain: The psychology of seeing. Weidenfeld and Nicolson, London
 This is a classic, and many editions have followed (the 5th ed. was in 1997), so it is not difficult to find a copy. A very good introduction to visual perception.
- Hoffman DD (2000) Visual intelligence: How we create what we see. W. W. Norton & Company, New York
 This is a short but fascinating book that covers many aspects of perception. It is not written as a textbook and it includes some personal reflections.
- Kanizsa G (1979) Organization in vision: Essays on Gestalt perception. Praeger Publishers, New York
 This book is old and you may struggle to find a copy (except in a library) but it is a classic and it has some great illustrations.
- Rock I (1985) The logic of perception. MIT Press, Cambridge MA
 As the title suggests, in this book Irvin Rock argues that perception is a sophisticated, intelligent process. Rock was a clever experimenter and he supports his thesis with demonstrations and empirical studies.
- Shapiro AG, Todorović D (eds) (2017) The Oxford compendium of visual illusions. Oxford University Press, Oxford
 This is a compendium, which means a commented list, of visual illusions. It is a reference book (880 pages long), so you may want to consult it in the library, unless you are after a nice coffee table book.
- Snowden RJ, Thompson P, Troscianko T (2012) Basic vision: An introduction to visual perception. Oxford University Press, Oxford
 The topics covered are the traditional topics of visual perception, but the style of this book is very engaging, with many jokes and the authors clearly had a lot of fun writing it.

Finally, I will also mention a few books that are about the link between visual perception and visual art.

- Arnheim R (1974) Art and visual perception: A psychology of the creative eye. Revised and expanded. University of California Press, Berkeley Los Angeles London
 If you are interested in understanding Art in relation to psychology and perception, this is a classic, beautifully written book published originally in 1954.
- Seckel A (2007) Masters of deception: Escher, Dalí & the artists of optical illusion. Sterling Press, New York
 This is a book that combines visual illusions with history of visual art.
- Wade N (2016) Art and illusionists. Springer, Cham Heidelberg New York Dordrecht London
 This extensively illustrated book celebrates the many ways of manipulating pictures to produce illusions and works of art.

On the one hand our senses are reliable because they are useful, we manage to move around in the world and successfully recognise, say, our bicycle by its colour and shape. On the other hand useful is not the same as truthful.

The Greek philosopher Plato (427–347 B.C.) used a famous metaphor. Let us imagine that we are in a cave and what we see are shadows, and because of the direction that we are facing we can only see shadows. If we just look at the projected shadows on the wall of a cave we can never see the objects casting the shadows. Humans, under these circumstances, will mistake appearance for reality.

If this idea sounds familiar it is because there are many other examples in history. Perhaps you can see the similarity with the plot of the film *The Matrix* (1999).

A related concept is whether all of our knowledge must ultimately come from our senses. Philosophers in the empiricism camp would answer yes. Famous champions of this view were John Locke (1632–1704) and David Hume (1711–1776). However, rationalists like René Descartes (1596–1650) would say that knowledge and truth come from reason.

You can find this and related issues discussed many times in the history of philosophy (for a more recent discussion see Hoffman 2000). These fascinating questions about what we know through our senses and how much we can trust knowledge acquired through perception extend to all sensory experiences and are not specific to illusions. So I will not pursue them any further in this book.

With respect to illusions in general, I should point out that this book only deals with **visual** illusions, but that there are many interesting examples of illusions that affect what we hear, what we touch and the sense of having a physical body (body representation). Clearly illusions are present in relation to all our senses, not just vision.

How Are Illusions Discovered?

Many illusions have been discovered by chance. For instance, in 1870, a German physiologist called Ludimar Hermann was reading a book. He noticed that there were grey spots at the intersections of a grid of dark figures, but these spots would disappear when he looked directly at them. This effect is now famous as the Hermann grid illusion (again taking the name of the person who described it in the scientific literature) and is shown in Fig. 1.3. A similar effect is also present with white squares on black background, and therefore black intersections and bright spots (so everything reversed). This was noted by Hering and is therefore known as Hering grid (1907).

It is useful to attach a name to a specific illusion. For example, we will see the Ponzo, Delbœuf, and Ebbinghaus illusions, named respectively after an Italian, a Belgian, and a German psychologist. Later it may emerge that there were earlier descriptions, although it may be impossible to change the established name. This was the case for the Hermann grid, which had been described by Brewster in 1844 (Wade 2005) and it is actually the case for several other famous illusions.

We have seen that looking at a colour produces adaptation, which in turn produces a colour afterimage, also called a colour aftereffect. Similarly, looking at motion in one direction produces motion adaptation, and a motion aftereffect. This is an illusion that had been observed already in antiquity. The Roman philosopher Lucretius (99–55 B.C.) in his poem *De Rerum Natura* noted that after watching the fast flowing water of a river, everything on the bank of the river appeared to move in the opposite

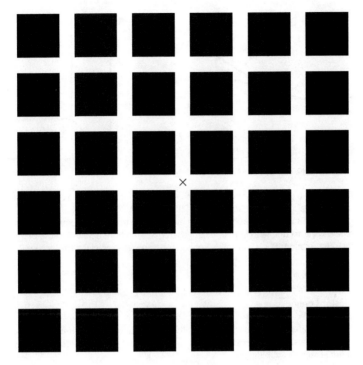

Figure 1.3. *Hermann grid*. Keep your eyes on the cross and pay attention to the rest of the grid. You will see dark spots on top of the white background at the intersections

direction (Verstraten 1996). This poem has had an interesting life. It was forgotten for over a millennium, and was rediscovered in a monastery by a book hunter called Poggio Bracciolini in 1417. It has many interesting observations about perception including possible descriptions of other illusions. Remember, however, that it was written as a poem about science, which is a fascinating format (we are certainly not used to this approach now).

As we have just seen there are descriptions of visual effects in the historical documents throughout the centuries. In the 19th century however we start to see articles written in academic journals that specifically report visual illusions and start to use the current terminology. J. J. Oppel (1855) was the first scholar to use of term "geometrical-optical illusions" (Phillips and Wade 2014; Vicario 2011). One simple configuration described by Oppel has three lines; the longer one is straight but appears to bend slightly in the middle where it is intersected by the other two.

In Fig. 1.4 I am showing an illustration of the illusion described by Oppel, and another effect that was described by Necker (1832).

Some of the best sources of illusions are online and they are listed in Box 1.2. If you are interested in a book about illusions, full of detailed and academic writing, then I recommend the *Oxford Compendium of Visual Illusions*, edited by Shapiro and Todorović (see Box 1.1). In this book there is a chapter titled *Early History of Illusions* by Nicholas J. Wade (University of Dundee).

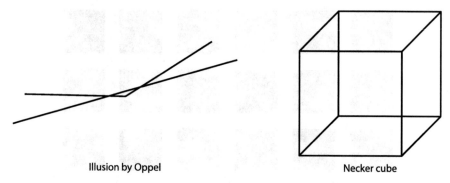

Illusion by Oppel Necker cube

Figure 1.4. These are two effects reported in the 19th century. On the left we see a configuration described by *Oppel* (1855). The straight line appears to bend in the middle. A different kind of effect is shown on the right. Here instead of a distortion of shape or size we have an image that is ambiguous and can be perceived in two different ways, as a cube seen from above, or as a cube seen from below. Because of the two possible and stable interpretations this is a bi-stable image. This example is called the *Necker cube* (Necker 1832)

Box 1.2. Illusions online

These are some wonderful sites on which to see illusions, including animations showing dynamic illusions. If you are aware of suffering of dizziness or epilepsy be conscious that you may want to avoid looking at some visual illusions.

- An extremely well organised set of pages created by Michael Bach. The site shows the illusions and it also provides scientific explanations:
 http://michaelbach.de/ot/index.html
- A large collection of illusions created by Akiyoshi Kitaoka. The site has many variants of some illusions that contribute some really beautiful images:
 http://www.ritsumei.ac.jp/~akitaoka/index-e.html
- A simple set of pages with beautiful images showing a selection (about 100) of the *most popular and cool* optical illusions:
 http://www.optillusions.com/
- A site in which illusions are illustrated with dynamic examples. Created by the Science and Mathematics Education Center at Boston University:
 http://lite.bu.edu
- A site by David Phillips with many examples and writings about illusions and visual effects:
 http://www.opticalillusion.net
- The official site of The Best Illusion of the Year Contest, with submissions starting from 2005:
 http://illusionoftheyear.com

In Message 1.1 we hear directly from Nicholas Wade. He provided a portrait especially designed for this book. It is an image that combines his face with a visual illusion of colour (the yellow is the same throughout) and an illusion of orientation (the red lines are all vertical and the words are horizontal). We will have other messages like this (12 in total) in various chapters, where we can meet some of the scientists who are working in the field.

Message 1.1. "Illusions" by Nicholas Wade

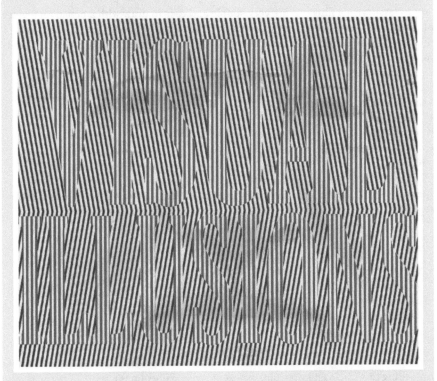

Illusions have fascinated observers for many centuries – the Moon looks larger when near the horizon, it looks to be moving in the opposite direction to passing clouds and water appears to flow uphill after looking for some time at a waterfall. These observations do not require any theory to make them remarkable, simply the assumption that objects (like the Moon) remain constant over time. What we now call geometrical optical illusions received that name in the 1850s. Unlike the ancient illusions, they are pictures rather than objects and distortions in size or shape can be induced and manipulated. It is puzzling that such simple flat figures entered into visual science so late – they could have been drawn at any time in the preceding two thousand years! What changed in the 19th century was a shift from observing objects in natural scenes to presenting flat depictions in laboratories using apparatus specially invented for the purpose. Since that time most experiments on vision have involved pictorial stimuli of which geometrical optical illusions provide a perfect example. It has been said that visual illusions reveal visual truths; it could equally be argued that visual truths will reveal the basis for visual illusions.

Nicholas (Nick) Wade received his degree in psychology from the University of Edinburgh and his PhD from Monash University, Australia. This was followed by a postdoctoral fellowship at Max-Planck-Institute for Behavioural Physiology, Germany. His subsequent academic career has been at Dundee University, where he is now Emeritus Professor. His research interests are in the history of vision research, binocular and motion perception, and the interplay between visual science and art.

Classifications

Some classic visual illusions are very simple and easy to draw with a pencil on a piece of paper. They often are about shape and size and therefore we can refer to them as geometrical illusions. Other illusions require dynamic displays, and for these programming will be very handy.

Richard Gregory (1997) has divided illusions into four types:

- ambiguities
- distortions
- paradoxes
- fictions (errors of language)

Coren et al. (1976) tried to group illusions based on the similarity in human responses (using a technique known as factor analysis). However, this approach only separated two groups, illusions of extent (size) and illusions of shape or direction.

Bach and Poloschek (2006) listed six classes based more on the type of stimulus:

- luminance and contrast
- motion
- geometric or angle illusions
- 3D interpretation: size constancy and impossible objects
- cognitive/Gestalt effects
- colour

The whole history and problems of classification are discussed in Vicario (2011). According to Vicario an important aspect of a visual illusion is a sense of surprise and puzzlement. This surprise must be evident in the image, and not only after some aspects are pointed out to the observer. Because of this definition, some of the illusions in this book would not qualify as illusions at all for Vicario.

Both Ninio (2014) and Hamburger (2016) have recently argued that we need more work and better classifications. Clearly no simple way of organising illusions has yet emerged.

Because of these difficulties with definition and classification, it would be hard and arbitrary to create a list of all known illusions. We have already seen some examples and in Fig. 1.5 I have compiled a selective parade of some of the best-known geometrical-optical illusions. Many take the name from a discoverer, but not all, for some we just have a name.

Figure 1.5. A parade of some famous geometrical illusions. *Amodal shrinkage* (Kanizsa 1972) (covered ▶ square shrinks), *Bourdon* (1902) (not straight edge), *Ehrenstein* (1941) (white disk), *Elevation* (Delbœuf 1865) (circle above bigger), *Gerbino* (1978) (hexagon distorted), *Giovannelli* (1966) (dots not aligned), *Helmholtz* (1866) (horizontal version taller), *Hering* (1861) (bending of horizontal lines), *Irradiation* (Galileo 1632) (white bigger), *Jastrow* (1892) (top shape smaller), *Loeb* (1895) (lines do not line up), *Müller-Lyer* (1889) (top line shorter), *Münsterberg* (1897), or *Café Wall* (Gregory and Heard 1979) (lines not parallel), *Oppel-Kundt* (Oppel 1855) (filled line longer), *Orbison* (1939) (circle distorted), *Poggendorff* (see Zöllner 1860) (lines do not appear aligned), *Sander* (1926) (right oblique line shorter), *Tolansky* (1964) (curvature different), *Vertical-horizontal* (Schumann 1900) (horizontal shorter), *Vicario* (1978) (steps not parallel), *Zöllner* (1860) (lines diverge)

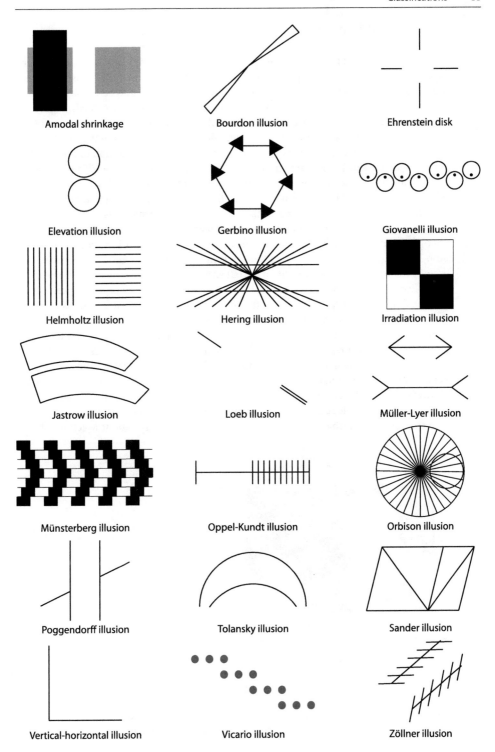

Amodal shrinkage

Bourdon illusion

Ehrenstein disk

Elevation illusion

Gerbino illusion

Giovanelli illusion

Helmholtz illusion

Hering illusion

Irradiation illusion

Jastrow illusion

Loeb illusion

Müller-Lyer illusion

Münsterberg illusion

Oppel-Kundt illusion

Orbison illusion

Poggendorff illusion

Tolansky illusion

Sander illusion

Vertical-horizontal illusion

Vicario illusion

Zöllner illusion

The Case of Brightness

Most of the examples provided in Fig. 1.5 should be clear from the image and the figure caption, but some illusions require a closer look. In some cases we only realise that there is an interesting effect when we analyse carefully the physical nature of the image.

To explore this, we can consider perception of brightness in more detail. Figure 1.6 describes an effect known as **Mach bands**. These bands take their name from Ernst Mach (1838–1916), a scientist who worked in many fields. He is most famous as a physicist, and you may be familiar for instance with the Mach number in relation to the speed of sound (a supersonic plane travels faster than *Mach one*). However, he also published a wonderful book on perception in 1897. He was one of the first to realise the importance of looking carefully at the difference between the physical and geometrical properties of the stimulus on one hand, and the human experience of that stimulus on the other.

I have used a simple line underneath the image in Fig. 1.6 to show how luminance changes from left to right. Luminance refers to how much light is coming from a region, but you can also think of it as the brightness of the grey region in this case. The rectangle starts off relatively bright on the left and its luminance is constant for one third of the horizontal distance, then it smoothly decreases and the image gets darker. In the last third of the image, on the right, the luminance is again constant but lower (and therefore it is darker). You should be able to observe that the perception of the transition does not appear smooth. In particular it seems as if there is a lighter band in correspondence of the first edge, and a darker one in correspondence of the second edge.

The simplest explanation of these bands is in terms of lateral inhibition. This is very similar to the explanation for the Hermann grid of Fig. 1.3 and the Brightness contrast of Fig. 1.8. The response to a stimulus by a channel in the system will be stronger or weaker depending on the response in the neighbouring channels. This is also the explanation that you will find on the Wikipedia page about Mach bands (as

Bands (higher contrast perceived near the edge)

Figure 1.6. *Mach bands.* The darkness of the grey region is shown as luminance (light reflected) in the graphs underneath the image. Look at the image and note whether you can see extra spikes of contrast near the edges

of January 2016 at least). At a more functional level, Mach also argued that the bands help to highlight and extract boundaries of objects.

It is true that lateral inhibition is present in the visual system. However, for both the Hermann grid and the Mach bands the actual explanation is more complex, too complex for this book, and still the subject of active research (Fiorentini 1972; McCourt 1982; Morrone et al. 1994; Wallis and Georgeson 2012). We will talk again about perception of brightness in Chapter 9.

Figure 1.7 shows the **Craik-O'Brien-Cornsweet illusion** (Cornsweet 1970). This is related to the Mach bands, and I have used the same method of showing how luminance changes with a line underneath the image.

There are two versions of the illusion, in the first the two rectangles are identical and sit side by side. However, they probably look quite different to you. In particular the one on the left looks darker than the one on the right.

In the second version of the illusion the change in luminance is only present in a small part of the image. Where the two halves come together there is a slight increase in brightness followed by a step change and then another increase back to the same original level. Compare the two halves and you should see the one on the left as darker than the one on the right. In this case you should cover the central strip with a finger or a pen and you will see that the left and the right sides are the same grey.

Just like for the Mach bands, the information about luminance is important to show that there is something strange going on. Our perception of brightness is not a direct result of the level of luminance of the image. What is happening instead is that abrupt changes are very powerful, and they affect what we perceive more than smooth changes.

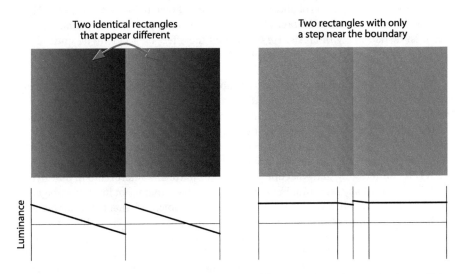

Figure 1.7. *Craik-O'Brien-Cornsweet illusion.* The darkness of the grey region is shown as luminance (light reflected) in the graphs underneath the image. In the demonstration on the left the two abutting rectangles are identical but they appear different in brightness, with the left one appearing darker. In the demonstration on the right the two rectangles are identical except for a strip in the middle. However you may perceive the left rectangle as uniform and darker than the one on the right. Try placing your finger on top of the central region to verify that they are the same

Note an important difference between the Mach bands and the Craik-O'Brien-Cornsweet illusion. In the images of Fig. 1.7, and in the second version in particular, what happens is that a local abrupt change in luminance affects how we perceive the whole surface. In other words the step at the edge between two surfaces is used to assign different colours to each of the two surfaces. We will see more examples of this phenomenon in the book (Chapter 10), but you can already see a similar case in relation to colour in the image of the Watercolour illusion in Fig. 1.8. Here it is a particular colour that spreads to a large surface.

Geometrical Illusions and Illusions of Ambiguity

In this book we focus on **visual** illusions. Many of these illusions are about shape and size: lines that do not appear straight, as in the Oppel illusion of Fig. 1.4, or shapes that appear distorted, as in the Shepard illusion of Fig. 1.1. More optical-geometrical illusions are in Fig. 1.5.

Figure 1.8 shows some illusions that do not fit into the category of classical geometrical illusions. I tried to show a range of effects. You can see three cases of ambiguity (Boring figure, Duck-rabbit illusion and Schröder staircase), one of brightness (Brightness contrast), one of colour (Watercolour illusion), one of alignment (Jittered squares), one of motion (Ouchi illusion), an impossible object (Penrose triangle) and even an illusion of numerosity (Solitaire illusion). As you may wonder, the Boring figure takes the name from an American psychologist called Edwin Boring (1886–1968).

An interesting class of illusions has to do with ambiguity. There are images that while not changing on the page are perceived as changing by the observer. The most famous reversible image is probably the Necker cube shown in Fig. 1.4 (Necker 1832).

The Swiss Louis Albert Necker (1786–1861) was not a psychologist, although as a scientist he had many interests. He discovered the effect by accident; he noticed the reversals in his work as a crystallographer, looking at the drawing of a crystal that had the shape of a cube.

The Necker cube can be perceived as a cube seen from above, and therefore the top square is seen as the top of the cube. It can also be perceived as a cube seen from below, as if it were stuck on the ceiling. In this case the observer is looking at the bottom of the cube. It may take a bit of time but if you explore the cube in Fig. 1.4 it will reverse at some point. The experience is quite remarkable as one is aware that nothing has changed on paper and yet one is suddenly seeing something different.

It is very interesting that what one perceives is a particular interpretation that gives a certain object. At any one point in time there is an object that is not in itself ambiguous or problematic. In other words each interpretation is stable, and what makes ambiguous is that it can abruptly change. For this reason this type of image is called **bi-stable**.

Another famous example of a bi-stable image is Schröder's staircase (or Schröder's stairs). This is also included in Fig. 1.8. The staircase can be seen as leading down from left to right or a staircase can be seen turned upside down. In one case the nearest wall is the one on the bottom left, in the other case it is the wall on the top right. It is named after Heinrich Schröder who published a paper about it in 1858 (Schröder 1858). If you are familiar with the artwork of M. C. Escher (1898–1972) you would have noticed that Escher made use of this type of illusion more than once (for example in the lithography *Relativity*, 1953).

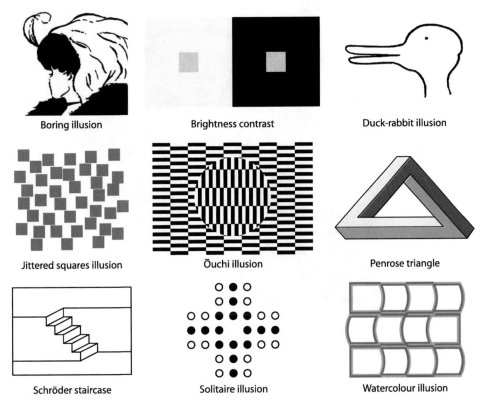

Figure 1.8. More illusions. *Boring* (1930) (young or old woman), *Brightness contrast* (Wallach 1948) (grey square on right lighter), *Duck-rabbit* (Wittgenstein 1953, but original from 19th century) (duck or rabbit), *Ōuchi* (1977) (inset moves), *Jittered squares* (Sowden and Watt 1998) (squares not level), *Penrose triangle* (Penrose and Penrose 1958) (impossible object), *Schröder stairs* (1858) (reverses over time), *Solitaire* (Frith and Frith, 1972) (black more numerous), *Watercolour* (Pinna et al. 2003) (line colour affects interior colour)

The Necker cube in Fig. 1.4 is a line drawing. This illusion, however, gives us also an opportunity to point out that visual illusions are not confined to images on paper or computer screen. In Fig. 1.9 I am photographed holding in my hands a Necker cube made as a solid metal object. The illusion is still taking place even with this object, as long as one closes one eye. Note another amazing aspect of this illusion. It is working even though the person is holding the object in their hands. When the cube reverses one perceives a change in what type of object they are holding (Bertamini et al. 2010a; Bruno et al. 2007; Shopland and Gregory 1964). If you are good at DIY you can build your own three-dimensional Necker cube with wood, wires or possibly long matchsticks.

Another example of a visual illusion that works as a solid object is the so-called **Witch ring**. These are rings that one can wear, but that have a pattern of reflections and when rotated they appear to expand or contract (Heard and Phillips 2014). The underlying visual illusion of expansion is related to the Zöllner illusion (see Fig. 1.5), and one version was described already by Michel de Montaigne (1533–1592) in the 16th century (Ninio 2001).

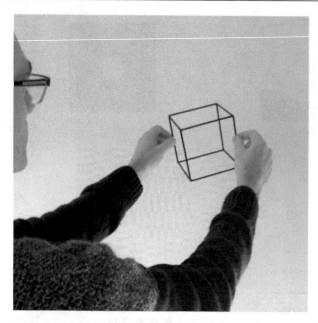

Figure 1.9. In this photo I am holding in my hands a three-dimensional *Necker cube* made of metal and painted black. Each side is 12 cm long. I still see the object reverse as the cube of Fig. 1.4 as long as I close one eye

The Necker cube and Schröder's staircase are examples of bi-stable images. The Boring illusion in which we can see a young or an old woman, and the Duck-rabbit illusion are also bi-stable and they can be organised in two very different ways. There are other types of ambiguity. Shadows for example can strongly affect the position of objects. In one famous study Kersten, Knill, Mamassian and Bülthoff (1996) describe illusory motion perception created by shadows. The movement of the shadow produces a perception of the motion of the object, even when the image of the object itself is stationary: *https://www.youtube.com/watch?v=eNqgg-wzXEM*

A final example of ambiguity relates to scene layout. Sometimes observers interpret a scene based on the visual information in a way that is incorrect, and we can call this error a type of illusion.

Let us consider the Venus effect (Bertamini et al. 2003; Bertamini et al. 2010b). Figure 1.10 illustrates the effect with a diagram and two examples from works of art. The diagram shows that when two people have different viewpoints they will see something different reflected in a mirror (the two people and the mirror form a triangle, person A can see person B and vice versa). It follows that in a scene in which we see a person and their face reflected, if we are not standing behind the person then that person cannot see what we see. Despite this basic fact most people describe these situations as if the person is looking at herself.

The next two chapters are about programming. After that we will start looking at visual illusions starting from some old classic. The first four (Kanizsa, Ponzo, Delbœuf, and Ebbinghaus) are the type of illusions known as geometrical-optical illusions, and

Figure 1.10. The *Venus effect*. The diagram shows that people standing in different locations see different images reflected in a small mirror. When people describe scenes, however, they tend to claim that the person in the scene is seeing herself in the mirror, even though that is what the mirror shows to the observer. On the right there are two examples of the toilette of Venus/Aphrodite theme. The first is a mosaic (3rd century) found near Philippopolis (Suweida Museum, Syria). The second is Velázquez's *Toilet of Venus* (National Gallery, UK). Whether the Venus effect is present depends on how people describe these scenes, not on what the artists did

in a sense they are the prototype for what a visual illusion is. Next we will see illusions of brightness, of colour, and we will finish with four illusions that involve motion.

Chapter 2
Programming
Is Fun

A programming language is a way to give commands to a computer. These commands are written as text and when we put many commands together we call that a program. Python® is a high-level, easy-to-read, interpreted language. We will see how to install Python together with an application called PsychoPy (which will be discussed in Chapter 3). We will also see how to write simple commands, perform mathematical operations, and control the flow of the program with if, for and while statements.

We have seen in Chapter 1 that illusions are fun. In Chapter 2 you will see that programming is also a lot of fun. OK, maybe not in the same way, and not without a little effort, but the effort required for what we will do in this book will not take much time, and the fun will continue forever (once you have started programming).

Programming is about asking a computer to do a series of tasks. Computers are clever and there is a lot that they can do. This list of commands needs to be written as text, therefore a computer program is always a text document, called the **source code**, but we will use the more general term **program**.

In order to be understood by the computer the program needs to be in a computer language, and therefore learning to program is about learning a new language. You may be familiar with the names of several programming languages such as Fortran, Basic, Pascal, C, Java™ and Python. They are a bit like French, Italian, Russian and so on; some things are common to all languages (the distinction between a verb and a noun) and some are specific (like learning the word for **cat**).

Because programming, in addition to knowing the rules of the language, requires a certain organisation and strategy, people debate whether programming is a skill, a craft, or an art. It is probably all of these things, which is what makes it fun in the sense that it allows us to be creative.

This is a very brief introduction to one general-purpose language called Python. I will discuss how to write simple commands, and also mention the few quirky aspects that may not be intuitive, like the fact that we will have to remember to count starting from 0 instead of 1.

Python®

It was Christmas time in 1989, in Amsterdam. **Guido van Rossum** (then 33) decided to write something that would go beyond the limitations of the languages he had worked on before, but without trying to come up with the perfect language (as a hobby project, something fun to do). We have all done that, creating something revolutionary over the winter holidays just because we were bored!

The name Python has nothing to do with snakes. Guido chose it because he was a fan of a TV show called **Monty Python's Flying Circus**. If you are too young to know who Monty Python are, do some research and watch some of their classic sketches. Then try to drag yourself away from YouTube and back to this chapter. The link with the TV show lives on because the official documentation often contains references to sketches from Monty Python (so don't be too surprised if the documentation refers to dead parrots for instance).

The project captured the interest and admiration of lots of other people and today Python is one of the most used and important languages around. True to its original philosophy, it is free and open-source, and has a community-based development model. The development is managed by the non-profit **Python Software Foundation** (*www.python.org/psf/*).

Because of its popularity you will find a large amount of useful information and tutorials online. The Python Software Foundation webpage is a good starting point. This chapter cannot be as detailed as an online tutorial; we will instead focus on the key concepts. A list of online tutorials is provided in Box 2.1. One word of caution, Python 2 is a bit different from Python 3, I will only talk about and use Python 2 (which is still the more popular version).

Box 2.1. Online tutorials and books

There are the links to some tutorials for beginners specific to Python 2.

- This first one is directly from the Python Software Foundation:
 https://docs.python.org/2.7/tutorial/
- This is a tutorial created for programming games but useful for anybody even with no programming experience:
 http://sthurlow.com/python/
- This is a very short introduction that fits on one (long) page, created by Magnus Lie Hetland:
 http://hetland.org/writing/instant-hacking.html
- This tutorial is for non-programmers and is a featured book on Wikibooks:
 http://en.wikibooks.org/wiki/Non-Programmer%27s_Tutorial_for_Python_2.6
- For PsychoPy there is a reference Manual here:
 http://www.psychopy.org/api/api.html

These two are tutorials that introduce Python as well as PsychoPy.

- The first one is from the Technical support group of the Radboud University in Nijmegen (Netherlands):
 https://www.socsci.ru.nl/wilberth/psychopy/index.html
- The second is from the GestaltReVision group (University of Leuven, Belgium):
 http://nbviewer.jupyter.org/github/gestaltrevision/python_for_visres/blob/master/index.ipynb

Although they are not tutorials, Jon Peirce has also published a couple of journal articles about PsychoPy. These are aimed at the academic readers.

- Peirce JW (2007) PsychoPy – Psychophysics software in Python. J Neurosci Methods 162:8–13
- Peirce JW (2008) Generating stimuli for neuroscience using PsychoPy. Front Neuroinform 2:10

Finally, although there is so much information available online, if you prefer to hold in your hands a book made of paper, here are two options (among many):

- Shaw ZA (2013) *Learn Python the hard way: A very simple introduction to the terrifyingly beautiful world of computers and code.* Addison Wesley Press, Reading MA
 This is the 3rd edition of a book that gives step-by-step instructions.
- Briggs JR (2012) *Python for kids: A playful introduction to programming.* No Starch Press, San Francisco
 This instead is written for kids, but nevertheless it is a proper introduction to Python and can be used by anybody new to programming.

Setting Up

Setting up is not the most fun part, but it will not take long and it needs to be done only once. The first thing to do is to install Python on your computer. Here is the good news: it is free, easy and possible on any major operating systems. Because of wanting to create illusions we will install it together with some useful libraries and packages. In our approach this is going to be a single download. The instructions to download and install Python together with an application called PsychoPy are in Box 2.2. I will explain more about this application and these libraries later, so for now just follow the instructions as a recipe.

Box 2.2. Downloading Python and PsychoPy

Using a web browser go to *www.psychopy.org*.

On the right side you will see a link called **download**. This will take you to a different location where the files are available. Here you will see a list with many different versions. We will use version 1.84.02 and therefore you can ignore everything else and select the file for the Operating system that you are using. For example:

- StandalonePsychoPy-1.84.02-OSX_64bit.dmg (if you use a Apple Macintosh® computer)
- StandalonePsychoPy-1.84.02-win32.exe (if you use Microsoft Windows®)

It is quite possible that by the time you are reading this the latest version has a higher version number. Older versions remain available by following the link to *https://github.com/psychopy/psychopy/releases*.

The word standalone refers to the fact that in a single file you are actually obtaining everything you need, including Python itself.

Mac® users should place the PsychoPy application inside the Applications folder. After installation MS Windows® users will find a link to PsychoPy in

- Start > Programs > PsychoPy2

There is also a Configuration Wizard with more information about the setting up.

The standalone file is large and it may take a bit of time for the download to complete.

As there are different versions of Linux, if you are a Linux user you need to read and follow the more specific instructions available here: *http://www.psychopy.org/installation.html*

The programs that we are going to write were created on a Mac®. However, it is my belief that they are suitable for any environment without modification.

The fact that there are many versions of PsychoPy (we will use 1.84.02) is a clue to the fact that this software is under active development, and improvements are released regularly. However, do not worry about which version you are using. It is not a good idea to feel that you have to race and get the one just released (although it is tempting).

Introduction to Programming

Since we have now downloaded and installed both Python and PsychoPy in a single step, we will use the PsychoPy application to learn a bit more about Python. Remember, Python is a language and for now we will focus on the structure of the language, so what we are doing is very general. We will issue a command and execute it by typing some text and then pressing the return key. This is called using Python in interactive mode.

The first step is to start the PsychoPy application that you have installed. Then inside the application go to the **View** menu and select **Go to Coder** view (on Windows® this may say **Open Coder view**). This is an important step because if you are seeing the Builder view instead of the Coder view nothing in this chapter will make any sense.

You should see a window similar to the one in Fig. 2.1 (this in particular is how it looks on an Apple Macintosh®). Note the two main horizontal panels. In the lower one there are two tabs called **Output** and **Shell**. Click on Shell and you will see a text that will inform you about which version of Python you are running. On my computer it looks like this:

Figure 2.1. The PsychoPy application (Coder view) showing two panels. The top panel is the *Editor* and is empty for now. The bottom panel has two tabs: *Output* and *Shell*

PyShell in PsychoPy – type some commands!

Python 2.7.12 (v2.7.12:d33e0cf91556, Jun 26 2016, 12:10:39)
[GCC 4.2.1 (Apple Inc. build 5666) (dot 3)] on darwin
Type "help", "copyright", "credits" or "license" for more information.
>>>

We can use this window to try out some Python commands and for now you can ignore the rest of the interface. Check that you see the prompt inside the Shell window. It looks like this: >>>

This means that the Python interpreter is listening to you. In other words Python expects an input. When Python will produce an output there will not be a prompt.

It is traditional to start by asking a computer to type the words "hello there". So please type the following followed by the return key.

>>> print("hello there")
hello there

The text should appear on a line below your command (without the prompt) as shown above. Congratulations, you asked the computer to do something and it did. Basically the shell environment in which you are working compiles and executes any command right away.

You have also learned that quotes identify a piece of text, and the text can include multiple words. Special words like print will appear automatically in blue, and any text like "hello there" will appear in red.

Now for some numbers and some variables. A variable is something that can take values, so the name of the variable is the name of the container.

```
>>> a = 0.5
>>> b = a * 2
>>> c = "word"
```

Variable a will have a value of 0.5, variable b 1.0 and c will be a string (text). No need to worry about the fact that these values are of different types, you can rely on Python to be able to cope with any kind of data. How? Basically by making an educated guess. This is known as **duck typing**. This name comes from the saying that if something walks like a duck, sounds like a duck, and swims like a duck, then it is probably a duck. I am not kidding, duck typing is a genuine technical term. For example by noticing that you used quotes around "word" Python knows that it is a string and the text editor has colour coded it as red.

Note that when you typed these lines nothing happened. The command print made something happen, but to fill a variable with a value will not generate an out. If you want to see the content of a variable you need to type its name followed by return, or ask for it to be printed.

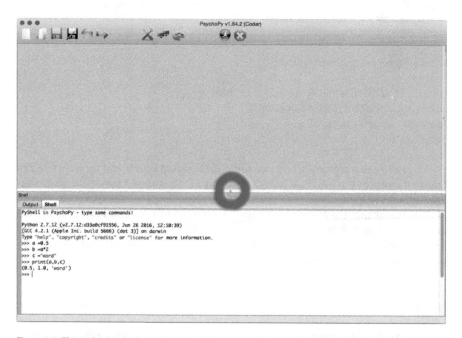

Figure 2.2. This is the PsychoPy application (Coder view) showing a few lines of commands in the Shell window. Here every Python command that is typed is immediately executed. Note that the size of the panels can be adjusted by dragging the handle (*small dot*) in the middle (highlighted in red)

Table 2.1. Python data types. This is a list of the main built-in Python data types, divided in *numerals*, *sequence* types, and *mapping* types. For each I give two examples

Data type	Name	Example 1	Example 2
Numerals			
int	integer	4	5912
float	floating point	7.23	3.14159
Sequence			
str	string	'hello'	"another example of a string"
list	list	[2,4,'a',9]	['Sheba', 'Simba', 'Smudge']
tuple	tuple	(2,4,'a',9)	('Sheba', 'Simba', 'Smudge')
Mapping			
dict	dictionary	{'one': 1, 'two': 2}	{'Sheba': 'black', 'Simba': 'ginger', 'Smudge': 'tabby'}

In the case of print you can ask for several variables to be printed by writing the names separated by commas.

```
>>> print(a, b, c)
(0.5, 1.0, 'word')
```

In a new line, without the prompt, you can see the values 0.5, 1.0, and 'word', as shown also in Fig. 2.2. This time the text 'word' is within single quotes ('word') rather than double quotes ("word"). Either way is OK for Python.

A list of the main built-in data types in Python, with examples, is given in Table 2.1. We have started to see values for integers (**int**), floating-point numbers (**float**), and strings (**str**). We will discuss lists next, they are very important.

Even though they are in Table 2.1 I will not say much about dictionaries because we will not have a need for this type of data. Briefly, they map a unique key (before the :) with a value (after the :). So you can see how they would be quite useful if you wanted to store for instance details of your cats (for each one a colour, a birthday, and so on). In this book we will focus on programming visual illusions, and therefore the most important types are the numerals, the strings for the text, and the lists for things like positions of vertices.

Lists and Strings

We often need to store a list of values. To do so we format the values with square brackets and separated by commas.

```
>>> aList = [12, 8, 4]
>>> aListOfLists = [[12, 8, 4], [2, 0]]
```

Lists are extremely important and we will make good use of them. The first example is a list with three elements, the second is a list of two elements (each with its own elements inside) and therefore it is a list of lists. You may have already guessed, but you could also have a list of lists of lists, and so on. Also, lists can contain elements other than numbers.

```
>>> myCats = ['Sheba','Simba','Smudge']
```

They can even contain elements of different types.

```
>>> myList = [1,'Sheba',2,99]
```

Next we need to know how to read values from a list. They are accessed with an index for the position of the element, starting from zero. Therefore try the following.

```
>>> print(aList[0])
12
>>> print(aList[2])
4
>>> print(myCats[0])
Sheba
```

Note that aList[3] is out of range. That means that we are looking at a position that does not exist and we will get an error. This is because our list has only three positions, 0, 1 and 2. Python is not the only language that counts from 0 instead of 1, it is something that computers like to do so we will have to get used to it.

You can also see a convention about naming variables. To make them easy to read we capitalise any new word within a complex name, for example we wrote aListOfLists. This is optional, not something necessary in Python, but we will follow this custom in writing variable names in this book.

Indices are very clever, for example you can give a range. aList[0:2] is a list with two elements (the first two). Another clever thing is that you can count from the back using negative numbers, so aList[-1] is the same as the last element which in our example is aList[2], and therefore it has a value of 4.

Given that we can specify a specific location we can use this to change a value inside the list. We specify the element using the index, and then use = to assign it a new value.

```
>>> aList = [12,8,4]
>>> aList[0] = 1
>>> print(aList)
[1,8,4]
```

What happens if we use round instead of square brackets? Actually more or less the same, you can also write lists that way, but in Python these are not called lists, they are called tuples. Once they are created tuples cannot be changed, and therefore are less

flexible than lists. For instance what we did in assigning a new value to aList[0] would give an error for aTuple[0].

```
>>> aTuple = (12,8,4)
```

If we were to check whether aList is equal to aTuple we would find that this is False (they have the same numbers inside, but they are not the same thing). We will mainly use lists rather than tuples.

```
>>> aList == aTuple
False
```

This comparison is False, but note that we need two equal signs to compare two variables. One equal sign simple replaces what is in the first (right side) with the second (left side). It's an easy mistake to make. Try to remember that = is always actively doing something, not making a simple comparison. The main Python operators, like ==, are listed in Box 2.3.

In a complex program we will need comments as well. Comments in Python start with the hash character, #, and extend to the end of the line (so there is no need to have an # at the end).

Box 2.3. Python operators

This is a list of the main built-in Python operators to perform comparisons. The result from any such comparison can only be True or False.

- == equal to
- != not equal to
- > larger than
- >= larger than or equal to
- < smaller than
- <= smaller than or equal to

This is a list of the main built-in Python math operators (to perform arithmetic operations). The result from any such operation is a number. Some are not used very often, so for example although the modulo operation (%) can be quite useful do not worry if it seems unfamiliar to you at the moment.

- $a + b$ addition
- $a - b$ subtraction
- $a * b$ multiplication
- a / b division (can give an integer or a float)
- $a // b$ division and rounding of the result to the lower whole number
- $a \% b$ modulo. It gives the remainder of a divided by b.
 Examples: 11 % 2 is 1, and 11.5 % 2 is 1.5 (what is left from the division)
- $a**2$ a to the power of 2, the same as a multiplied by itself: $a * a$
- $a**b$ a to the power of b
- $-a$ negation (changes the sign of a)

Python As a Pocket Calculator

Now let's practice some simple maths. Here is a bit of arithmetic (followed by a comment, which of course plays no part in the maths, it is shown in green here and comments will be green also in all our programs). What is the result of this operation?

```
>>> 4 + 3 * 2 #a bit of arithmetic, four plus three times two
10
```

The result is 10. If you thought it should be 14 this is a mistake (easy mistake to make, it was a bit of a trick question). Just remember the rule of precedence of operations: power, division, multiplication, addition, subtraction (PoDMAS). So the multiplication happens first even if it is written after the addition. We can avoid any ambiguity by using brackets when necessary, as in (4 + 3) * 2.

```
>>> (4 + 3) * 2 #a bit of arithmetic, four plus three, and the result of that times two
14
```

Next, what is the result of this operation?

```
>>> 10 / 4 #ten divided by four
2
```

That's easy, it should be 2.5. Well, your maths is correct but unfortunately this was another trick question. Really tricky this time. Because we expressed the division in terms of integers (whole numbers without decimals) we get an integer and the result is 2. Annoying perhaps, but easily solved by remembering that if we want operations with decimals we should include a decimal point.

```
>>> 10. / 4.
2.5
```

The result now is 2.5, and you don't even need to type the zero because 10. (ten followed by a full stop) is the same as 10.0 for Python.

OK, enough trick questions, now for text, you can use single or double quotes around text. The latter has the advantage that it copes with having apostrophes (single quotes) inside. So you can write "Father's day" using double quotes around it.

```
>>> print("Father's day")
Father's day
```

You can do clever operations with strings, using + and *.

```
>>> s = "hello" + " there"
>>> father = "pa" * 2
```

You may experiment and use print to see the results. Quite logically the results are "hello there" (placed inside a variable called s) and "papa" (placed inside a variable called father).

We can get the length of a string with len(). Therefore, len("Father's day") is 12, the total number of characters including spaces. This command applies to lists as well, for example len([1, 2, 8]) is 3.

Just like len(aList) provides the length of the list, there are other similar built-in functions, such as max(aList), min(aList) and sum(aList). They find the maximum value, the minimum value and the sum of all values.

```
>>> sum([1, 2, 10])
13
```

What if a list has text inside instead of numbers? max and min will treat strings in alphabetical order, so max will give the element that comes last alphabetically, but sum will not work with strings. Here are a couple of simple examples using "Father's day".

```
>>> len("Father's day")
12
>>> max("Father's day")
'y'
```

One final point about numbers and strings. And here you will see how Python can be really clever and flexible with data types. Suppose you have a number in a variable called, say, number.

```
>>> number = 5
```

What you want is to use it as a string, mixed in with some other text perhaps. You can turn the number into a string by saying the following:

```
>>> numberAsText = str(number)
```

Using the built-in function str() we are asking Python to treat what is inside the brackets as a string. And you can also go the other way:

```
>>> numberAsNumber = int(numberAsText)
```

This gets back a number again, something on which we can do some maths. This works for other types of variables as well. So here is another way to obtain 2.5 (the correct result) when diving 10 by 4. We can use float() to make sure that an integer is treated as a floating point number.

```
>>> float(10) / float(4)
2.5
```

As we have seen, inside the Shell window Python tries to execute each command typed after the prompt, and it will provide an error message if there is a problem. We can

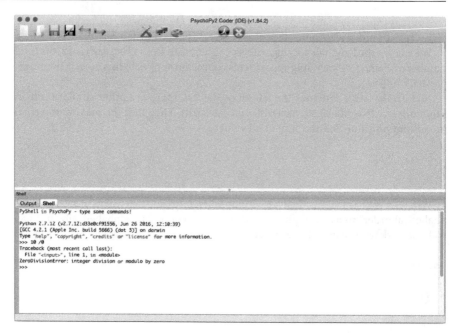

Figure 2.3. The Shell window of PsychoPy showing the error message generated when trying to divide 10 by 0

generate an error for example if we try to divide a number by zero (something that is not possible as there is no defined result). You can see the error message below and in Fig. 2.3.

```
>>> 10 / 0
Traceback (most recent call last):
  File "<input>", line 1, in <module>
ZeroDivisionError: integer division or modulo by zero
```

This is another example of an error generated when trying to find the sum of a string. In this case the message says that the operation is unsupported for this data type.

```
>>> sum("Father's day")
Traceback (most recent call last):
  File "<input>", line 1, in <module>
TypeError: unsupported operand type(s) for +: 'int' and 'str'
```

Controlling the Flow

We have seen how to issue simple commands, and put values in variables. But the real power of a program is when we write a series of commands and control how they are executed. This is done with special instructions that control the **flow of the program**. There are three control flow statements in Python: if, while, for.

Here is a first example that uses a for loop.

```
>>> aList = [1, 2, 3, 4, 5] #creates a list with numbers
>>> for item in aList: print(item) #loops over all the elements of the list and prints each one
1
2
3
4
5
```

This loop prints all the numbers in the list. To do that it uses a new variable item not used before. This variable is created within the for statement. Also note the : before the print command, this punctuation is necessary for any control flow situation, and you can read : to mean *do the following* (do say it aloud as you read the program, it does help).

Special words like for, while, but also not, in, print and others are written in blue in this book and are automatically coded as blue by default in PsychoPy.

```
>>> if len(aList) > 0: print(aList[0])
1
```

This will print the first element in the list. We checked that the list was not empty with an if and the len() command. This is useful because we can avoid the problem of trying to print from an empty list (which would give an error).

An if can also be combined with an else. After the word else and : there will be commands executed only when the if condition is False. For more complex situations where we need to deal with multiple possibilities we can use an elif, which is a contraction of the words *else if*. It does exactly what it says, it checks something (but only if the first if condition is False).

In a program you may want to use a for loop over a large range of numbers. Instead of preparing a long list we can generate the list using range().

```
>>> range(20)
[0, 1, 2, 3, 4, 5, 6, 7, 8, 9, 10, 11, 12, 13, 14, 15, 16, 17, 18, 19]
```

This command is very useful and we just have to remember a few facts about how it works. range(20) is a list of numbers from 0 to 19. Those are 20 elements in total because we start from 0, so it does make sense. To get the numbers from 1 to 20 we need to specify the starting number as well as the stopping number: range(1, 21). Again this will include 20 but not 21.

Therefore, as we have seen, when range() is written with just one parameter it produces all the numbers from 0 to the number just before the one given (the stopping number is never included). If range() is used with two parameters the first is the start and the second is the stopping number. Apart from that the result is as before, that is a sequence of numbers excluding the stopping number.

Finally we can even use range() with three parameters, in which case the third is the step.

```
>>> range(1,21,2)
[1,3,5,7,9,11,13,15,17,19]
```

This is a list of numbers stepping up two at a time. In this case this means all the odd numbers from 1 to 19 (again no 21, as before the last is always excluded).

You see here an example of how flexible Python is, range() can take one, two, or three parameters. The three parameters are **start, stop** and **step**. Stop is not optional, it has to be there (we need to know when to stop). If one of the others is missing there is a default value, so if the start is missing the start will be 0, if the step is missing the step will be 1.

Let us make a loop that prints odd numbers from 1 to 19.

```
>>> for item in range(1,21,2):print(item)
1
3
5
7
9
11
13
15
17
19
```

Now, before reading the solution (just below, but don't look!), try and write down (in the Shell window) a way to print all the even numbers from 2 to 20.

```
>>> for item in range(2,21,2):print(item)
2
4
6
8
10
12
14
16
18
20
```

Well done. You can start from 2 go until 21, and use a step of 2. Remember that you still have to put 21 as the end of the range, because if you enter 20 you will only see the numbers up to 18.

We have seen the for and the if, the while control loop works in a similar fashion.

```
>>> item = 0
>>> while item < 10:item = item + 1
>>> print(item)
10
```

Table 2.2. Iteration-dependent values of our variables

Iteration	Value of item	
	as we enter	as we come out
first	0	1
second	1	2
third	2	3
fourth	3	4
fifth	4	5
sixth	5	6
seventh	6	7
eighth	7	8
ninth	8	9
tenth	9	10

This loop will increment the value of item from 1 (the first time, when we add 1 to 0) to 10 (the last time, when we add 1 to 9), but will not execute anything when item is greater than 9 (therefore we will never add 1 to 10).

Sometimes it is useful to write down a little table showing the values of our variables on each turn (called iteration) of the loop. That is the value as we get in and as we come out. Table 2.2 shows how it would look like for our simple example.

A special command is called pass and does absolutely nothing. This can be useful when we get into a control flow situation that should have no effect.

```
>>> if myStomachIsFull == True and IAmSittingByTheFire == True: pass
```

I have taken the opportunity here to show a if followed by two conditions, joined by the logical operator and. You can see how this is easy to read, and special words like and and or work exactly as expected. The fact that they are automatically coded in blue also helps in making clear that they are special words.

You could read this line aloud like so: if it is true that myStomachIsFull and it is true that IAmSittingByTheFire, then do the following: absolutely nothing.

Here is a different example that uses or instead of and. Note that the two statements with == are either True or False, and only one of them needs to be True for the if statement to be executed. After the : the command with = assigns a value to the variable isTimeToEat. = and == should not be confused.

```
>>> if isLunchTime == True or isDinnerTime == True: isTimeToEat = True
```

Indentations

There is an important feature of Python, which is very specific to Python and that I cannot easily demonstrate from the prompt. Often we need to group a whole set of commands together. For example we may need to do that after a if or a for. Instead of using brackets Python uses indentations. This makes the text very clean and uncluttered, but it requires careful attention to the size of the indentation, as there can be multiple levels.

You will see many examples of indentations in the programs but here is a snippet of code with two levels.

```
for x in range(-10, 11): #remember these are numbers from -10 to 10 (not 11)
⟶for y in range(-10, 11):
⟶ ⟶ position = [x, y]
```

Now I will write something very similar but with the wrong indentation. This will produce an error.

```
for x in range(-10, 11): #remember these are numbers from -10 to 10 (not 11)
⟶for y in range(-10, 11):
⟶ position = [x, y]
```

This is known as an indentation error. After : (read it as *do the following*) Python expects some commands, but the next line is not indented and therefore it is not part of what should happen within the second for loop. As there are no commands after the second : this is an error.

When running a script the error message will appear in the Output panel (the one next to the Shell panel). For an indentation error it will print out the file name (containing the script) and the line on which the problem occurred.

```
File "/Users/marco/Projects/PythonIllusions/myProgram.py", line 78
    position = [x, y]
        ^
IndentationError: expected an indented block
```

This is very useful and most of the times you can then fix exactly the line where the problem is. The example above refers to the name of a file from my computer. We will learn more about how to save scripts in files in the next chapter.

Box 2.4 illustrates the way to look at indentations. Basically indentations create blocks, and these blocks are separate groups of commands. Therefore a change in indentation has a direct effect on the execution of the script.

We can fix the problem by moving the third line to be just after the :

```
for x in range(-10, 11): #remember these are numbers from -10 to 10 (not 11)
⟶for y in range(-10, 11): position = [x, y]
```

However, in most cases it is not practical to write what follows after : on a single line. We have done it in this chapter because we were just practicing simple one line commands. In the scripts that we will write as full programs we will need indentations. When we will have a loop, the many lines of commands that need to be executed within the loop should increase by one level of indentation.

In the example above we have seen a message about the indetation error generated by Python. However, for complex scripts an indentation error may also simply change the flow of the commands in a way that does not generate an error. The consequence is that what should be inside a block ends up outside that block. These

errors are harder to find and solve. The moral is that we always have to pay close attention to indentation.

By controlling the flow of the commands programs can be clever. We will also see how to group commands so that these groups will carry our specific tasks. When they are given a specific definition (a name and maybe some parameters) we will call these structures, logically, **functions**, but they will have to wait a bit.

Box 2.4. Indentations

Indentations in Python create blocks of commands. For example block 2 may only be executed after a condition is checked with an if in block 1, and block 3 may be part of a loop and be controlled by a for in block 2. In the book the tabs that create indentations are always shown as arrows. You will not see these arrows when you type in the Editor.

Moreover, you can use tabs or you can use spaces (Python will replace tabs with spaces behind the scenes). In general is a good idea not to mix tabs and spaces.

```
Line 1 in block 1
Line 2 in block 1
Line 3 in block 1
──→ Line 1 in block 2
──→ Line 2 in block 2
──→ ──→ Line 1 in block 3
──→ ──→ Line 2 in block 3
──→ ──→ Line 3 in block 3
──→ Line 3 in block 2
──→ Line 4 in block 2
Line 4 in block 1
```

Box 2.5. The Zen of Python in 20 aphorisms

- Beautiful is better than ugly.
- Explicit is better than implicit.
- Simple is better than complex.
- Complex is better than complicated.
- Flat is better than nested.
- Sparse is better than dense.
- Readability counts.
- Special cases aren't special enough to break the rules.
- Although practicality beats purity.
- Errors should never pass silently.
- Unless explicitly silenced.
- In the face of ambiguity, refuse the temptation to guess.
- There should be one – and preferably only one – obvious way to do it.
- Although that way may not be obvious at first unless you're Dutch.
- Now is better than never.
- Although never is often better than *right* now.
- If the implementation is hard to explain, it's a bad idea.
- If the implementation is easy to explain, it may be a good idea.
- Namespaces are one honking great idea – let's do more of those!

This chapter has probably set a record as the briefest and most incomplete introduction to Python. Not to worry, what we have learned is enough to start putting together some interesting programs, or at least it will be after we learn about the PsychoPy commands in the next chapter. What is necessary is, however, not to simply read about the way that Python works but to experiment by typing lots of slightly different things, lists, strings and operations from the prompt. Do spend at least ten minutes doing that from within the Shell panel before moving on to Chapter 3.

Finally, before we start using Python you may also be interested in the famous 20 aphorisms written by long-time Python developer Tim Peters (Box 2.5). They give a flavour of the programming philosophy, and some may apply to life in general (and yes, there are only 19 in the list, it's a Zen thing).

Chapter 3

PsychoPy
Is Fun

In this chapter we start to use Python within PsychoPy. PsychoPy is an open-source Python tool that makes it easy to get images and animations on the screen of a computer. It includes a text editor and we will see how to start a program by writing lines and saving the script to a file. In the process of learning how to use PsychoPy we also start learning about objects and object-oriented programming. Once we have created objects we will learn how to draw them on screen and after that we will be ready to write our first program (in Chapter 4).

250

X

But what is PsychoPy? Unlike illusions and computer programming which were the topics of the first two chapters you may have never heard of PsychoPy. PsychoPy is an open-source Python® tool that makes it easy to get images and animations on the screen of a computer. It was created for researchers working in psychology or neuroscience, because they have a need to control images on a computer screen, but this goal of making nice images is not confined to those fields and everybody can use it. It is also platform-independent so the same program can run on Windows®, Mac OS X® or Linux.

In Chapter 2 I have introduced the idea that writing a computer program is like speaking a new language. We have also learnt some of the words of this language. In Python we know how to say *assign a value ten to a variable called a*. But thanks to PsychoPy we will learn more useful phrases, such as *draw a red square please*.

PsychoPy was created by Jon Peirce (University of Nottingham), and we can read a special welcome note from him in Message 3.1.

Message 3.1. "Welcome to PsychoPy" from Jon Peirce

I should note immediately that, like Marco Bertamini, I am not a professional programmer. My degree and PhD were in psychology and neuroscience. I just enjoy writing code. For me programming is problem solving, and I really enjoy problem solving. Some people like the challenge of cracking sudoku puzzles, but I enjoy working out what code will make my computer do what I want. As with sudoku, I sometimes hit a barrier that can drive me crazy for a while, but usually I solve the problem and then I'm even more happy that I worked it out. The difference is that I then have something tangible to take away and keep (what do people do with their solved sudokus?).

I began writing PsychoPy because I needed something where I could change my stimulus dynamically and easily. This was in 2002 and there weren't many options for that in those days. Psychophysics tool-box, the nearest possibility, was not capable of using OpenGL (see Box. 4.1) for real-time stimuli back then, so I began writing my own system in Python. Initially this was written as a proof-of-principal that we could use Python and OpenGL to do some cool graphical tricks but it just grew. By late 2003 I was developing PsychoPy for my own experiments. I made it available to others online and, gradually, people starting using it and asking me to add things. Remember, I like problem solving, so when I was asked to add something interesting ("Could PsychoPy present a movie stimulus?") I often couldn't resist the temptation and it appeared as a feature.

Gradually other volunteer developers (mostly academics) got involved as well and, over the years, the PsychoPy library and application became relatively bug-free and widely used.

In short, it was never my intention to write such a substantial package. It all just began with me programming a few stimuli, in much the same way that you are learning the basics of presenting some stimuli now. So just watch out in case your programming addiction snowballs like mine did!

Jonathan (Jon) Peirce received his degree in psychology from the University of St Andrews and his PhD from Cambridge University. This was followed by a period in America at New York University. He has been at the University of Nottingham since 2003. His research interests are in visual neuroscience.

In this chapter you will learn about PsychoPy. The focus is on understanding the logic and the commands, and therefore the programs are not trying to be elegant or fast. The main criterion will be a consistent way of doing things (across all the illusions) that can be understood and adapted, so that you will know what your program does and you can change it to experiment with new images. Full details about all the features of PsychoPy are online at *www.psychopy.org*, and in particular the so-called **application programming interface** (API) is at *www.psychopy.org/api/api.html*.

If your computer is online the API and its detailed documentation on the website is the obvious tool for reference. In addition to the API the site includes much information specific to creating experiments and collecting responses, this may not be relevant except for vision scientists and advanced users, but *www.psychopy.org* is still the key reference for anything to do with PsychoPy.

Writing a Script in the Coder Editor

PsychoPy has a **Builder** view and the **Coder** view. I will say nothing about the Builder (except in Box 3.1), because we want to have fun programming, so remember to switch view to Coder (from the View menu).

Box 3.1. Builder and Coder

PsychoPy is a package with a specific purpose. It was born to create experiments in the field of psychology and neuroscience, and in particular what are known as studies in psychophysics. Therefore the typical program is about an experiment in which certain images are shown and certain responses collected from participants. Imagine for instance that you want to find out how much brightness you need before a participant is able to read a word. The brightness of the word is changed up and down and the observer has to try and read it. This is the simplest example I could think of, and countless other experiments can investigate how people perceive shape, colour, motion, faces and so on.

Because of this purpose, PsychoPy includes a series of tools to create experiments. In particular the Builder allow the rapid development of experiments. Instead of asking the programmer to write commands, it provides two panels in which there is a visual interface with boxes that represent what in the Builder are called the *routines* (in one panel) and the *flow* of the experiment (in another panel).

From within PsychoPy there are two main views, when we are in Builder view we see routines and flow, when we are in Coder view instead we see the *text editor* in which we write a series of commands in Python (this is shown in Fig. 2.1).

I will not describe the details of how the Builder works because in this book we are not interested in creating experiments. The key idea is that the flow represents the flowchart of the experiment. This flowchart is created by selecting options from menus, so the Builder allows a user to create a program without actually doing the programming.

In the background the Builder is doing all the work of translating the options selected by the user in actual Python commands. The result is that the Builder does create a program that is a Python script and can be seen and modified by the user.

The bottom line is that there are two good reasons why we are not going to use the Builder. The first as I said is that we are not putting together experiments. The second is that I have argued that programming in the sense of writing commands in a programming language is fun. We are learning bit by bit how to **speak** Python, and that means that we will be able to communicate much more effectively with the computer using this language.

If you decide that you do want to know more about the Builder, the logical place to go is the main PsychoPy website and in particular the following page:
http://www.psychopy.org/builder/builder.html

Languages like Python have many features that are built-in, and many others that are available as additional packages. In Python these packages are added by importing **modules**. Therefore, the first thing that we are going to do is to write a few lines in the Editor about what modules we want to import. In Python this is simple and transparent.

```
import math, numpy, random #to have handy system and math functions
from psychopy import core, event, visual, gui #these are the PsychoPy modules
```

The first three are modules that allow the program to work with numerical operations and maths. The second line is a bit different as it says that from PsychoPy we want a set of specific modules to deal in particular with core commands (such as quitting the program), events (such as pressing keys on a keyboard), visual stimuli (drawing) and the graphical user interface (gui).

These lines and all the following lines can be typed into the main PsychoPy Editor window. Just click on the first of the icons (the blank rectangle) to open a new document. The first two lines in the Editor are shown in Fig. 3.1. A full listing of the programs in this book is available online (*www.programmingvisualillusionsforeveryone.online*).

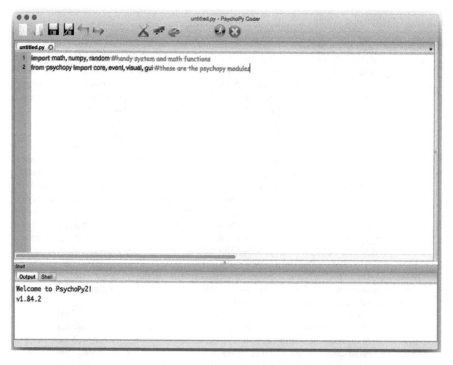

Figure 3.1. This is the PsychoPy application showing the *Editor window* and the first two lines of a program. Special words are in blue and comments are in green. The Editor provides this colour coding for us automatically

You can either type the commands or download the script, but I recommend that you try typing all the commands.

The name **module** may sound strange. In reality a module is a Python file that has definitions of variables, functions, and classes, and can be used as a library that holds useful information. In other words if you were to open up some of PsychoPy modules, or any other module, you could read all the details of its functions. It is all in the Python language and in plain text (although the scripts may be long and complex). You will never need to do that, but it's nice to remember that there is nothing mysterious about modules, they are just places where lots of stuff has already been programmed for us to use.

Note the useful colours, within the Editor window PsychoPy will colour as blue any special keyword (such as import) and as green any comment. As we saw in Chapter 2, comments are whatever you type after a # sign, and they are just there for information. They play no part in the actual program and if you were to remove all of them it would make no difference. But do not underestimate the importance of comments to humans! They are there to make clear what is happening and for future reference.

I have added comments for the two lines that you have seen already, saying that here we are importing the necessary modules. I will also add a comment before every new function later. However I will not add comments for most of the commands as the script may end up being too wordy and the explanation is hopefully clear from the text in the book. Feel free to add your own comments as you type.

Unlike the commands written after the prompt >>>, we are now writing a whole script in the Editor window, and therefore nothing will happen until we run our script. That will be in the next chapter, where we have an illusion to look at.

Although it may feel a bit different to write a whole script in the Editor window compared to issue commands directly in the Shell window, the difference is mostly superficial. All the lines in our script will eventually be read and executed by Python one after the other, exactly the same way that they would be executed if we were to type them all in the shell. The main difference therefore is that we like to put a whole script together and save it as a file somewhere (to be open up again when we need it). This long script is what we call a program.

Creating a Python Object (a Window)

Next we specify the window that we want to use. Python supports an **object-oriented** style of programming and most stimuli in PsychoPy are Python objects, with various associated functions and information (see Box 3.2). So what is an object within a program? It can be many things. An **object** is a specific implementation of a type of objects, which in Python is called a **class** (think of Sheba, asleep on your sofa, as an implementation of the class cat).

Our window will be an object, so we can learn more about objects by considering this specific example. We create an object of type window by giving it a name.

```
myWin = visual.Window(color = 'white', units = 'pix', size = [1000, 1000],
                      allowGUI = False, fullscr = False) #creates a window
```

Box 3.2. Object-Oriented Programming (OOP)

In this book we do not learn object-oriented programming, but we make use of objects. Therefore in this box I mention a few more things about this type of programming. Traditionally programming has been thought as a logical way to solve a problem, and therefore a series of instructions, which perform actions on a computer. In the early seventies the idea was proposed that it is better to think in terms of data rather than actions. The grandfather of OOP was called **Smalltalk**, developed for educational use at Xerox Palo Alto Research Centre and released in 1972.

What objects are needed for a program? Maybe an object could be a person (if I want to create a contact list) or a button on the screen (to interact with the user) and so on. Each type of object, also referred to as a class, has its own specific variables and functions, called methods. One advantage of OOP is that for a class, like cats, we can have subclasses, like for examples male cats and female cats. They will share most features and have some that are additional. Once there is a class or a subclass many individual exemplars can be created. These are implementations of a class, for instance Sheba and Simba could be implementations of the class cat. Or Sheba could be an implementation of a female cat, which makes her automatically a cat.

Modern languages that allow object-oriented programming include Python, Java™ and C++. It is interesting to note that not everybody agrees that OOP is always the best way to program.

It is worth spending some time on this, as it is the first PsychoPy object that we have seen. We start with the name myWin. This is a label and you can select the one that makes more sense to use, so for instance we could have used myFirstWindow. This is like choosing a name for your cat, you can call her whatever you like. From now on, however, for consistency, our window will always be called myWin.

After the name and an equal sign there are two words connected by a full stop: visual.Window. You will see many of these. It says that we are creating an object based on the class window, which is inside the module visual. We can use the module visual because we have imported it at the beginning of the script (from psychopy import core, event, visual, gui). From this point onwards an object called myWin exists and it can be used. At the time of creation we specify a few things with parameters. Parameters are inside brackets and separated by commas.

The parameters for our window specify: colour of the background (color = 'white'), the units of measurement (pixels, units = 'pix'), the window size (1 000 × 1 000 pixels, size = [1000, 1000]), the fact that it is not a normal window with buttons (therefore no graphical user interface, allowGUI = False), and the automatic taking up of the full screen is switched off (fullscr = False).

The class window has many parameters, and we have only set a few of them. This is fine because what we do not set is left to its default value, which in most cases is OK. This will also happen for other objects that we will see later. Some arguments are strings, some are numbers and some are lists, for instance size is a list with two values (the x and the y, which are the width and the height of the window).

When we have many parameters the line may be long and it may not fit nicely on your screen. Fortunately it is possible to put parameters on separate lines as long as we have an open bracket. Remember formatting and indentations are important in Python so we have to do this like this:

```
myWin = visual.Window(color = 'white', units = 'pix', size = [1000, 1000],
                      allowGUI = False, fullscr = False) #creates a window
```

Actually you can break a line more than once, Python will not get confused because this is all within brackets. In this case the indentation does not create blocks and is there only to line things up nicely. Therefore we could also write the following.

```
myWin = visual.Window(color = 'white',
                      units = 'pix',
                      size = [1000, 1000],
                      allowGUI = False,
                      fullscr = False) #creates a window
```

The comment is completely ignored by Python so we could also do the following (but I think it is confusing so we will never do that).

```
myWin = visual.Window(color = 'white', #creates a window
                      units = 'pix',
                      size = [1000, 1000],
                      allowGUI = False,
                      fullscr = False)
```

You may recall that range() also could take a variable number of parameters (between one and three: start, stop and step), although in that case they did not have names within the brackets. This is a general feature of programming in Python, parameters can be named or not. Importantly, when some parameters are missing and therefore the values are not specified a default value will be used. Again we had already seen that with range(). If there was no start the starting number was 0. In other words range(0, 10) is the same as range(10).

Although PsychoPy was born in Britain it uses American spelling, so note **color** and a few other words should be written wrongly (well, from a British point of view that is).

Our Canvas

PsychoPy is very flexible on many things, for instance in the use of different units, from pixels to centimetres to screen size. We will use pixels as it is more intuitive and allows us to work and think in terms of integers.

What we have now, thanks to just three lines, is a canvas on which to work, like a blank piece of paper. It is a square space (1 000 × 1 000 pixels) and the line that creates the object myWin will also make it visible on the computer screen. A window of this size will probably not take over the whole screen, which is useful for now, as it will give us more control in terms of switching between our program and other applications, and in particular it makes it easy to go back to the Editor. You can make the window take over the whole screen easily at any point by changing the parameter fullscr = False to fullscr = True.

The **origin** (0,0) by default will be in the middle of the screen. Positive values go to the right and up, and negative to the left and down, again this should be intuitive and is illustrated in Fig. 3.2. You can refer back to this figure to know the location of your coordinates for all our programs.

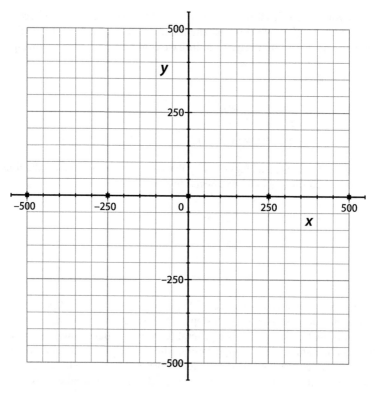

Figure 3.2. The coordinates of our window. The centre is [0,0] and the values increase to the right and upwards. If we move to the left or downwards the values decrease and therefore become negative

Creating a Python Object (a Clock)

Just like we have created a window and given it a name, we can create a clock and give it a name.

```
myClock = core.Clock() #this creates and starts a clock which we can later read
```

As you see we just need to know that a clock can be created using the PsychoPy core module. Similarly to the naming of the window we chose a logical name for our clock. Having a clock means that at any point we can read the time. We can also reset the start of the clock if we want to use it as a stopwatch and therefore use it to check how much time has elapsed.

For the first time I will now describe a command given to an object, this is a function specific to that object. For a clock the logical thing to ask is the time. You don't need to type this in the window because we will not use the clock in our first program.

```
timeNow = myClock.getTime() #this places the current time in a variable called timeNow
```

What you can do with an object depends on the object. PsychoPy is clear and logical on how it is organised, so it is not surprising that for most objects created using the visual module (like circles and rectangles, and unlike a clock) there will be a command called .draw().

```
myCircle.draw()
```

Please note the brackets at the end of .getTime() and .draw(). Even though in these cases there was no need for parameters it is important to note that the brackets are part of how commands are written. We will see many more examples of this in the next chapters.

A Setup for All Our Illusions

At the end of our script we will close the window and quit the program.

```
myWin.close() #closes the window
core.quit() #quits
```

These lines are not very interesting, although they show other examples of commands (the command .close() for a window and the command .quit()). We will always include these two lines at the end of our script for nice housekeeping.

For now we have described a **setup**. We will use exactly this setup for all our programs. In the process of explaining the setup we have seen the object-oriented logic that is key to how we will create our programs. Within the window we will present different shapes, and we will create these typically once, at the beginning of the script, and then use them. Conveniently objects can be changed after they have been created, so a single object can for instance be presented in a number of different colours. Think of an object that you have created as something you can play with, if it is a square you can move it, spin it, change colour and so on.

To repeat this concept, an object is not a unique entity that can only exist in one place. This would force you to create ten objects if you wanted to show ten objects on the screen. This is not necessary, you can have one object and show it in ten different places at once, maybe with ten different colours. Of course we have not seen yet how to do this, but we will soon.

We have seen in the case of the window that when we create an object we use parameters to set up attributes. Sometimes attributes will be text, other times they will be numbers, or lists.

As we have seen in Chapter 2, in Python there are flexible ways to write numbers. If it is a single integer and floating point we have introduced the term **numerals**. As we work in pixels it makes sense to think of *x*- and *y*-coordinates as integers, but we can also use floating-point values (with decimals). These are perfectly reasonable ways to refer to coordinates, and they will be treated by the program with the best precision available (given the underlying environment of your computer). Basically if you specify a line with a starting and ending point you then leave it to PsychoPy to draw it as smoothly and precisely as possible. That's great as we can just focus on what we care, that is the drawing in terms of objects such as lines, circles and so on.

With respect to x-,y-coordinates, it makes sense to pair them in a list.

aPoint = [0, 0]

This specifies a position in the centre of our window. We have to remember that we put the x first and the y second. For complicated reasons, mainly to do with doing sophisticated maths, the numpy module uses its own numpy arrays instead of simple lists. As you remember numpy is one of the modules we have imported, but not yet used. PsychoPy will turn lists into numpy arrays for its own internal working. Fortunately we do not need to worry about this distinction. Although it is useful to know, we will always specify x,y-coordinates as lists and not as numpy arrays.

Often an object will need more than one location (two points for a line, four for a rectangle). These are collections of pairs, so it makes sense to use a list of lists.

verticesOfSquare = [[2, 2], [-2, 2], [-2, -2], [2, -2]]

The equal sign means we have placed these values inside a variable called verticesOfSquare. These coordinates specify a square with a side of 4 (from –2 to 2). We can practice what we learned in Chapter 2 and read each of the pairs using indices.

verticesOfSquare[0]

This is the first pair, and it specifies the first vertex. If you were to print this variable you would read [2, 2] and these are x,y-coordinates. Given that they are both positive this vertex is in the top right quadrant (refer back to Fig. 3.2 for the way the coordinates are set up).

The second vertex is

verticesOfSquare[1]

This is [-2, 2] and therefore this vertex is in the top left quadrant. To practice what we know about lists, we can see how to access just the x- or y-value of the first pair.

verticesOfSquare[0][0]
verticesOfSquare[0][1]

Each of these is a numeral, not a list. When you see something written like this you need to think that you are using two indices because you have a list of lists, so the first example verticesOfSquare[0][0] refers to the **first** element of the **first** element.

Sometimes in programming we make compromises, and as one of the Python principle says *simple is better than complex*. In the case of x- and y-coordinates we could have created objects with explicit x- and y-components. Instead we have chosen to use a list with two elements, and the first (position 0) will always be the x-value and the second (position 1) the y. We will always specify x,y-coordinates this way.

Different Types of Functions

At this point it is best to go over the different types of commands that we have seen. In Chapter 2 we have learnt about some built-in commands like len(). This command is a function that takes a list as an argument (within the brackets) and computes the length.

```
>>> aList = [2, 4, 8]
>>> print(len(aList))
3
```

Now we have introduced modules, and some functions come from these modules. Therefore to use these functions we need the name of the module followed by a full stop. Here is an example we have seen from the core module.

```
core.quit()
```

We have also introduced objects, which are instances of a class. Each class, and therefore each object, has its own functions. We have seen a few examples like .draw() and .getTime(). Because they are specific to that object they are attached to the name of the object with a full stop.

```
myCircle.draw()
timeNow = myClock.getTime()
```

It is important to understand the differences and also the similarities. All functions may take parameters, and which parameters can be used is something that one has to learn. Fortunately there is no need to spend a lot of time trying to memorise how a function works because it is easy to look up the information when it is needed. As we have seen both Python and PsychoPy are beautifully documented online.

Functions may or may not return something. We have seen that len() returns a number (the length of a list) and that .getTime() returns the time. Again, when in doubt we can always look up the information about what is returned by a function. We have also seen how to store something returned by a function in a variable.

When starting to program it may seem strange that we can use functions that are specific to an object that we have created ourselves. So for example myClock is a name we have chosen. Something with that name did not exist before the line in which we have created this particular instance of the class Clock(). I am showing that line below again.

```
myClock = core.Clock() #this creates and starts a clock which we can later read
```

This is the key idea of object-oriented programming. We create objects that have properties and functions associated with them. Then we use these objects when we need them, by calling their functions and also accessing variables that are stored inside them.

Gaetano Kanizsa (1913–1993) was an Italian psychologist and artist. Kanizsa may not sound like an Italian name, and this is because he had a Hungarian-Jewish father and a Slovenian mother. He was born in Trieste, a beautiful city on the Adriatic Sea with a long and rich history and a mix of cultures.

Kanizsa is best known for his work on illusory contours and perceived completion of partly occluded shapes. In particular his name is used in many psychology textbooks to describe the Kanizsa triangle. Properly aligned circles with gaps give a strong impression that a triangle is present on top of the black shapes, as shown in Fig. 4.1 (Kanizsa 1955). If you see the edges of the triangle, this is an illusion because there is no edge there, in the sense of a change in colour or brightness that we can measure. Because we see contours that are not present in the image these contours are referred to as **illusory contours,** or sometimes as **subjective contours** (Kanizsa 1976).

The importance of this type of demonstrations is clear in some of Kanizsa's own writing: "The optical system always fills gaps, goes beyond the information given through perceptual interpolation. This must be considered not simply as an interesting phenomenon, curious or worthy of note, but on the contrary, as a norm of visual perception, a universal fact that happens every time we find ourselves in front of a field organised as figure and background" (Kanizsa 1979).

In most scenes there are multiple objects, some are nearer and some farther away. It is normal to see incomplete objects, with many parts hidden. Therefore the visual system must make sense of a scene in terms of figure and ground all the time, and go "beyond the information" to use Kanizsa's words.

Illusory contours have been the subject of much research. For example we know something about how the brain responds to these contours, and that this response is in the early part of the visual cortex. In particular studies have shown a response in visual area V2, an area devoted to encode edges and orientations (von der Heydt et al. 1984).

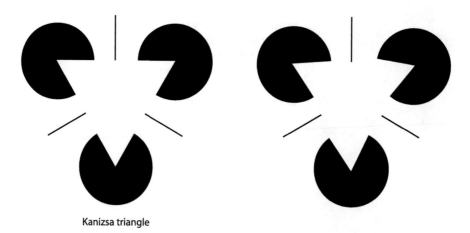

Kanizsa triangle

Figure 4.1. *Kanizsa triangle.* On the left there is the illusion of a white triangle on top of black circles and lines. The triangle may appear a bit brighter than the background. This configuration is typical of many that are used as demonstrations of illusory contours. Although the edges are sharp on the left, you may be able to still see illusory edges also in the configuration on the right. This demonstrates that perfect alignment is not necessary. Moreover it also shows that we can see illusory surfaces that are not perfectly regular

To support the view that perceiving illusory contours is part of the natural way of seeing the word for most visual systems, it is also interesting to note that many other species of animals perceive illusory contours. Using clever experiments and procedures, perception of illusory contour has been documented in domestic chicks (Zanforlin 1981), barn owls (Nieder and Wagner 1999), cats (Bravo et al. 1988), sharks (Fuss et al. 2014), goldfish (Wyzisk and Neumeyer 2007) and cuttlefish (Zylinski et al. 2012).

In Message 4.1. we hear from Giorgio Vallortigara. He has studied extensively the visual system of domestic chicks, and also that of several other species. Some aspects, such as perception of visual illusions but also differences between the left and the right hemispheres of the brain, are shared across many species, although there are also interesting differences.

In Fig. 4.1 if you see a white triangle you also see that the circles are partly occluded. We cannot see the bits of circles that are covered up, so we do not see these black regions the same way that we see the illusory white triangle. Although we don't see the missing parts of the circles, we experience their existence. Psychologists have come up with a special word to describe that: **amodal perception**. The first to use it was a Belgian psychologist called Albert Michotte (Michotte et al. 1964). Since then there has been much work using a number of techniques (Corballis et al. 1999; Fantoni et al. 2005; Kellman et al. 2001; Sekuler and Murray 2001; van Lier and Wagemans 1999).

In the Kanizsa triangle of Fig. 4.1 we therefore have two phenomena: illusory contours for the white triangle, and amodal perception of the partly hidden black circles. There is evidence that objects are perceived amodally, and that we do not just **know** that there are circles. An example comes from Albert Michotte and is shown in Fig. 4.2. There are three different shapes, but as soon as they are covered up with a pencil (you can also use a real pencil) they appear as identical triangles.

Studies have shown that when occlusion is present, perception of the complete object behind another occluding object is fast and automatic. We use the word 'automatic' to mean that what we perceive occurs spontaneously, quickly, and without conscious thought or attention.

To test this, scientists have devised a number of situations where objects were presented briefly or where observers had to produce a response as quickly and accurately as possible (Gold et al. 2000; Sekuler and Palmer 1992). An example of one study is described in Fig. 4.3. Observers are fast at matching a fully visible shape with the same shape partly occluded. By contrast, they are slower when they have to match two

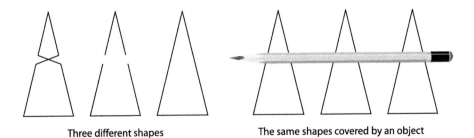

Three different shapes The same shapes covered by an object

Figure 4.2. On the left you can see three *different shapes*. Next, try to cover up these shapes with a finger or with a pencil, as shown on the right. When occluded the triangles are perceived as complete and identical, despite the fact that we know from memory that they are different (Michotte et al. 1964)

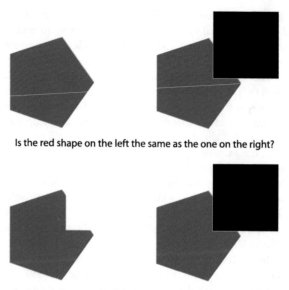

Is the red shape on the left the same as the one on the right?

Is the red shape on the left the same as the one on the right?

Figure 4.3. *Matching shapes* with parts occluded. In one experiment by Bruno et al. (1997), observers saw a shape like the red one shown here (left). Then the shape would disappear and reappear farther to the right, as shown on the right. Observers had to quickly decide whether it was the same shape. Here the answer would be 'yes', but sometimes a different shape would be shown (the hexagon was replaced with a pentagon, or vice versa). Let us only consider the case where the correct answer is 'yes'. People were fast and found it easy to say that the two shapes were the same in the top situation (the object seems to move underneath a black square). They were slower in the bottom situation, even though the red regions are identical in this case (for details see Bruno et al. 1997)

shapes that are identical, but one is occluded and the other is not (Bruno et al. 1997). The best explanation is that it is impossible not to see the shape as occluded and therefore complete whether we want to do that or not.

The Kanizsa.py Program

Let's write a program that shows a square with illusory contours. You can download the file from *www.programmingvisualillusionsforeveryone.online* and the name is Kanizsa.py. After downloading it you can open it up from within PsychoPy (or drag it on top of the Editor window).

If you prefer to type everything just remember to save the file and use a name like Kanizsa.py or perhaps myKanizsa.py. The extension .py is always attached to Python® programs. I recommend that you type the commands, the script is not very long (Kanizsa.py will have a total of 43 lines).

We will use a square instead of a triangle, but the idea is the same. Illusory contours can exist for simple or complex shapes, and for both regular and irregular shapes. We will start with the setup that you have already seen in Chapter 3.

Message 4.1. "Shared illusions" by Giorgio Vallortigara

I have a long-standing interest for the study of visual illusions in other animals. One reason is of course associated with the idea of homology. Structures in the mammalian brain that process, say, occlusion, might have evolved from early chordates and being now observed in different taxonomic groups, for instance birds. Thus, perception of illusory contours or amodal completion that I studied in young domestic chicks could provide evidence for shared brain mechanisms. I must confess, however, that I am more intrigued intellectually by a second line of reasoning. I believe that Mother Nature (alias natural selection) must have available only a limited number of tricks, for given the properties of the physical world, the physical/chemical material available, and the needs for organisms of picking up basic information in that world, nervous systems are strikingly constrained in the way they can be built up. Thus, for me studying illusions in creatures so different from us such as birds or bees is a way to unveil the boundaries for the design of a brain (Vallortigara 2004).

Giorgio Vallortigara received his degree and PhD at the University of Padua. After a period at University of Sussex, in UK he held positions at University of Trieste first and then at University of Trento, where he also served as director of the Centre for Mind-Brain Sciences. His main research interest is comparative behavioural neuroscience.

```
import math, numpy, random #to have handy system and math functions
from psychopy import core, event, visual, gui #these are the PsychoPy modules

myWin = visual.Window(color = 'white', units = 'pix', size = [1000, 1000],
                      allowGUI = False, fullscr = False) # creates a window
myClock = core.Clock() #this creates and starts a clock which we can later read
```

Thanks to these lines we have a window to draw in. It has a white background and it has a size of 1 000 × 1 000 pixels. Next we create some new objects, in particular a circle and a square. The logic is that once we have an object we can then place it in the window, which is like our canvas.

```
disk = visual.Circle(myWin, radius = 80, fillColor = 'black', lineColor = None)
square = visual.Rect(myWin, width = 200, height = 200, fillColor = 'white', lineColor = None)
```

The name disk is just a name we have chosen for a circle. It is true that we want the circles to be only partly visible but this will be achieved by drawing the square on top. Similarly, square is our name for a square.

As we create these objects we set some parameters. For the circle we specify a radius in pixels, a colour for the inside of the shape and a colour for the outline. This will be a black circle with no outline. For the square we specify a width and a height, and we want the square to be white. Note how PsychoPy is able to understand strings such as 'black' and 'white' for the colours. Later we will see that we can use other ways to specify colours with more precision.

We have learned about two classes, visual.Circle and visual.Rect. The full list is on *www.psychopy.org/api/api.html* but fortunately many of the properties are shared. For example, as you can see, fillColor and lineColor are parameters for the colour of the inside of the shape, and of the outline of the shape. They apply to the square and to the circle. Other parameters can be easily understood, as in the case of radius for a circle. Circle and Rect (as well as Polygon and Line) are closely related because they are special cases of a more general visual.ShapeStim class. We will see more of these objects in other chapters.

The disk and the square now exist, but we have not drawn them yet on our screen. To do that we need to use the .draw() command for each of them.

```
disk.draw()
square.draw()
```

As we have not set a position they will be placed on the centre of the screen. Here is a surprise: at this point they have been drawn, but not yet made visible. There is one more aspect of PsychoPy that we have to introduce. As is often the case with images on a computer screen, instead of drawing right away on the visible screen, by default images are drawn on a hidden (back) page.

Let's use a metaphor, you are at school and the teacher has asked you to draw something on paper. Because your drawings are quite nice she wants to put them on display. You start with a blank piece of paper and draw a cat, as you finish you give it to the teacher who hangs it on a board and at the same time gives you another blank paper. So what you are drawing is always just a private effort, and only when the drawing is finished it gets displayed on the board. The computer will do the same. You can draw lots of shapes but they will not be visible unless and until you hand them over to the teacher.

There is a command to do just that. Think about our canvas as it is shown in Fig. 3.2. Now think of a second identical copy, the drawings always end up on this hidden copy, then you swap the invisible (back) with the visible (front) canvas. They are also called back buffer and front buffer and the operation is called **flipping** the buffers.

```
myWin.flip()
```

The bottom line is that only a .draw() (or many of these) followed by a .flip() will produce something that we can see inside the window. I tried to show the idea of a back and front windows in Fig. 4.4.

Just as in the drawing metaphor this system is convenient as you can combine many objects and shapes, take all the time you want, and then just decide when to show them. In our specific case it is also convenient because we want the circles to become visible only after we have placed the square on top of them.

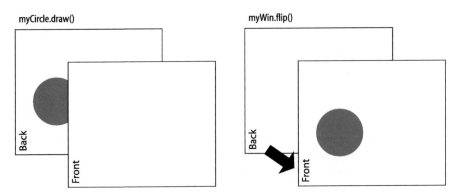

Figure 4.4. The process of *flipping*. It is convenient to think of the back and the front windows as if they both exist somewhere in your computer, but only the front window is visible. They are also called back buffer and front buffer. Flipping is the action of making what was in the back come to the front

Box 4.1. OpenGL

Drawing objects on a screen is complex and computationally demanding (i.e. it takes time and lots of maths). The hardware inside your computer divides this difficult job between a central processing unit (CPU) and a graphics processing unit (GPU). In this book we are learning to program in a way that leaves most of this work to PsychoPy. To do this PsychoPy uses a graphics library called **OpenGL** (for Open Graphics Library). This is an open cross-platform standard and is very powerful. For instance it deals with both 2D and 3D graphics and therefore is used for many games.

I am mentioning OpenGL because you will see the name, but you will not need to learn about it (unless you decide to look under the hood). The development of OpenGL is carried out by a nonprofit industry consortium called Khronos Group. To learn more about OpenGL you can visit the website:

https://www.opengl.org

We will now talk about the position of our objects. We will leave the square in the middle (its position by default is at the origin, that is [0, 0]). The four disks we will place at its corners. We have only created one disk, but as you recall from Chapter 3 an object is something we can use as many times as we like, so let's place this disk in four different positions.

```
disk.setPos([-100, -100])
disk.draw()
disk.setPos([-100, 100])
disk.draw()
disk.setPos([100, 100])
disk.draw()
disk.setPos([100, -100])
disk.draw()

square.draw()
```

Using the coordinates in Fig. 3.2 you can see that for a square with side of 200 pixels its corners are 100 pixels to the left and to the right of the origin. The side of the square is 200 pixels because it goes from −100 to 100. We have used .setPos() with a list to specify positions in terms of *x,y*-coordinates and we have drawn the disk in the four positions that correspond to the corners of the square.

Note that the order matters, here we have drawn the four disks and then the square on top! This way a slice of the disk will be covered up. If we had drawn the square first the disks would be on top of the square and we would see four full disks.

Drawing on our canvas therefore is more like a **collage**, with pieces of papers placed on top of others, rather than drawing with a pencil or a pen. This is well worth keeping in mind. After all, drawing an incomplete circle would have been harder than drawing a circle and covering up part of it.

If after these lines we also include a myWin.flip() then we would see a white Kanizsa square, as shown in Fig. 4.5, inside our window.

It is fascinating that what we have done matches what we perceive. We placed a square on top of four circles and that is the impression that we get: a square on top of four circles.

This is logical because we have used the simplest way to draw this configuration, and what we perceive is a simplest organisation of the scene with a minimum number of objects placed in front or behind others. The concept of **simplicity** is key to understand how the visual system organises the information in an image (Pomerantz and Kubovy 1986; Makin et al. 2016; Wagemans 2017). By choosing the simplest interpretation the visual system is able to resolve some of the ambiguity in the image.

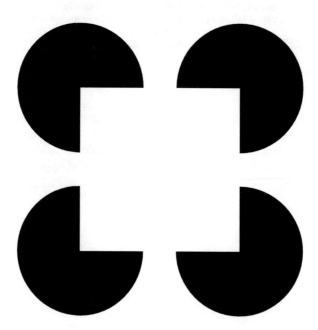

Figure 4.5. This *Kanizsa square* was created in Python using PsychoPy modules. The four circles were drawn first, then a white square, and finally we flipped the back and front images to see the result

Let's write again all the lines of the program, and add at the end the two lines that close down the window (from Chapter 3). Before closing the window I have also added a line that waits for 5 seconds so we can see something on the screen without it disappearing right away. This is a command called core.wait() and it waits for a specified number of seconds. What you would see is what is shown in Fig. 4.5.

```
import math, numpy, random #to have handy system and math functions
from psychopy import core, event, visual, gui #these are the PsychoPy modules

myWin = visual.Window(color = 'white', units = 'pix', size = [1000, 1000],
                      allowGUI = False, fullscr = False) #creates a window
myClock = core.Clock() #this creates and starts a clock which we can later read

disk = visual.Circle(myWin, radius = 80, fillColor = 'black', lineColor = None)
square = visual.Rect(myWin, width = 200, height = 200, fillColor = 'white', lineColor = None)

disk.setPos([-100, -100])
disk.draw()
disk.setPos([-100, 100])
disk.draw()
disk.setPos([100, 100])
disk.draw()
disk.setPos([100, -100])
disk.draw()

square.draw()

myWin.flip()

core.wait(5) #waits for 5 seconds
myWin.close() #closes the window
core.quit() #quits
```

This program is simple and it amounts to only 25 lines (including blank ones). This version of the Kanizsa program is called KanizsaNoLoop.py and is available from *www.programmingvisualillusionsforeveryone.online.*

You can execute this program and you would see the Kanizsa square. But I suggest that we add something before we call this our first program. Drawing is good but the real power of a computer is in being able to interact with the user. We want this drawing to change based on a setting and for that we need a controller.

We will use a class called visual.RatingScale() combined with a bit of text to display the setting. As the name says the rating scale was created to let people rate something. We are going to twist its purpose a bit and use it to adjust the size of the circles.

```
myScale = visual.RatingScale(myWin, pos = [0, -360], low = 10, high = 100, textSize = 0.5,
                             lineColor = 'black', tickHeight = False,
                             scale = None, showAccept = False, singleClick = True)
```

Note that the new object myScale was created using several parameters. When something that was created to do something else is hijacked, as we are doing, the parameters become important. Here we specify position (low down on the screen, below our square), minimum and maximum values (these are called low and high), the absence of a visible scale with numbers, the absence of an accept button, and the control through a single mouse click. This way we can just move the cursor with the mouse along a line and click.

We will not spend too much time on these parameters; on this occasion we will trust that this bit of code produces a controller. How the controller looks and works will become clearer once we see it on the screen. What is important is its purpose. We will use this scale to set the size of the disks. By making the disks larger we will increase the part of the square that has a visible edge. At the maximum value of 100 the disks will touch in the middle, and so this is the extreme case in which no illusory contour is present (because there is a white square with real contours). At the minimum value of 10 the disks are tiny and it will be hard to see an illusory square.

The controller that we have created needs to be drawn, like all other objects. We draw the controller using myScale.draw(), and after that we will be able to click on it with the mouse. This functionality comes from using this special type of object. The mouse will move a triangle along a horizontal line. Once we have clicked, the new value is set and the disks will get bigger or smaller. But it is useful to display the exact value and for that we will use a visual.TextStim() object.

```
information = visual.TextStim(myWin, pos = [0, -385], text = '', height = 18, color = 'black')
```

As you see when we create this object to contain text we fill it with an empty string (text = ''). This string is written as two single quotes, one to open and one to close the string (make sure you don't just write a double quote, that would be an error as it opens but does not close the string).

The value will come later from the controller, and we are including an empty string as a placeholder. We could have even skipped this parameter altogether if the default value for text was an empty string. Unfortunately the default value is "hello world". The position of this text object is just below the controller.

OK, now we have two new objects that we can draw. But here is the next big challenge, we can't draw everything once, if we want to interact with our illusion we need the illusion to be updated all the time. What we need is a loop.

Let's set up a loop in a way that we can then reuse it also for all the other illusions in future chapters. Even the controller will be reused, to control different aspects of the various illusions. To start the loop we ask ourselves the following question: do we know how many times we want to do the drawing? The answer is no, so we start a loop that will continue forever.

```
finished = False
while not finished:
──→ #everything else goes here and is indented
```

We have a variable called finished which is False, the while will therefore never stop. This is OK, it is exactly what we want: a program that in theory could go on forever.

In practice we need to find a way to change the value of finished from False to True inside the loop. We will monitor the keyboard and finished will become True when the Escape button is pressed.

```
if event.getKeys(keyList = ['escape']): #pressing ESC quits the program
→ finished = True
```

The module that deals with events is called event, so from that module we are using event.getKeys(). This will report back what has been pressed (if anything). Instead of monitoring everything we can specify that we only want to know about one key. This goes inside a parameter called keyList. Even though in this case we are only interested in one key we have to provide the keyList as a list, as the name says. So you can see that this is a list (square brackets) with only one element. PsychoPy is clever and understands that the word 'escape' refers to the ESC key.

Note that the function .getKeys is not going to stop and wait for someone to press the keyboard. That would stop our loop. This function simply checks the input from the keyboard, there may be some input of the type listed in the keyList (in which case the if condition becomes True, and we change the value of finished) or there may not be any (in which case we go on to repeat the loop because finished remains False).

We have used a variable finished that can take the value of True or False. This is a common type of data in programming and is called Boolean. The name comes form the English mathematician George Boole (1815–1864) who worked on logic and the simple but powerful idea that some things can only be True or False. He was a great mind of his time, but died before turning 50. He worked in Ireland, and he had developed a cold and a fever after walking in the rain and giving a lecture in wet clothes. His wife thought that remedies should resemble the cause, so after putting him to bed she poured buckets of water on the poor man. He died of pneumonia.

Next, let's use the controller. This, as well as most of the 25 lines we have seen earlier, will now be written indented, this way they will keep happening inside the loop.

```
if myScale.noResponse == False: #some new value has been selected with the mouse
→ radius = myScale.getRating()
→ disk.setRadius(radius)
→ information.setText(str(radius))
→ myScale.reset()
```

The myScale object has a variable inside called noResponse. It might have been more logical to have one called Response, but we have to use it as it is. So if we monitor noResponse when it becomes False it means that there was a response (see the double negative?). Therefore a response means that there was a mouse click on the scale.

We collect the value of the response in the next line, because we can read it using getRating() and store it in a new variable called radius. We have chosen this name to make it clear that we will use the number to set the radius of the disks. The object myScale has the function getRating() for the purpose of collecting a response. We will use the expression **returning a value** in these situations, because getRating() is a function that returns something that we then store in a variable.

In order to know the value of radius we place it inside the object information and later we will draw this object on the screen using information.draw(). This is a type of object that can contain text, and we have created it at the beginning of the program exacly for this purpose. We may not be sure about the type of the returned value, so to be on the safe side when we set the text we enclose the variable name in str(). This way we are telling Python that radius is to be treated as a string.

Note an important difference, myScale.noResponse is simply a variable we can check, but myScale.getRating() (with brackets at the end) is a function that returns a value. In the previous chapter we mentioned a similar function in relation to the clock: timeNow = myClock.getTime().

The myScale.getRating() is an example of a function returning a value. It is worth remembering that some functions return something but others return nothing. When there is something returned it could be more than just one number, because a function can return multiple variables. For now we are seeing an example here where what is returned is just a number, but is useful to understand that this flexibility is part of how functions can be set up.

Next we change the radius (and therefore the size) of the disk. Because we want to see this value we also write it in the object called information, which will be displayed underneath the scale. Finally we reset the scale so we can take a new mouse click.

We only need to change the radius of the disk once. This will change the size of all four disks because they are the same object drawn four times. In this case it is quite convenient that we have not created four different objects.

I suggest one final addition to the script. The illusion is even stronger with a thin line that stops where the white square begins. We can make a line with a thin rectangle similar to the other objects we have created.

```
line = visual.Rect(myWin, width = 2, height = 400, fillColor = 'black', lineColor = None)
```

This line is black, like the circles, and will be drawn just after we draw the circles and before we draw the square. Let's put everything together.

```
import math, numpy, random #to have handy system and math functions
from psychopy import core, event, visual, gui #these are the PsychoPy modules

myWin = visual.Window(color = 'white', units = 'pix', size = [1000, 1000],
                      allowGUI = False, fullscr = False) #creates a window
myClock = core.Clock() #this creates and starts a clock which we can later read

disk = visual.Circle(myWin, radius = 80, fillColor = 'black', lineColor = None)
line = visual.Rect(myWin, width = 2, height = 400, fillColor = 'black', lineColor = None)
square = visual.Rect(myWin, width = 200, height = 200, fillColor = 'white', lineColor = None)

myScale = visual.RatingScale(myWin, pos = [0, -360], low = 10, high = 100, textSize = 0.5, lineColor = 'black',
                      tickHeight=False, scale=None, showAccept=False, singleClick=True)
information = visual.TextStim(myWin, pos = [0, -385], text = '', height = 18, color = 'black')

finished = False
while not finished:
```

```
——→ disk.setPos([-100, -100])
——→ disk.draw()
——→ disk.setPos([-100, 100])
——→ disk.draw()
——→ disk.setPos([100, 100])
——→ disk.draw()
——→ disk.setPos([100, -100])
——→ disk.draw()

——→ line.draw()
——→ square.draw()
——→ information.draw()
——→ myScale.draw()
——→ myWin.flip()

——→ if myScale.noResponse == False: #some new value has been selected with the mouse
——→ ——→ radius = myScale.getRating()
——→ ——→ disk.setRadius(radius)
——→ ——→ information.setText(str(radius))
——→ ——→ myScale.reset()

——→ if event.getKeys(keyList = ['escape']): #pressing ESC quits the program
——→ ——→ finished = True

myWin.close() #closes the window
core.quit() #quits
```

Note the very important way in which indentations create groups of commands. At the beginning it is likely that you will encounter occasionally some indentation errors. In other words it is easy to make mistakes with the indentations. Over time you will learn to pay close attention to this key feature of Python. Also note that we have deleted the line that waited for 5 seconds. This is not necessary any longer as we are displaying an interactive demonstration of the illusion. The program will terminate only when the user presses the ESC key.

How complicated would have been to program a controller without the class visual.RatingScale()? Well, certainly we would have needed many lines and many instructions. This is a good example of how powerful object-oriented programming is. We do not need to know all the commands inside visual.RatingScale(), we just need to know what kind of object it is and how it behaves. By the way, for this feature of PsychoPy we have to thank in particular **Jeremy Gray** who introduced it in 2010.

And now (drum roll) let's execute the program! This final version is called Kanizsa.py (and is available for download on the website). Executing is generally called **running** a program and this explains why to execute a PsychoPy script we have to click on the icon with a running person (it's the green icon highlighted in Fig. 4.6).

Enjoy!

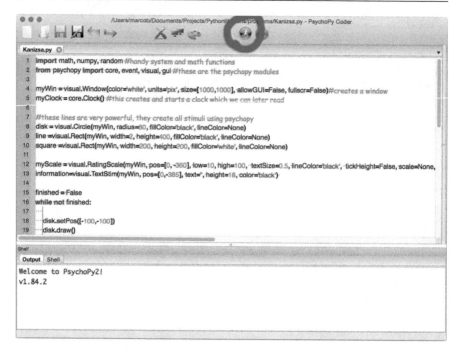

Figure 4.6. The Kanizsa.py program is ready. Click on the green circle on the top to run it. The icon shows a man running and is circled in red in this image

Extra Programming Challenge for Extra Fun

The best way to fully understand a program is to change it and make it do something different. So here a couple of things you can try. The first is to make the disk 'grey' instead of 'black' to see if the Kanizsa square is still visible. You can do that using the parameters when you set up the objects. The second change is a bit more difficult; can you replace the square with a circle? That way you have a circle partly hidden by four circles. You would need to replace the object called square with a different type of object. To create this new circle object you need to look and copy the way that we have defined the disk. I suggest you try a radius of 100 pixels, and of course the fillColor needs to be white like it was for the square.

Chapter 5

Ponzo
Illusion

The Ponzo illusion is old and well known. In the classic configuration two lines converge and when other objects are placed in between the lines they appear different in size. We will learn how to program this with simple lines and rectangles. In our program the angle of convergence of the lines will be controlled interactively with the mouse, and the observer will therefore be able to explore the conditions that make the effect strongest.

The Ponzo illusion is very famous and is reproduced in most books on illusions. One amazing aspect of the illusion is that it is so simple. The effect can be demonstrated with just four lines on a piece of paper! Two lines need to converge (getting closer together) similarly to a road or railway track that extends towards the horizon. The other two lines sit horizontally in the lower and upper part of the image. Although identical the one farther up on the page will appear bigger.

The illusion takes the name from an Italian psychologist. Mario Ponzo published a scientific paper about it in 1912. Many variants exist. Indeed you could photograph a stretch of railway tracks (without bends) and then place the drawing of an object on top of the photo and you will see how the object will appear bigger if it is placed farther up along the tracks. Any image with a strong sense of perspective will have this effect, as shown in Fig. 5.1. As a way to summarise the effect we can say that any object is perceived in relation to its background.

As we discussed in the first chapter, names are often linked to scholars that have studied the illusion. It does not mean that they have necessarily published the very first paper on it. In the case of the Ponzo illusion the effect can already be seen in Thiéry (1895), and Ponzo did not pretend to be the first to describe the effect.

One explanation of the Ponzo illusion, as suggested by the example of the railway tracks, is based on perspective: converging lines are a strong cue about a slanting surface and what we perceive is based on a sense of space (3D) in which objects are located (Gregory 1963; Gregory 2004). If they appear farther away they are bigger than when they appear closer to us (given the same size in the image). Ponzo argued that the fact that the Moon appears larger near the horizon has a similar explanation (Ponzo 1912).

The fact that the Moon appears larger near the horizon is a very strong effect. We call this the **Moon illusion,** but also the Sun or other constellations appear

Figure 5.1. The *Ponzo illusion* (on the left) and a similar effect with a photograph of a road. The horizontal black lines are the same length in all cases. This type of demonstration has been used to support a perspective interpretation of the illusion, although this is not the whole story

larger near the horizon. Many explanantions have been provided, some people have speculated that it may have to do with by the Earth's atmosphere. This is not true. You can verify that the image is the same using a piece of paper with a hole and holding it up to the Moon, or by taking a photo and measuring the image with some precision. The large increase in perceived size is an illusion. It is possible that, just like in the Ponzo effect, there is a role of perception of distance. If the Moon is seen as farther near the horizon then it should also be perceived as larger. The problem with this idea, however, is that observers do not judge the Moon to be farther away when near the horizon, although they do tend to believe that the sky near the horizon is farther away than the sky overhead. You can read more about the Moon illusion in a book by Ross and Plug (2002). In the book you will find a fascinating history that goes back to antiquity, and the authors discuss over thirty different explanations.

Note that the Ponzo illusion works even if we organise the whole configuration horizontally, with the lines converging not from bottom to top but from left to right (or vice versa). Surprisingly the illusion is weak if the two lines that should be compared instead of being horizontal as in Fig. 5.1 are placed vertically (Humphrey and Morgan 1965). Other factors have been studied and may contribute to the Ponzo illusion, in particular the contrast between small and large spaces (without linear perspective). There may also be a (mis)perceived tilt (Prinzmetal et al. 2001) or a process of assimilation (Pressey et al. 1971).

In his own research, Ponzo was also interested in perceived numerosity. When instead of a line we have a set of dots, there appear to be more dots in the position where the line appears longer. In other words elements occupying a wider region (because of the illusion) appear more numerous than those confined to a smaller region (Ponzo 1928).

Happé (1996) used both the Kanizsa triangle and the Ponzo illusion, together with four other geometrical illusions, in a study that compared autism spectrum disorder (ASD) individuals with a control group. Happé (1996) found that the ASD individuals were less likely to succumb to the illusions. She interpreted this as evidence that ASD is characterised by problems in processing global information, and a stronger focus on the local elements. In this sense, the ASD individuals had an advantage and perceived the patterns more accurately. However, there are difficulties in how to select the best possible control group, and more work is necessary (for a review of the literature on illusions and autism see Gori et al. 2016).

Recently, the Ponzo illusion has also been used to see how perceived size is related to the anatomy of the visual system. In the illusion circles appear different but are the same size, so this stimulus is ideal to study conscious perception of size. Schwarzkopf et al. (2011) started from the observation that the size of the visual cortex (V1) varies between individuals (and by the way it is not clear why). They found that V1 size was related to the strength of the Ponzo illusion (as well as the Ebbinghaus illusion), and concluded that the area of V1 predicts variability in conscious experience of size.

The Ponzo.py Program

Let's write a program that shows a simple version of the Ponzo illusion. You can download the file Ponzo.py from *www.programmingvisualillusionsforeveryone.online*.

After downloading it you can open it up from within PsychoPy (second icon on the top bar, the one that looks like a folder). Remember to save the file in the same folder as the Kanizsa.py file, so we keep all our programs together.

The first five lines are the ones you have seen before (they will be the same for all our programs). They import some modules and create (and open) a window called myWin, and a clock called myClock (which we will not use in this program).

```
import math, numpy, random #to have handy system and math functions
from psychopy import core, event, visual, gui #these are the PsychoPy modules

myWin = visual.Window(color = 'white', units = 'pix', size = [1000, 1000], allowGUI = False,
                 fullscr = False) #creates a window
myClock = core.Clock() #this creates and starts a clock which we can later read
```

Next we create new objects, in particular two lines that will converge, and a rectangle that will be shown in two locations. Although these are two copies of the same rectangle they will appear different in size.

```
lineLeft = visual.Line(myWin, start = [-160, -340], end = [-160, 200], lineColor = 'black', lineWidth = 5, ori = 5)
lineRight = visual.Line(myWin, start = [160, -340], end = [160, 200], lineColor = 'black', lineWidth = 5, ori = -5)
rectangle = visual.Rect(myWin, width = 180, height = 30, pos = [0, -160], fillColor = 'grey', lineColor = None)
```

The two converging lines are called lineLeft and lineRight. We have not used the class visual.Line() before. A line needs a starting point and a finish point (the parameters are called start and end, each with an x,y-pair of coordinates, written as a list within square brackets). The coordinates we have chosen place one line to the left (−160 pixels) and one line to the right of the centre (160 pixels) along the horizontal axis. Vertically the lines go from −340 to 200 so they are 540 pixels long.

We are using a new interesting parameter inside these objects, called ori. This word is short for orientation and we have set the two lines to be tilted by 5 and −5 degrees. Orientation increases clockwise and therefore 5 degree is a displacement clockwise and −5 is a displacement counter-clockwise. These two orientations set the lines as tilting inwards and converging. Five degree is not much tilt but we will vary orientation within the program as well.

The horizontal object is called rectangle. It is set up as a visual.Rect type rather than a visual.Line. We could have used lines but it may be nice to be able to make this object wide, looking a bit like a brick. The rectangle is 180 pixels wide and 30 pixels tall. We also made it grey instead of black. Feel free to use whichever colour you prefer using fillColor.

The next two lines are similar to those used in Kanizsa.py because they create the controller and the text with information about the value changed by the controller. What value should the controller be affecting for the Ponzo illusion? The most interesting is the orientation of the lines, so we have set the controller to change a value between 0 (the lines are vertical) and 45 degrees.

```
myScale = visual.RatingScale(myWin, pos = [0, -360], low = 0, high = 45, textSize = 0.5, lineColor = 'black',
                  tickHeight = False, scale = None, showAccept = False, singleClick = True)
information = visual.TextStim(myWin, pos = [0, -385], text = '', height = 18, color = 'black')
```

Inside the loop we do the drawing of all these objects and display them using myWin.flip(). Note how the rectangle is drawn twice, in a low and a high position on the screen.

```
lineLeft.draw()
lineRight.draw()

rectangle.setPos([0,-160])
rectangle.draw()
rectangle.setPos([0, 140])
rectangle.draw()

myScale.draw()
information.draw()
myWin.flip()
```

As a reminder, this is a list of commands that draw four shapes, two lines and two rectangles, a controller and some text. None of these are visible on the screen until the very last line. This is the flipping operation that exchanges back and front windows.

Now let's update the loop that uses the controller. We want the user to be able to change the tilt of the lines.

```
if myScale.noResponse == False: #some new value has been selected with the mouse
    orientation = myScale.getRating()
    lineLeft.setOri(orientation)
    lineRight.setOri(-orientation)
    information.setText(str(orientation))
    myScale.reset()
```

The value that is returned by myScale.getRating() is something we place in a variable called orientation. The only tricky aspect to pay attention to is the fact that we use the orientation to change both the left and the right line, but we use orientation in one case (a positive value) and -orientation in the other (a negative value). This is because to make the lines converge the two orientations have to be opposite to each other. As mentioned before, orientation increases clockwise and a negative value is a counterclockwise change.

Another pattern that you may have noticed already is that when there is a parameter for an object, there is usually a way of changing that parameter using a function, and they all look like they have the same format. For width we have .setWidth(), for orientation we have .setOri(), for text we have .setText() and so on.

By changing orientation using .setOri() we can see on the screen how much the illusion depends on the convergence of the lines. At one extreme, when the lines are vertical, the two rectangles will probably look the same. At the other extreme they should look different.

Note also that for orientation greater than 30 degrees the lines end up underneath the rectangles. This may make the effect stronger, with the top rectangles looking bigger, if it provides even more of a sense of perspective, or contrast. However, for the

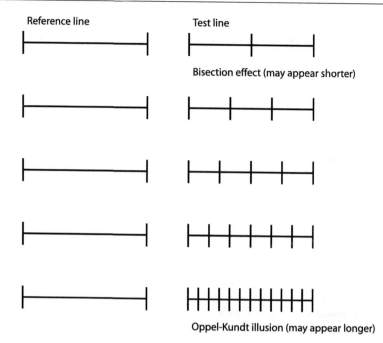

Figure 5.2. On the left there is a simple horizontal line, on the right there is another line which you should try to compare to the reference line. The same length on the right may appear shorter or longer than the reference depending on how many vertical lines are placed on top. For one line (*bisection*) this should make the line on the right appear a bit shorter, but as the lines increase the line on the right should start to appear longer

more oblique orientation the effect may weaken. One problem is that the apparent length of a line is affected by having other lines that divide it. A simple line that splits a horizontal line into two (bisection) makes a line appear shorter (Finger and Spelt 1947; Mamassian and de Montalembert 2010). But wait, if you have more lines, even just two or three, the effect is the opposite and the horizontal line will appear longer. This mysterious and complex pattern observed by Oppel (1855) is still under investigation (Wolfe et al. 2005). I tried to illustrate it in Fig. 5.2. When there are many vertical lines that mark the horizontal length the phenomenon is described as a comparison between an empty space and a filled space: the filled space appears greater. This is also known as the Oppel-Kundt illusion.

The moral of this story is that even extremely simple configurations may behave in complex ways. You can hardly think of something simpler than a horizontal line with some other small vertical lines on top. This combination affects perceived length and it changes with the number of vertical lines.

Before completing the program we are going to add something else compared to Kanizsa.py. In our first program we had included some libraries (modules), created some objects, then started a while loop. Within this loop we updated the drawing to adjust the size of the disks. Finally we closed down the windows and closed the program.

It is better to place our main loop inside a function that we will name mainLoop. This way our program will call the mainLoop, and at the very end, when we come out of the main loop, do the closing down.

This is straightforward, we have to define the function in the following way.

```
#the main loop
def mainLoop():
```

I wrote a very short line with a comment just before the definition of the function. This has the role of a header text with some information. In this case it has just the name for the function. In this book we will include one such comment line before any function that we write.

Note the : after the brackets. It is there to say that once we call the main loop everything that follows (indented) is executed as part of the function. When we will write the name mainLoop() as a command we say that we have called this function. That means that as soon as it is called the function mainLoop() *will do the following* (that is the meaning of : as you remember) and execute all the block of commands inside.

You can see this function as a container for most of our commands. The keyword def is how we define functions in Python®. For this first example there is no need for parameters but when a function will need parameters we will place them inside the brackets.

Let's write all the lines of the program. Notice that we are setting things up, including creating the main loop, and only after that, at the very bottom of all the lines, we start with a call to mainLoop. This structure will be the standard setup of all our future programs, including when we will have more than one function. By the way, feel free to add (as an exercise) a main loop also to your Kanizsa.py program.

```
import math, numpy, random #to have handy system and math functions
from psychopy import core, event, visual, gui #these are the PsychoPy modules

myWin = visual.Window(color = 'white', units = 'pix', size = [1000, 1000],
                      allowGUI = False, fullscr = False) #creates a window
myClock = core.Clock() #this creates and starts a clock which we can later read

lineLeft = visual.Line(myWin, start = [-160, -320], end = [-160, 200], lineColor = 'black', lineWidth = 5, ori = 5)
lineRight = visual.Line(myWin, start = [160, -320], end = [160, 200], lineColor = 'black', lineWidth = 5, ori = -5)
rectangle = visual.Rect(myWin, width = 180, height = 30, pos = [0, -140], fillColor = 'grey')

myScale = visual.RatingScale(myWin, pos = [0, -360], low = 0, high = 45, textSize = 0.5, lineColor = 'black',
                             tickHeight = False, scale = None, showAccept = False, singleClick = True)
information = visual.TextStim(myWin, pos = [0, -385], text = '', height = 18, color = 'black')

#the main loop
def mainLoop():

    finished = False
    while not finished:
```

```
⟶ ⟶lineLeft.draw()
⟶ ⟶lineRight.draw()

⟶ ⟶rectangle.setPos([0, -160])
⟶ ⟶rectangle.draw()
⟶ ⟶rectangle.setPos([0, 140])
⟶ ⟶rectangle.draw()

⟶ ⟶myScale.draw()
⟶ ⟶information.draw()
⟶ ⟶myWin.flip()

⟶ ⟶if myScale.noResponse == False: #some new value has been selected with the mouse
⟶ ⟶ ⟶orientation = myScale.getRating()
⟶ ⟶ ⟶lineLeft.setOri(orientation)
⟶ ⟶ ⟶lineRight.setOri(-orientation)
⟶ ⟶ ⟶information.setText(str(orientation))
⟶ ⟶ ⟶myScale.reset()

⟶ ⟶if event.getKeys(keyList = ['escape']): #pressing ESC quits the program
⟶ ⟶ ⟶finished = True

mainLoop() #enters the main loop
myWin.close() #closes the window
core.quit() #quits
```

Figure 5.3. The *Ponzo.py program* is shown running on my computer. Because we have set the window to be 1 000 × 1 000 pixels in size this window takes up a central area of my screen

As before, pay attention to the indentations. We have added an extra indentation to locate most of our commands inside the main loop. And now let's execute the program. You can also make changes to positions, colours, and thickness of the lines to get the strongest effect for you on your monitor.

Are you impressed that even with all these features we still have a script that is only 43 lines long? Without counting the empty lines the actual commands are 32 lines. That is how powerful the combination of Python and PsychoPy is. Enjoy!

Extra Programming Challenge for Extra Fun

This is a short program and there are just four objects drawn on a white background. Can you change the colour of the background from white to green? Is everything else still working fine? Try also to make the left line thinner than the right line (they are set to a thickness of 5 pixels now, but you can set thickness to just 1 pixel). Again, you can use this as a way to check if the illusion is robust to all these changes.

Chapter 6

Delbœuf
Illusion

In the Delbœuf illusion two disks appear different in size depending on whether they are inside a large circle or a small circle. In the interactive program the user can adjust one of the two disks so as to reach a point where they appear the same. We will also learn how to show the difference in size as a percentage on the screen.

Like the Ponzo illusion the Delbœuf illusion is about perception of size. The Belgian psychologist Joseph Remi Leopold Delbœuf described it in 1865. Delbœuf was a scientist interested in many things, like hypnosis and the emergent field of psychophysics. He was a well-known figure in Europe at the time, and wrote also for popular science magazines. For instance in 1893 he described his pet lizards and their behaviour, including their displays of friendship and jealousy. His point was that lizards are not only clever but have individual personalities, and his Spanish lizard had a different personality from his French lizard. He concluded that we need to reconsider our view of reptiles, and see animals as sharing a lot more with humans than previously assumed.

In the discussion of the Ponzo illusion we have already mentioned the importance of context and contrast. This is clearly shown in the Delbœuf illusion (see Fig. 6.1), and the term size contrast has been used to describe it. On his online discussion, within his extensive collection of illusions, Michael Bach says that this illusion is particularly interesting because it may have some practical consequences. In a series of studies Van Ittersum and Wansink (2012) demonstrated that plate size influences the amount we serve and what we eat. The same amount of food appears more substantial in a small plate.

Size contrast may not be the whole story, as the size difference between inner and outer circle creates different effects. For small differences in size between the two circles, the central circle tends to be overestimated (relative to a circle on its own), making this an **assimilation** effect. For large differences, however, the central circle is underestimated, making this a **contrast** effect (Girgus and Coren 1982). To get a sense of this in Fig. 6.1 I have included a reference circle below the other two.

This illusion has also been studied in children, to see if there is a change with age. The most famous study is by Piaget and colleagues (Piaget et al. 1942). He varied the size of the outer circle and therefore was able to document how for a small circle there is assimilation (that is the inner circle appears bigger than a comparison test), and for a large one there is contrast (that is the inner circle appears smaller than a comparison test). Piaget also found that the effect of the illusion decreases with age.

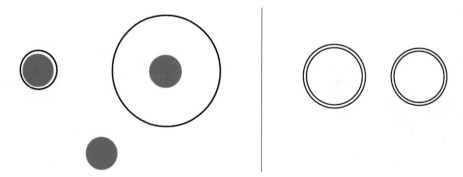

Figure 6.1. The *Delbœuf illusion*. In the first image (left) you can compare the perceived size of the red circles on the left and on the right to each other. You can also compare each of them to the red circle on its own which is shown underneath. On the right there is another way of showing the illusion, also drawn originally by Delbœuf. Here the inner circle on the left has the same size as the outer circle on the right, but this is hard to see

Message 6.1. "Three messages about visual illusions" by Johan Wagemans

Like Joseph Delbœuf, I am also a Belgian scientist with a broad interest (e.g., visual perception, arts, and autism – to name a few). Unlike Delbœuf, I do not know anything about the personality of lizards but I have added an image of a chameleon to trigger your interest [Bodypainting by Johannes Stötter/*wb-production.com*]. Search for "chameleon body art" online and check out the movie created by the artist Johannes Stötter to maximize your experience. What you see there will also tell you a lot about visual perception. Camouflage is one of nature's most powerful tricks to enhance the prey's chance of survival by trying to beat the predator's visual system.

Because there is always more than you think, my message in fact consists of three messages. First, Delbœuf's illusion deals with the powerful effects of contrast and assimilation. Apparently, the visual system enhances small differences ("contrast effect") and reduces large differences ("assimilation effect"). I strongly believe that this is a general principle underlying much of perception and cognition, which helps to reduce information overload and to facilitate faster and more efficient information processing. Second, like many (all?) other visual illusions, Delbœuf's illusion illustrates that visual perception is not giving us accurate information about absolute properties of isolated elements but deals with relative properties of parts or objects in larger contexts. This is a fundamental characteristic of perceptual organisation, which has mainly been studied by Gestalt psychology (e.g., Wagemans 2017). Third, and most importantly, visual illusions and perceptual ambiguities demonstrate convincingly that visual perception is generally not interested in a veridical reconstruction of the 3-D world from 2-D images, as often suggested in textbooks. Instead, visual perception offers quick and dirty constructions of perceptual objects in a perceptual world – an interface to the real world that is good enough to support appropriate actions most of the time. This is the main reason why I am

fascinated in visual perception and happy to study it 24/7: It offers all humans (and other animals gifted with the sense of vision) a window on the world and it offers all scientists a unique window on the mind – the last big mystery for science to solve.

Johan Wagemans (JW) has a BA in psychology (1983) and philosophy (1984), an MSc (1986) and a PhD (1991) in experimental psychology, all from the University of Leuven, where he is currently a full professor (since 2001). He receives long-term structural funding from the Flemish Government (2008–2022) to try to understand visual Gestalts (www.gestaltrevision.be). He has recently edited the Oxford Handbook of Perceptual Organization.

The Delboeuf.py Program

Let's write a program that shows a simple version of the Delbœuf illusion. You can download the file Delbœuf.py from *www.programmingvisualillusionsforeveryone.online* (as for all programs).

The first five lines are the ones you have seen before (they will be the same for all our programs), so I will not print them out again here. Next we create new objects, similar to those for the Ponzo illusion.

```
diskLeft = visual.Circle(myWin, radius = 40, pos = [-200, 0], lineWidth = 2.5, fillColor = 'red', lineColor = None)
diskRight = visual.Circle(myWin, radius = 40, pos = [200, 0], lineWidth = 2.5, fillColor = 'red', lineColor = None)
ringLeft = visual.Circle(myWin, radius = 48, pos = [-200, 0], lineWidth = 2.5, fillColor = None, lineColor = 'black')
ringRight = visual.Circle(myWin, radius = 140, pos = [200, 0], lineWidth = 2.5, fillColor = None, lineColor = 'black')
```

In this list we have a disk on the left side (radius 40 pixels), a disk on the right side (same radius), a ring that we will put around the disk to obtain the effect, one on the left (small, radius 48 pixels) and one on the right (large, radius 140 pixels.)

Next we set up the familiar myScale and information, located in the bottom part of the screen.

```
myScale = visual.RatingScale(myWin, pos = [0, -360], low = 20, high = 60, textSize = 0.5, lineColor = 'black',
                tickHeight = False, scale = None, showAccept = False, singleClick = True)
information = visual.TextStim(myWin, pos = [0, -385], text = '', height = 18, color = 'black')
```

The controller will change the size of the disk on the right. As the disks start off with a radius of 40 pixels, the controller will let us go as low as 20 and as high as 60 pixels. This way we will make the two disks different in size (their real size) to see when they are perceived as the same (their perceived size). Psychologists refer to this match as the **point of subjective equality**.

We could now start the loop. But we are going to place the standard radius size of 40 pixels into a variable, and reset our disks to that value.

```
standardRadius = 40.
diskLeft.setRadius(standardRadius)
diskRight.setRadius(standardRadius)
```

This may seem unnecessary, but it has two advantages. One is to give a clear name to our standardRadius. The other is that if at some point you want to experiment with a different radius you can just change the value of this variable on this line of the script.

Inside the loop we do the drawing of all these objects and display them using myWin.flip().

```
diskLeft.draw()
diskRight.draw()

ringLeft.draw()
ringRight.draw()
```

```
myScale.draw()
information.draw()
myWin.flip()
```

Now let's update the loop that uses the controller to change the size of the right disk.

```
if myScale.noResponse == False: #some new value has been selected with the mouse
⟶ size = myScale.getRating()
⟶ percentage = (size - standardRadius) / standardRadius * 100
⟶ information.setText(str(percentage) + "%")
⟶ diskRight.setRadius(size)
⟶ myScale.reset()
```

We have done something slightly different here. The value that is returned by myScale.getRating() is placed in a variable called size, and we use setRadius to change the disk to that new radius. But we are not going to display size in pixels. It is more interesting to display the difference between the left and the right disk.

The size of the disk on the left, which does not change within the loop and is therefore the comparison size, is what we called standardRadius. In our program this radius is 40 pixels. We therefore take a difference from our new value and the standardRadius. This is the difference in pixels. Then we divide it by standardRadius to get a proportion, if the new size is, say, 50, then 50 minus 40 is 10 and 10 / 40 is 0.25. The new disk size is 25% bigger than the comparison. To express this as a percentage we have to multiply the proportion by 100 as a final step.

```
percentage = (size - standardRadius) / standardRadius * 100
```

I have illustrated the logic with a value of 50, try other values to see what happens. In particular when size will be smaller than 40 you will get negative values. This tells us that the new size is smaller than the standard by that percentage value. For example a value of 30 will be 25% smaller than the standard.

We will display this percentage underneath our controller. This way we will always immediately see the relative difference between the two disks.

```
information.setText(str(percentage) + "%")
```

Note how we made use of something else that we had discussed in Chapter 2. We can add strings together using the + sign. So here we are going to show the percentage with a % sign after it.

Let's write all the lines of the Delboeuf.py program. It has a very similar structure to the programs you have already seen.

```
import math, numpy, random #to have handy system and math functions
from psychopy import core, event, visual, gui #these are the PsychoPy modules

myWin = visual.Window(color = 'white', units = 'pix', size = [1000, 1000], allowGUI = False,
                      fullscr = False) #creates a window
```

```
myClock = core.Clock() #this creates and starts a clock which we can later read

diskLeft = visual.Circle(myWin, radius = 40, pos = [-200, 0], lineWidth = 2.5, fillColor = 'red', lineColor = None)
diskRight = visual.Circle(myWin, radius = 40, pos = [200, 0], lineWidth = 2.5, fillColor = 'red', lineColor = None)
ringLeft = visual.Circle(myWin, radius = 48, pos = [-200, 0], lineWidth = 2.5, fillColor = None, lineColor = 'black')
ringRight = visual.Circle(myWin, radius = 140, pos = [200, 0], lineWidth = 2.5, fillColor = None, lineColor = 'black')

myScale = visual.RatingScale(myWin, pos = [0, -360], low = 20, high = 60, textSize = 0.5, lineColor = 'black',
                tickHeight = False, scale = None, showAccept = False, singleClick = True)
information = visual.TextStim(myWin, pos = [0, -385], text = '', height = 18, color = 'black')

#the main loop
def mainLoop():

    finished = False
    standardRadius = 40.
    diskLeft.setRadius(standardRadius)
    diskRight.setRadius(standardRadius)

    while not finished:

        diskLeft.draw()
        diskRight.draw()

        ringLeft.draw()
        ringRight.draw()

        myScale.draw()
        information.draw()
        myWin.flip()

        if myScale.noResponse == False: #some new value has been selected with the mouse
            size = myScale.getRating()
            percentage = (size - standardRadius) / standardRadius * 100
            information.setText(str(percentage) + "%")
            diskRight.setRadius(size)
            myScale.reset()

        pressedList = event.getKeys(keyList = ['escape'])
        if len(pressedList) > 0:
            if pressedList[0] == 'escape': #pressing ESC quits the program
                finished = True
        event.clearEvents()

mainLoop() #enters the main loop
myWin.close() #closes the window
core.quit() #quits
```

As before, pay attention to the indentations. Note also that we have changed slightly the way we check whether the ESC was pressed. The result of event.getKeys is stored in a variable called pressedList. What we get is a list, because that is how event.getKeys works. Next we check that this list is not empty, and if there is something inside we check whether the first element in the list (index 0) was the key 'escape'.

In this case it could not possibly be anything else, so this is a bit of an overkill. It cannot be anything else because we had specified keyList = ['escape']. The way getKeys work is that it returns something only if the input from the keyboard is in the keylist.

The reason we are doing all of these changes is because in the future we may want to check for multiple keys. For now it is just an exercise in the use of if and len(). We also end this bit of script with event.clearEvents(). You can see this as similar to myScale.reset(); we are just making sure that we are ready to collect new information.

Now let's execute the program. Enjoy!

Extra Programming Challenge for Extra Fun

We have placed the circles side by side horizontally. This makes the comparison easy and the Delbœuf illusion less compelling. Try and move the two configurations one a bit higher than the other. When they are not aligned it is harder to compare size and the illusion may appear stronger. You can move just one pair of disk and ring, say the one on the left. You will need to change the y-position to move both of them upwards, while keeping the x-position the same.

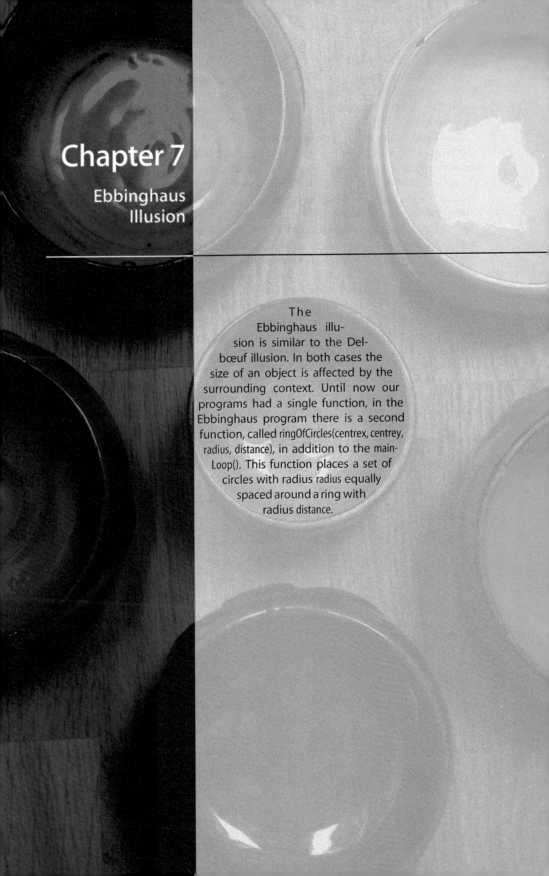

Chapter 7

Ebbinghaus Illusion

The Ebbinghaus illusion is similar to the Delbœuf illusion. In both cases the size of an object is affected by the surrounding context. Until now our programs had a single function, in the Ebbinghaus program there is a second function, called ringOfCircles(centrex, centrey, radius, distance), in addition to the mainLoop(). This function places a set of circles with radius radius equally spaced around a ring with radius distance.

Hermann Ebbinghaus (1850–1909) was a German psychologist. He is mostly famous for his empirical study of memory (his book "On memory" was published in 1885) and the description of the forgetting curve: an exponential loss of learned information over time.

To study memory Ebbinghaus developed techniques including the use of meaningless words (made up words). For example, starting with 2 300 syllables made up of two consonants separated by a vowel (e.g., bac) he created words of three syllables (e.g., bacdefgim). Then used these to test himself and his own memory. Among other things he discovered that the position in a list is important. Both the items at the beginning (primacy effect) and the items at the end (recency effect) are remembered more easily that those in the middle. He also discovered that spacing out the learning is more effective than trying to memorise something in a single session. His methods were very careful and by testing himself he was also able to use long intervals, checking memory after one or three years.

With respect to the illusion that takes his name, you will notice a certain similarity with the Delbœuf illusion. We start wit the disks of the same size, and surround them with two different contexts. One disk is surrounded by large circles, the other by small circles. As a consequence the disk surrounded by large circles is perceived as smaller than the other. An example with 8 circles is shown in Fig. 7.1. While discussing the Kanizsa square we have mentioned that many animals see classic illusions, and this is the case also for the Ebbinghaus illusion. For instance Rosa Salva et al. (2013) tested this illusion with four-day-old domestic chicks.

A particularly strong variation on the Ebbinghaus illusion can be created using an animation in which the circles get bigger or smaller. This dynamic Ebbinghaus illusion was the winner at the 2014 Visual Illusion Contest. You can see it online at the website of the contest, and read about it in Mruczek et al. (2015).

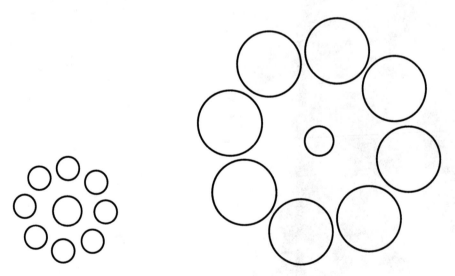

Figure 7.1. In this figure you can see a version of the *Ebbinghaus illusion* with eight circles. There is a circle on the left surrounded by small circles. This circle appears larger than the circle on the right, which is surrounded by large circles. They are in fact identical and you can check that with a ruler

The Ebbinghaus illusion was also described by Edward B. Titchener, a British psychologist who had moved to America, and therefore you can find it referred to as the Titchener illusion or at times as the Ebbinghaus-Titchener illusion.

In more recent years, the Ebbinghaus illusion has proved useful to test the idea that there are different perception systems. One idea, called the *two visual system hypothesis*, is that conscious perception and visual control of action are distinct systems both functionally and anatomically (Milner and Goodale 1995; Goodale and Humphreys 1998). One line of evidence supporting the two visual systems hypothesis is that visual illusions have a powerful effect on perception of objects, but they have little or no effect on visual control of action. In one famous study, Aglioti et al. (1995) asked participants to report which target appeared larger, which they did in line with the illusion. However, in this study the targets were physical disks, like poker chips. When asked to pick up a target, the grip aperture (how far people opened the fingers) was appropriate for the actual physical size of the disk, and therefore was not affected by the illusion. Aglioti concluded that only one of the systems, the perception one, is affected by illusions. This is a very exciting literature, on which, it should be said, there are still contrasting views (Bruno 2001b; Franz 2001).

The Ebbinghaus.py Program

Let's write a program that shows the Ebbinghaus illusion. You can download the file Ebbinghaus.py from *www.programmingvisualillusionsforeveryone.online* (as for all programs).

The first five lines are the ones you have seen before (so I am not copying them here again). Next we create some objects, similar to those for the Delbœuf illusion. We include in the list a controller called mySale and an information text. These are all familiar to you by now.

```
diskLeft = visual.Circle(myWin, radius = 40, pos = [-160, 0], lineWidth = 2.5, fillColor = 'red', lineColor = None)
diskRight = visual.Circle(myWin, radius = 40, pos = [160, 0], lineWidth = 2.5, fillColor = 'red', lineColor = None)
myCircle = visual.Circle(myWin, radius = 80, lineWidth = 2.5, fillColor = None, lineColor = 'black')

mySale = visual.RatingScale(myWin, pos = [0, -360], low = 20, high = 60, textSize = 0.5, lineColor = 'black',
                tickHeight = False, scale = None, showAccept = False, singleClick = True)
information = visual.TextStim(myWin, pos = [0, -385], text = '', height = 18, color = 'black')
```

The controller will change the size of the disk on the right. The disks start off with a radius of 40 pixels and the controller will go as low as 20 and as high as 60 pixels. We place the standardRadius of 40 into a variable, and reset our disks to that value. This is exactly what we did also for the Delbœuf illusion.

We still have a mainLoop as a function. As before this is set up like this:

```
#the main loop
def mainLoop():
```

Everything inside the function is indented. However, drawing a set of circles is best done by its own loop. This we will place in a separate function, and we will write this new function before the main loop.

The main loop was our first example of a function. We have seen that def followed by the name defines a function. Our new function will be called ringOfCircles, and this time we will use some parameters. What we want is to write a function that will draw a set of six circles in a circular configuration. That is, a ring of circles. The parameters will be the following: the *x*- and *y*-coordinates of where to place this whole configuration (the whole ring), the radius of the individual circles, and the radius of the circular configuration (so a bigger radius will place the circles farther out, making a bigger ring).

In the future we will write more functions, and we will always place them before the main loop. There is logic to this, we are setting up these as our tools that we can then **call** whenever we need. In terms of execution, the lines that include the call to the main loop will remain at the end of the script. These lines will be executed fist because they are not indented. Remember that indentation creates blocks. We will only enter a specific function (with its own block of commands) after it has been called. It would not be possible to call functions without having set up these functions to call, that's why they are written first.

Let's look at our ringOfCircles function. The first line uses the parameter radius to set the radius of the circle. Remember that myCircle is the name of the object that we have created. It is an object from the class visual.Circle(). We need to use a bit of **trigonometry** to place six copies of the circle in six positions around a ring.

We are using a for loop for the first time, which is one of the control flow statements we have seen in Chapter 2. This is a loop for a set of values of a variable called angle, and the values are written inside a list within square brackets.

As a general rule we will also always have a comment before the definition of a function. This will say in a few words what the function does.

```
#draw circles with radius 'radius' around a ring with radius 'distance'
def ringOfCircles(centrex, centrey, radius, distance):
    myCircle.setRadius(radius)
    for angle in [0, 60, 120, 180, 240, 300]:
        angle = math.radians(angle)
        x = math.cos(angle) * distance
        y = math.sin(angle) * distance
        myCircle.setPos([centrex + x, centrey + y])
        myCircle.draw()
```

Trigonometry deals with triangles and is extremely useful for many practical applications. Here we use it to find the *x,y*-coordinates of six positions around a circle. We move around this circle, our ring, by incrementing a variable angle from 0 to 300 in steps of 60 degrees. This is because we want to place 6 circles equally spaced, and 360 / 6 is 60. We don't include 360 as that would be the same position as 0.

OK, we have six angles pointing like the hands of a clock in different directions (0°, 60°, 120°, 180°, 240°, 300°). As you can see in Fig. 7.2 within a circle the horizontal distance is given by cos(angle) and the vertical distance is given by sin(angle). This is all we need for a radius of 1. When the radius is different we multiply (scale things up or down) the cos and sin values by this radius. This is what we do in our script when we multiply cos(angle) * distance and sin(angle) * distance.

In Fig. 7.2 there is also a busy version illustrating other important trigonometric functions, including tangent and secant and so on. Think of this as a handy Swiss-

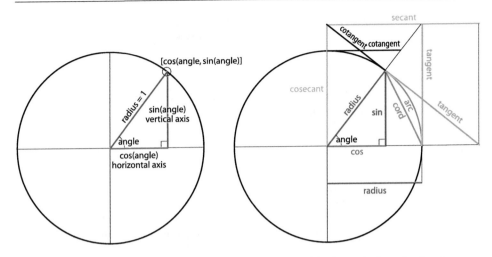

Figure 7.2. *Trigonometric functions.* On the left you see how the cos and the sin give horizontal and vertical distances for a point on the circumference. On the right you can see a full list of functions that may be handy one day. Feel free to ignore this for now but you have to admit that it is pretty and colourful

army-knife for any time you are dealing with triangles. For instance suppose you want to know how tall is a tree because your cat Sheba has climbed it to the top and she is now stuck. The tree is taking up 6 degree of your field of view, and is 100 metres away. What object would have that visual angle at that distance?

The tree is like the tangent in the figure (green vertical line). The answer is given by the tan(6°) multiplied (scaled) by the distance (the pink radius of our system). So the tree is 0.105 × 100 m tall, which is 10.5 m (approximately). Time to look for a 10 metres ladder.

People have come up with a trick to remember the key trigonometric information. If we consider the triangle on the left in Fig. 7.2, the radius is the longer side of a rectangular triangle and thus is also called **hypotenuse**. Therefore you can remember that *Some People Have, Curly Brown Hair, Till Painted Black.* The initials in the sentence tell you that the Sin = Perpendicular side / Hypotenuse, Cos = Base / Hypotenuse, and Tan = Perpendicular / Base.

Now a few technicalities. We use sin and cos from the math module, so we write math.cos() and math.sin(). They expect an angle expressed as **radians** instead of **degrees**, so we transform our angle using math.radians(). Radians are a way of expressing angles from 0 to 2π instead of from 0 to 360. Therefore 0 becomes 0, 60 becomes 1.05, 120 becomes 2.09, and so on until 360, which is 6.28 (2π).

angle = math.radians(angle)

We can let the math module do the work of translating degrees to radians, but it is worth making a mental note that strange behaviours in a program may emerge if we pass a parameter in the wrong units, for example as degrees instead of radians. No error message would be produced (as it is just the wrong number) but we would certainly not get the correct result.

Finally, we need to displace our resulting ring to the correct position on the screen, so we translate the x and y by adding centrex and centrey.

```
myCircle.setPos([centrex + x, centrey + y])
```

When we arrive inside our while loop, to display all our drawings we make use of the new ringOfCircles function.

```
diskLeft.draw()
diskRight.draw()

ringOfCircles(centrex = -180, centrey = 0, radius = 10, distance = 60)
ringOfCircles(centrex = 180, centrey = 0, radius = 60, distance = 125)
```

Finally we draw the controller and flip the back and front windows to see the drawing.

```
myScale.draw()
information.draw()
myWin.flip()
```

Note that the centres of the two rings are one on the left side (–180 pixels) and one on the right side (180 pixels), because one has negative and the other positive x-values. The one on the left has small circles in the ring (radius 10) and the one on the right has large circles (radius 60).

The final parameter is the radius of the ring itself, called distance. One has a radius of 60 pixels and the other of 125 pixels. We chose these values to get the circles fairly close to the disks without touching the edges of the other circles. You can experiment and move them closer or farther by changing this distance.

Note also how the parameters have names. This is not actually a requirement in Python®, you could just have values, but it is a good idea to name the parameters. If the parameters have names we can write them in any order we like. For example the two lines below have the same effect.

```
ringOfCircles(centrex = -180, centrey = 0, radius = 10, distance = 65)
ringOfCircles(distance = 65, centrex = -180, radius = 10, centrey = 0)
```

The other good reason to use names for the parameters is **readability**. It is nice to be able to see them with their names when we call the function. One final point about parameters. We did not make use of this in our script, but in the function itself we can specify default values. We could have defined ringOfCircles like this:

```
#draw circles with radius 'radius' around a ring with radius 'distance'
def ringOfCircles(centrex = 0, centre = 0, radius = 10, distance = 100):
```

In this case any parameter missing when we call the function is used with its default value. For example we could have written the following and the ring would have been drawn in the middle of the screen (at position [0, 0]).

```
ringOfCircles(radius = 10, distance = 65)
```

Let's write all the lines of the Ebbinghaus.py program. It has a very similar structure to the program Delbeouf.py.

```python
import math, numpy, random #to have handy system and math functions
from psychopy import core, event, visual, gui #these are the PsychoPy modules

myWin = visual.Window(color = 'white', units = 'pix', size = [1000, 1000],
                      allowGUI = False, fullscr = False) #creates a window
myClock = core.Clock() #this creates and starts a clock which we can later read

diskLeft = visual.Circle(myWin, radius = 40, pos = [-180, 0], lineWidth = 2.5, fillColor = 'red', lineColor = None)
diskRight = visual.Circle(myWin, radius = 40, pos = [180, 0], lineWidth = 2.5, fillColor = 'red', lineColor = None)
myCircle = visual.Circle(myWin, radius = 80, lineWidth = 2.5, fillColor = None, lineColor = 'black')

myScale = visual.RatingScale(myWin, pos = [0, -360], low = 20, high = 60, textSize = 0.5, lineColor = 'black',
                             tickHeight = False, scale = None, showAccept = False, singleClick = True)
information = visual.TextStim(myWin, pos = [0, -385], text = '', height = 18, color = 'black')

#draw circles with radius 'radius' around a ring with radius 'distance'
def ringOfCircles(centrex, centrey, radius, distance):

    myCircle.setRadius(radius)
    for angle in [0, 60, 120, 180, 240, 300]:
        angle = math.radians(angle)
        x = math.cos(angle) * distance
        y = math.sin(angle) * distance
        myCircle.setPos([centrex + x, centrey + y])
        myCircle.draw()

#the main loop
def mainLoop():

    finished = False
    standardRadius = 40.

    diskLeft.setRadius(standardRadius)
    diskRight.setRadius(standardRadius)

    while not finished:

        diskLeft.draw()
        diskRight.draw()

        ringOfCircles(centrex = -180, centrey = 0, radius = 10, distance = 65)
        ringOfCircles(centrex = 180, centrey = 0, radius = 60, distance = 130)
```

```
⟶ ⟶ myScale.draw()
⟶ ⟶ information.draw()
⟶ ⟶ myWin.flip()

⟶ ⟶ if myScale.noResponse == False: #some new value has been selected with the mouse
⟶ ⟶ ⟶ size = myScale.getRating()
⟶ ⟶ ⟶ percentage = (size - 40) / 40. * 100
⟶ ⟶ ⟶ information.setText(str(percentage) + "%")
⟶ ⟶ ⟶ diskRight.setRadius(size)
⟶ ⟶ ⟶ myScale.reset()

⟶ ⟶ pressedList = event.getKeys(keyList = ['escape'])
⟶ ⟶ if len(pressedList) > 0:
⟶ ⟶ ⟶ if pressedList[0] == 'escape': #pressing ESC quits the program
⟶ ⟶ ⟶ ⟶ finished = True
⟶ ⟶ ⟶ event.clearEvents()

mainLoop() #enters the main loop
myWin.close() #closes the window
core.quit() #quits
```

Let's execute the program. Use the controller to make the circles appear perfectly matched in size to you. The information shows below the controller will tell you exactly how strong the illusion is for you in terms of the percentage difference.

Extra Programming Challenge for Extra Fun

Do you want a challenge? Modify your script so that instead of a ring with six circles you draw a ring with eight circles. The result should look like the image of Fig. 7.1. This require a set of changes, so is more complex than what we have done in previous chapters. One way to solve this challenge is to make the number of circles a new parameter for the ringOfCircles function. When you change the function to take a parameter you can then see the illusion with any number of circles by only changing what argument is given to the function.

Chapter 8

Münsterberg and Café Wall Illusions

The Café wall illusion is a strong effect. Bricks or tiles can create a pattern in which the mortar lines between them do not look parallel. Like many illusions it has an interesting story (and the café that gave the name to the illusion is an actual place in Bristol). It is also closely related to an older effect known as the Münsterberg illusion. We will write a program in which we can toggle between the two illusions. The pattern drawn will have seven columns and nine rows, and the controller will allow the user to shift the black objects and optimise the effect.

The story goes that one day walking in Bristol Steve Simpson, a member of Richard Gregory's lab at the University of Bristol, noticed a strange effect on the wall of a local café (on St Michael's Hill). The wall had a pattern of green and cream tiles, with a thin line of grey cement as mortar. The mortar lines were parallel but they appeared to converge markedly in alternate-direction wedges. Richard Gregory and Priscilla Heard studied the phenomenon and reported it in 1979 in the journal Perception. In Message 8.1 we can hear a few words from Priscilla Heard.

The illusion is strongest when the mortar has a brightness that is in between that of the two tiles. The typical example has black and white tiles and grey mortar lines. This was the case on the wall of the café as well. The extreme case with mortar of the same colour as the tiles (white or black), or when the mortar line is absent, still produces an effect, but weaker. This effect had been reported by Münsterberg (1897) and is known as the Münsterberg illusion. Both illusions are shown side by side in Fig. 8.1.

There is actually nothing special about black and white, other colours can be used, as long as they differ in brightness. A number of variations on the Café wall effect are possible, changing the alignment of the tiles, or placing them on a circular pattern. Akiyoshi Kitaoka has created a number of variations, and studied many of them. Some are highly artistic and you can see them on his webpage, which includes notes and references: *http://www.psy.ritsumei.ac.jp/~akitaoka/cafewalle.html*

A full explanation of the Café wall illusion is not available yet. Authors have speculated about the role of orientation-sensitive simple cells in V1, and responses to luminance borders. In the original article Gregory and Heard (1979) suggested that regions of different luminance need to be held in spatial register by locking their boundaries. This border-locking mechanism produces inappropriate contour shifts from regions separated by narrow gaps. This remains a functional description in need of more work.

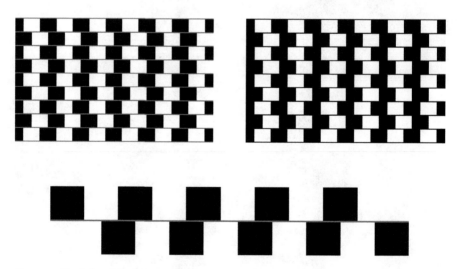

Figure 8.1. The *Café wall illusion* (left) and a version of the *Münsterberg illusion* (right) drawn so as to highlight the similarities. The direction of the effect is the same, although the thin grey lines in the Café wall illusion make the effect stronger. Below them you can see a basic version of the illusion with just one line that appears tilted to the right

Message 8.1. "How the Café wall illusion got its name" by Priscilla Heard

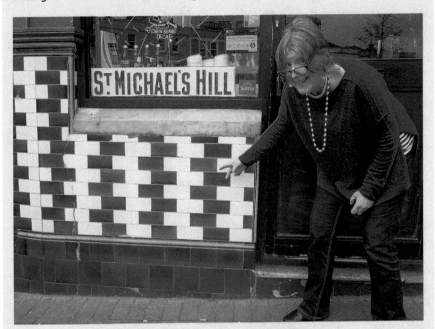

I got involved with helping Richard Gregory investigate the Café wall illusion after he had been so impressed with it as an illusion he had tried to make a model to take to the Tomorrow's World TV Christmas party. The first model was a disaster. It was a chessboard of black and white squares, with every other row made to slide across to make the overlapping tiled illusion. The illusion did not appear. There was no gap between the rows. Richard found that putting a thin piece of grey metal between the rows did the trick, the illusion appeared and could be reversed by sliding the tiles the other way so was a great success at the party.

Back in the lab we built a model that had lots of variables we could control. We could slide the tiles to be overlapping or chessboard, we could adjust the width and luminance of the mortar, we had a clever method of changing the luminance ratio of the tiles and could make them red and green but the same luminance. We got participants to adjust the wedginess of a couple of black wires to match the wedginess of the middle row of tiles to measure the illusion. We formulated the laws of the Café wall. The illusion was strongest with half overlapping tiles, which had the greatest luminance difference and the narrowest mortar of intermediate luminance between the light and dark tiles. It was clear that there were two effects. Without any mortar there was weak wedginess of each tile, with the mortar there was a large-scale integration of wedginess along the whole row of tiles, which exaggerated the illusion.

Building the apparatus to carry out the experiments was very difficult as it involved a lot of workshop activity but you can do the experiments yourself with PsychoPy. Have fun and see if you agree with our laws of the Café wall. [photo by Carol Laidler]

Priscilla Heard received her degree in psychology and PhD from the University of Bristol. This was followed by a postdoctoral fellowship also at Bristol University. She was a founding trustee of the Exploratory Hands on Science Centre Bristol, which she helped to start. Her subsequent academic career has been at The University of the West of England Bristol. Her research interests are in visual neuroscience and illusions.

The CafeWall.py Program

Let's write a program that shows the Café wall illusion. As for all programs you can down-load the file CafeWall.py from *www.programmingvisualillusionsforeveryone.online*.

The first five lines are the ones you have seen before. Next we create some objects, similar to those for the Delbœuf and Ebbinghaus illusions. We include in the list a controller called myScale and an information text. These are all familiar to you by now.

```
blackBar = visual.Rect(myWin, width = 50, height = 10, fillColor = 'black', lineColor = None)
mortar = visual.Rect(myWin, width = 50, height = 2, fillColor = [0.2, 0.2, 0.2], lineColor = None)

myScale = visual.RatingScale(myWin, pos = [0, -360], textSize = 0.4, lineColor = 'black', tickHeight = False,
                scale = None, low = 0, high = 50, showAccept = False, singleClick = True)
information = visual.TextStim(myWin, pos = [0, -385], text = '', height = 18, color = 'black')
```

The blackBar will be used for the black cells of the chequerboard pattern (on a white background), and the object called mortar is a thin rectangle for the grey mortar line. As you can see it makes sense to choose names that are meaningful and easy to remember.

One thing is different from all previous programs. Before colours had names, like black, green or blue. Now we want more control on the brightness and more control on the actual grey colour of the mortar. Therefore we specify colour with 3 values, fillColor = [0.2, 0.2, 0.2]. This is the usual way to set colours on a computer because monitors produce three types of lights, red (R) green (G) and blue (B). You may have come across the term RGB before. By changing the intensity of these three light sources a very large number of different colours can be achieved.

Within PsychoPy each of the three RGB values can vary between –1 (completely off) to 1 (maximum intensity). Every colour is specified by a triplet of values between –1 and 1. Therefore a medium grey is given by [0, 0, 0]. This is what we have chosen for greyRectangleLeft and greyRectangleRight but we will also change this grey within the program. To give a few examples, [1, –1, –1] would be a bright red because the first value is 1 and the other two are –1, and [–1, 1, –1] would be a bright green. A dark grey would be [–0.5, –0.5, –0.5].

For our mortar lines we will use a light grey, specified by fillColor = [0.2, 0.2, 0.2]. As we discussed above it is important that the mortar is darker than one of the colour of the chequerboard and lighter than the other.

As we will switch between the Café wall illusion and the Münsterberg illusion, we have added a title that will be placed above the image. This is going to be green so as to set it apart from anything else.

```
title = visual.TextStim(myWin, pos = [0, 305], text = 'Cafe Wall Illusion', height = 24, color = 'green')
```

The controller will change the offset of the black tiles. They start off with an offset which is half the width of the bar. The controller can go as low as 0 (all tiles lined up) and as high as 50 pixels (the tiles make a regular chequerboard). The strongest effect will be somewhere in the middle.

To draw the chequerboard we will use a function, which keeps all the drawing nicely in one place. Inside this function we need a few lines of maths to set the

start and end position for the *x*- and *y*-positions of the black objects. We want these to be based on the height and width of the bar, which are provided to the function. To draw the pattern, which is a type of chequerboard, we also need two loops one inside the other, one will increment *x* and the other will increment *y*. This is a typical case when dealing with two-dimensional patterns, so I will spend a bit of time on this.

The *x*-value will start from minus six times the width of a bar. So if the bar is 50 pixels long the starting point is –300. The end point is the same but without the minus, 300. Remember that in our coordinate system negative numbers are on the left and positive on the right side.

We increment the *x*-value in steps of twice the width of a bar (100), that is: –300, –200, –100, 0, 100, 200, and 300. These are seven values, so we will have seven columns of tiles across the screen. The reason we increase *x* by twice the width of the bar is because after every black bar there is a white space.

For the *y*-values we start from minus four times the bar height and end at four times this value. However, this time we increment *y* by the bar height, not twice the height, because there is no white space vertically between bars. For a bar that is 40 pixels high we have –160, –120, –80, –40, 0, 40, 80, 120, 160. These are nine rows.

There is nothing special about these values (seven columns and nine rows). You can make the pattern with more rows and more columns if you want. Changing the 4 to a 5 for instance gives 11 rows. Note also that when we use range to move the *x*- and the *y*-values inside the loops we have written range(startX, endX + 1, barWidth * 2) and (startY, endY + 1, barHeight). The fact that we have added 1 to the end value is because as you recall in the range command the stop values is always excluded, but we want the end value that we have calculated to be included, so we set a stop value just beyond that.

```
#black rectangles drawn in columns, shifting every other bar to the right by shift
def drawColumns(shift, barHeight, barWidth):

    startX = - barWidth * 6
    endX = barWidth * 6
    startY = - barHeight * 4
    endY = barHeight * 4
    for x in range(startX, endX + 1, barWidth * 2):
        oddRow = True
        for y in range(startY, endY + 1, barHeight):
            if oddRow == True:
                blackBar.setPos([x + shift, y])
                oddRow = False
            else:
                blackBar.setPos([x, y])
                oddRow = True
            blackBar.draw()
```

We have not finished explaining this function. There is one more feature, but it is important because it is this offset of the bars that will create the illusion. As you can

see in Fig. 8.1 one row of black bars is shifted with respect to the next row. Therefore, within the y-loop we do not want all the bars aligned, we want some of them displaced to the right. We displace them by adding something to the x-position. We call this shift and it is the first parameter of the function.

A challenge is that we need to apply shift only to every other object as we move up along the y-axis (along a column). To do so I set a variable oddRow to False to begin with, but when it is False it changes into True and when it is True it changes into False. This is why it is called oddRow. It tells us whether we are in an odd or even row of the pattern. Only when this variable is True the shift is added to the x-position.

There are other ways to achieve this result. I hope this solution has some transparency, in the sense that we are explicitly coding whether we are on an odd or an even row. Alternatively we could have counted the rows, and checked whether the row number was odd or even.

When you program something like this for the first time it is hard to have a sense of the order of the drawing operations. One needs to keep checking and in some cases test the program. So here is an example of a test. We will add two lines that will be removed in the final program. Just after a blackBar is drawn using blackBar.draw() (at the end of the function) we will flip the image to make it visible and add a small delay to be able to see the resulting animation.

```
blackBar.draw()
myWin.flip() #this is to be removed from the final program
core.wait(0.1) #a delay of 0.1 seconds, this also is to be removed from the final program
```

This will show an animation in which you can see that the bars are drawn one at a time from the bottom left to the top right. We will have to finish the program to actually run it and see what happens, but we have added comments to make sure we will not forget to remove these lines at the end. Online you can find two versions of the program: CafeWall.py (without these lines) and CafeWallExtraFliping.py (with these two lines).

Now we have a black and white pattern, created by the function drawColumns() specialised for that job. On top of this pattern we want to draw the grey mortar lines. This is done by another, shorter, function.

```
#draw the mortar lines
def drawMortar(barHeight):

    startY = - barHeight * 5 + barHeight / 2
    endY = barHeight * 5 - barHeight / 2
    for y in range(startY, endY + 1, barHeight):
        mortar.setPos([0, y])
        mortar.draw()
```

As the mortar line is a long horizontal line we only need to move it along the y-axis. No need to change the x-position because that can stay at 0. This means that the lines are centred horizontally.

For the y-position the loop is similar to that which we have seen for the blackBar objects. The difference is that we want the mortar lines above and below and not on top

of the black object, so we have to shift the first up by half the bar height and the last down by half the bar height. Therefore we add an extra half a bar to startY and we take that away from endY.

Note also that we multiply the start and end values by 5 and not 4. That is because for 9 rows of black bars we need 10 mortar lines. This is clear if you look at Fig. 8.1 again.

After these two functions that take care of the drawing we have a mainLoop function. Within this main loop, as in previous programs, we check whether a key has been pressed. The ESC key will quit the program. In addition to ESC we will also use another key to switch between the Café wall and the Münsterberg version of the illusion.

```python
pressedList = event.getKeys(keyList = ['escape', 'a'])
if len(pressedList) > 0:
    if pressedList[0] == 'escape': #pressing ESC quits the program
        finished = True
    elif pressedList[0] == 'a':
        if illusionName == 'Cafe wall illusion':
            illusionName = 'Munsterberg illusion'
            mortar.setFillColor('black')
        elif illusionName == 'Munsterberg illusion':
            illusionName = 'Cafe wall illusion'
            mortar.setFillColor('grey')
```

This part of the program is inside the main loop. Note that when the key 'a' is pressed we do two things.

First, we change the name of the illusion, this toggles between the two names and it will change what appears written on the top of the screen. Because inside our while not finished loop we not only draw the image but we also draw the title (title.draw()), any change to the title will immediately take effect.

Second, we change the colour of the mortar line. Again this will happen immediately. Without a grey line we have an image that we call the Münsterberg illusion. As for the title the same key toggles between the two images. What happens should be clear when you run the program because it is seen immediately on the screen.

You may dislike the fact that I wrote Café wall in the title without the accent on the (Cafe Wall). Similarly I wrote Münsterberg without the two dots on the u (they are called diaeresis). I apologise. It is possible to use an extended character set in Python® and PsychoPy, but it does require some extra work that I did not want to introduce in this chapter.

Let's write all the lines of the CafeWall.py program.

```python
import math, numpy, random #to have handy system and math functions
from psychopy import core, event, visual, gui #these are the PsychoPy modules

myWin = visual.Window(color = 'white', units = 'pix', size = [1000, 1000],
                      allowGUI = False, fullscr = False) #creates a window
myClock = core.Clock() #this creates and starts a clock which we can later read

blackBar = visual.Rect(myWin, width = 50, height = 10, fillColor = 'black', lineColor = None)
mortar = visual.Rect(myWin, width = 50, height = 2, fillColor = [0.2, 0.2, 0.2], lineColor = None)
```

```
myScale = visual.RatingScale(myWin, pos = [0, -360], low = 0, high = 50, textSize = 0.5, lineColor = 'black',
                             tickHeight = False, scale = None, showAccept = False, singleClick = True)
information = visual.TextStim(myWin, pos = [0, -385], text = '', height = 18, color = 'black')
title = visual.TextStim(myWin, pos = [0, 305], text = 'Cafe Wall Illusion', height = 24, color = 'green')

#black rectangles drawn in columns, shifting every other to the right by shift
def drawColumns(shift, barHeight, barWidth):

    startX = - barWidth * 6
    endX = barWidth * 6
    startY = - barHeight * 4
    endY = barHeight * 4
    for x in range(startX, endX + 1, barWidth * 2):
        oddRow = False
        for y in range(startY, endY + 1, barHeight):
            if oddRow == True:
                blackBar.setPos([x + shift, y])
                oddRow = False
            else:
                blackBar.setPos([x, y])
                oddRow = True
            blackBar.draw()
        #myWin.flip() # this is to be removed from the final program
        #core.wait(0.1) #a delay of 0.1 seconds, this also is to be removed from the final program

#draw the mortar lines
def drawMortar(barHeight):

    startY = - barHeight * 5 + barHeight / 2
    endY = barHeight * 5 - barHeight / 2
    for y in range(startY, endY + 1, barHeight):
        mortar.setPos([0, y])
        mortar.draw()

#the main loop
def mainLoop():

    finished = False
    illusionName = 'Cafe Wall illusion'
    barHeight = 40
    barWidth = 50
    shift = barWidth / 2
    blackBar.setHeight(barHeight)
    blackBar.setWidth(barWidth)
    mortar.setWidth(barWidth * 14)

    while not finished:
```

```
→ → drawColumns(shift, barHeight, barWidth)
→ → drawMortar(barHeight)
→ → title.setText(illusionName)
→ → information.draw()
→ → myScale.draw()
→ → title.draw()
→ → myWin.flip()

→ → if myScale.noResponse == False: #some new value has been selected with the mouse
→ → → shift = myScale.getRating()
→ → → information.setText(str(shift))
→ → → myScale.reset()

→ → pressedList = event.getKeys(keyList = ['escape', 'a'])
→ → if len(pressedList) > 0:
→ → → if pressedList[0] == 'escape': #pressing ESC quits the program
→ → → → finished = True
→ → → elif pressedList[0] == 'a':
→ → → → if illusionName == 'Cafe Wall illusion':
→ → → → → illusionName = 'Munsterberg illusion'
→ → → → → mortar.setFillColor('black')
→ → → → elif illusionName == 'Munsterberg illusion':
→ → → → → illusionName = 'Cafe Wall illusion'
→ → → → → mortar.setFillColor('grey')
→ → → → event.clearEvents()

mainLoop() #enters the main loop
myWin.close() #closes the window
core.quit() #quits
```

Let's execute the program. If you have the two lines in it that show each bar immediately after it is drawn you will see an animation with a black bar moving up on the screen, along a column, and then again for the next column. Why from the bottom? Because we start with a negative value of *y*. Similarly we see the left side before the right because we start with a negative value of *x*. Look again at Fig. 3.2 for the way negative and positive values correspond to the coordinates of our window.

Extra Programming Challenge for Extra Fun

The program creates a pattern with 7 columns and 9 rows, but as we have mentioned there is nothing special about these numbers. You can create a larger pattern with 11 columns and 11 rows. This will fill the whole window horizontally. Remember though that once you change the number of black and white cells you also need to change the length of the mortar lines.

The next three chapters show illusions of brightness and of colour. These are spectacular illusions because the effects are very robust and compelling.

Chapter 9

Brightness Contrast and White Illusion

This chapter is about brightness. We will draw some grey rectangles, and see when they appear darker or brighter. We will see a very strong illusion described by White in 1979 (The White illusion). It is hard to believe that two grey patches are the same when they look so different. The program will allow the user to set the grey levels so that they appear the same, and then to switch off the context. This can be done for the White effect and also for comparison it can be done for a contrast configuration in which the grey within a black square appears brighter and within a white square it appears darker. The comparison between the White illusion and the Brightness contrast is interesting, it shows that it is not sufficient to consider what colour is next to what other colour in the image.

This chapter is about brightness. We will draw some grey rectangles, and see when they appear darker or brighter. Brightness is a general term to refer to how objects of all colours (including grey) may appear "bright" or "light". We will use the words "brighter" and "lighter" to mean the same thing.

We will start with the **Simultaneous brightness contrast** effect. This is a long name but the effect is simple: a grey patch surrounded by black appears brighter than the same grey patch surrounded by white. You can see why we call this a **contrast** effect, and the word **simultaneous** says that we look at the images side by side, at the same time. This is to make it clear we are not talking about afterimages. The light region on a dark background also looks larger, an effect known as irradiation and first described by Galieo Galilei (1632).

There are many ways in which the surrounding colour can have an effect. An old and powerful idea is that of lateral inhibition (for the historical context see Kingdom 1997). Basically the response to one stimulus is strengthened or weakened by the presence of a similar or different response in neighbouring regions (**lateral** here refers to side by side spatial position). As the wise man says "it is in the winter that the fir tree is green". Complex interactions between neurons that respond to neighbouring regions of a visual image certainly take place in the brain. As we will see, however, lateral inhibition is far from the whole story.

An example of Simultaneous brightness contrast is included in Fig. 1.5. It is also worth looking again at the Hermann grid in Fig. 1.3. The grey patches appear at the intersections, and at these locations the white region has less black around (because they are at the intersection of two white roads). Therefore one can see the Hermann grid as a special case of Simultaneous brightness contrast. So far so good for the idea that perceived brightness depends on the amount of brightness in neighbouring regions. If there is a lot of black next to a grey patch it will look brighter, and if there is a lot of white it will look darker.

But I have already mentioned in Chapter 1 that this old explanation for the Hermann grid does not work. For example, it has been noted that the illusion disappears when extra thin bars are added to the grid, but that there are illusory spots in an outline grid with hollow squares (Spillmann 1994). Another interesting case is a grid that does not have straight edges and is therefore made of waves. This should not affect the contrast but the effect disappears (Geier et al. 2008).

The White illusion takes the name from the Australian Psychologist Michael White (1979). It would have been even more interesting if he had found a collaborator called John Black, now we could refer to the illusion as the Black and White illusion. A related version with colours was actually published even earlier and is known as the Munker illusion (Munker 1970). A similar modulation of perceived brightness is known as the Benary cross (Benary 1924) and is even older. Figure 9.1 shows both the White illusion (two versions, both from White) and the Benary cross.

What is common to the White illusion and to the Benary cross is that the amount of black and white next to a grey patch does not produce Simultaneous brightness contrast. In the case of the White illusion what happens is the opposite of what one would expect. The grey next to horizontal black lines (the lines just above and below the rectangle) is seen as darker than the grey next to horizontal white lines. In the case of the Benary cross the grey on top of the cross is seen as darker even though it is surrounded by the same amount of black as the grey patch that is not on top of the cross. Again this is inconsistent with Simultaneous brightness contrast.

I think you will notice that the White illusion is a very strong effect. It is therefore a very important puzzle that holds a key to understanding how people perceive brightness.

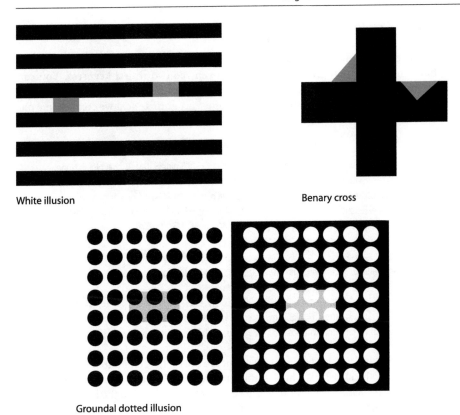

White illusion Benary cross

Groundal dotted illusion

Figure 9.1. In the *White illusion* the two grey patches are physically identical but the one on the left appears darker. The two triangles in the *Benary cross* are also identical, but the one on the left appears darker. Below you can see another version of the *White illusion*. This is my version of an image that White published in 1982. The grey on the left again appears darker despite the large dots on top of it

The explanations are still debated in the literature but I will mention here the general idea that allows us to make sense of these effects.

When describing the Simultaneous brightness contrast effect we said that there is a contrast with the surrounding region. Now consider the following idea. What if the surrounding region is not to be understood as what is next in the image, but what is next in the scene, and the scene is made of multiple surfaces.

Now everything makes sense, at least in terms of the direction of the effect. There is always a contrast but the grey patch in the White illusion is contrasted with the surface (or the object) on which it is perceived. When it appears on top of a black bar it is seen as lighter, when it appears on top of a white background it is seen as darker. The same logic applies to the Benary cross, the triangle that is perceived on top of the cross is subjected to contrast with the black of the cross.

Figure 9.1 also shows a third example that White called *Groundal dotted illusion* (White 1982). This effect fits the explanation very well. The contrast is with the background of the grey rectangles, despite the large dots placed on top of them.

The White.py Program

Let's write a program that shows both the Simultaneous brightness contrast and the White illusion. The program will switch between the two with a keypress. You can download the file White.py from *www.programmingvisualillusionsforeveryone.online.*

The first five lines are the same as for the other programs. Next we create some objects. We include in the list a controller called myScale and an information text. These are all familiar to you by now.

```
grayRectangleLeft = visual.Rect(myWin, width = 100, height = 25, fillColor = [0, 0, 0], lineColor = None)
grayRectangleRight = visual.Rect(myWin, width = 100, height = 25, fillColor = [0, 0, 0], lineColor = None)
blackBar = visual.Rect(myWin, width = 600, height = 25, fillColor = 'black', lineColor = None)
blackSquare = visual.Rect(myWin, width = 300, height = 400, pos = [-150, 0], fillColor = 'black', lineColor = None)
whiteSquare = visual.Rect(myWin, width = 300, height = 400, pos = [150, 0], fillColor = 'white',
                lineColor = 'black')

myScale = visual.RatingScale(myWin, pos = [0, -360], textSize = 0.4, lineColor = 'black',
                tickHeight = False, scale = None,
                choices = [-.28, -.24, -.20, -.16, -.12, -.08, -.04, 0, .04, .08, .12, .16, .20, .24, .28],
                stretch = 2.0, showAccept = False, singleClick = True)
information = visual.TextStim(myWin, pos = [0, -385], text = '', height = 18, color = 'black')
```

The greyRectangleLeft and greyRectangleRight are the rectangular patches to be placed left and right. The blackBar is a horizontal bar that we will draw seven times to make a set of bars. The blackSquare and whiteSquare are set up to provide the background for the Simultaneous brightness contrast effect.

Our controller will manage the change in grey level for the patches. Because we want our rectangles to remain grey we will vary all three RGB values together, moving for instance from $[0, 0, 0]$ to $[0.04, 0.04, 0.04]$. We changed the controller a bit to take values between -0.28 and 0.28. This is done by using a parameter choices = $[-.28, -.24, -.20, -.16, -.12, -.08, .04, 0, .04, .08, .12, .16, .20, .24, .28]$. Note that this parameter has replaced the parameters low and high. We need to specify the exact values to have more control on small changes.

The visual.RatingScale is a complex class and we are using here some of its many parameters to make it look and behave just like we want. You may wonder how can one know about all the ways to change a RatingScale. Rather than learning by heart it makes more sense to look them up when necessary. The details are in the API here: *www.psychopy.org/api/visual.html*

In the list of what we are setting up there is one additional item. The program will show both the Simultaneous brightness contrast effect and the White illusion and therefore there will be a title high on the screen that will provide information (it will say either Simultaneous brightness contrast effect or White illusion).

```
title = visual.TextStim(myWin, pos = [0, 305], text = '', height = 24, color = 'green')
```

This title is green to set it apart from everything else. We will add the text later, for now it contains an empty string.

Before we start building out main loop we set up a couple of functions. These are places in which we do some drawing. On this occasion they are mainly serving the purpose of keeping groups of commands nicely separated and organised.

The first function is called switchStatesAndDrawBackground and it controls the possible states of the program. We have two illusions, so we will use one key to switch between them. But we also like to see the grey rectangles on their own, to check how they look without anything around. We will use another key to switch the context on and off.

So one variable (illusionName) controls the effect, and another (showIllusion) controls if we see the illusion or not. Figure 9.2 illustrates the four possible combinations of these two variables. We call these **states** and each state has a different title in the sense that the title at the top of the screen will always tell us exactly in which state we are. Therefore the title will be changed inside the function that controls the states.

I chose to introduce this new way of changing what is on the screen in part to learn something new. The logic of having states within an interactive program is one approach that may be useful in the future.

Within the function switchStatesAndDrawBackground we use if to check the values of the two variables. First we check whether showIllusion == True and illusionName == "White". In this case we draw the horizontal bars for the White illusion. There are seven bars, alternated with white space, so we shift each bar vertically. As the background is white we only need to draw the black bars.

Note how the vertical position is set using range(-7,8,2). As we have seen in Chapter 2, range will give us numbers from the start value to the end value (excluded) in steps (the step is 2 in this case). Therefore, inside the loop, the y-value is barHeight * -6, barHeight * -4, barHeight * -2, barHeight * 0, barHeight * 2, barHeight * 4, barHeight * 6. You can check the actual values and see that they locate seven black bars evenly spaced in the window. The x-value is always 0 because we keep these bars centred horizontally.

The if is followed by three elif to deal with all four cases. This is both inefficient (slow) and redundant. You may have already noticed that once we arrive at the last elif there is no need to check anything because there is only one possible combination left! So why are we doing it this way?

		illusionName	
		Simultaneous brightness contrast **"SBC"**	White illusion **"White"**
showIllusion	**True**	SBC on screen	White illusion on screen
	False	Only the gray rectangles	Only the gray rectangles

Figure 9.2. The four possible states of the program. The variables are called illusionName and showIllusion. The values of these variables are in bold and their combination gives four possible "states"

There are alternatives, and some may be better and more elegant. However, with respect to efficiency and speed, the extra checks make a tiny difference and one that the user will never notice. With respect to redundancy, redundant checks may be useful because they may catch possible errors in the program, and they also make the program more explicit and readable.

```
#there are 4 possible states in terms of what is on screen
def switchStatesAndDrawBackground(barHeight, showIllusion, illusionName):

    if showIllusion == True and illusionName == "White":
        title.setText('White illusion')
        for index in range(-6, 8, 2):
            blackBar.setPos([0, barHeight * index])
            blackBar.draw()
    elif showIllusion == True and illusionName == "SBC":
        title.setText('Simultaneous Brightness Contrast')
        blackSquare.draw()
        whiteSquare.draw()
    elif showIllusion == False and illusionName == "White":
        title.setText('White illusion - OFF')
    elif showIllusion == False and illusionName == "SBC":
        title.setText('Simultaneous Brightness Contrast - OFF')
```

The next function is called drawRectangles and draws the six grey rectangles. The rectangles are 100 pixels in length, and they are positioned 120 pixels to the right (three of them) and 120 pixels to the left (the other three). Again the position is adjusted vertically in multiple of barHeight. Note that three are on top of the black bars (even multiples of barHeight), and three are on the white spaces (odd multiples of barHeight).

```
#six grey rectangles, three on the left three on the right
def drawRectangles(barHeight):

    xPos = 120

    grayRectangleRight.setPos([xPos, barHeight * -2])
    grayRectangleRight.draw()
    grayRectangleRight.setPos([xPos, barHeight * 0])
    grayRectangleRight.draw()
    grayRectangleRight.setPos([xPos, barHeight * 2])
    grayRectangleRight.draw()

    grayRectangleLeft.setPos([-xPos, barHeight * -3])
    grayRectangleLeft.draw()
    grayRectangleLeft.setPos([-xPos, barHeight * -1])
    grayRectangleLeft.draw()
    grayRectangleLeft.setPos([-xPos, barHeight * 1])
    grayRectangleLeft.draw()
```

We then start the main loop. As always we set finished to False, and we start with some values for illusionName ("White") and showIllusion (True). This way we will see the White illusion on the screen. We also enter the barHeight in a variable, and reset the height of our rectangles to this value of barHeight. We will not alter this in the program but you can change it to see what happens.

```
#the main loop
def mainLoop():

    finished = False
    illusionName = "White"
    showIllusion = True
    barHeight = 25
    grayRectangleLeft.setHeight(barHeight)
    grayRectangleRight.setHeight(barHeight)
    blackBar.setHeight(barHeight)
```

After this there is the while loop. Here is where we call the switchStatesAndDrawBackground() function, and also the drawRectangles() function.

We said that we want to switch state based on a keypress. Therefore getKeys will accept three possible keys, 'escape', 'a' for switching between the White illusion and Simultaneous brightness contrast, and 's' for making the illusion visible or not.

```
pressedList = event.getKeys(keyList = ['escape', 'a', 's'])
if len(pressedList) > 0:
    if pressedList[0] == 'escape': #pressing ESC quits the program
        finished = True
    elif pressedList[0] == 'a':
        if illusionName == 'White': illusionName = 'SBC'
        elif illusionName == 'SBC': illusionName = 'White'
    elif pressedList[0] == 's':
        showIllusion = not showIllusion
    event.clearEvents()
```

If you look at what we do based on the key you can see that when 'a' is pressed the name of the illusion changes (toggles between the two). Note how important the indentations are, within an elif there is one if and then another elif.

Similarly when the 's' is pressed it is the value of showIllusion that toggles between True and False. This is done in a slightly different way. We took advantage of the fact that *something not True is False* and *something not False is True*. So to toggle the value of a variable that contains Boolean data we just negate the current value. If this is confusing you can check the behaviour of a Boolean value in the Shell panel of PsychoPy.

```
>>> a = False
>>> a
False
>>> not a
```

```
True
>>> not not a
False
```

If this is still confusing, you can replace the single line showIllusion = not showIllusion with the following. It is longer but it achieves the same result.

```
if showIllusion == True: showIllusion = False
elif showIllusion == False: showIllusion = True
```

Figure 9.3 shows the image of the program when it starts. The White illusion is shown and the controller can be used to make the two grey rectangles appear the same in brightness.

Let's write all the lines of the White.py program.

```
import math, numpy, random #to have handy system and math functions
from psychopy import core, event, visual, gui #these are the PsychoPy modules

myWin = visual.Window(color = 'white', units = 'pix', size = [1000, 1000],
                    allowGUI = False, fullscr = False) #creates a window
```

White illusion

Figure 9.3. The White.py program displays the White illusion and a scale to control the difference in brightness of the grey rectangles

```
myClock = core.Clock() #this creates and starts a clock which we can later read

grayRectangleLeft = visual.Rect(myWin, width = 100, height = 25, fillColor = [0,0,0], lineColor = None)
grayRectangleRight = visual.Rect(myWin, width = 100, height = 25, fillColor = [0,0,0], lineColor = None)
blackBar = visual.Rect(myWin, width = 600, height = 25, fillColor = 'black', lineColor = None)
blackSquare = visual.Rect(myWin, width = 300, height = 400, pos = [-150,0], fillColor = 'black', lineColor = None)
whiteSquare = visual.Rect(myWin, width = 300, height = 400, pos = [150,0], fillColor = 'white',
                          lineColor = 'black')

myScale = visual.RatingScale(myWin, pos = [0, -360], textSize = 0.4, lineColor = 'black',
                          tickHeight = False, scale = None,
                          choices = [-.28, -.24, -.20, -.16, -.12, -.08, -.04, 0, .04, .08, .12, .16, .20, .24, .28],
                          stretch = 2.0, showAccept = False, singleClick = True)
information = visual.TextStim(myWin, pos = [0, -385], text = '', height = 18, color = 'black')
title = visual.TextStim(myWin, pos = [0, 305], text = '', height = 24, color = 'green')

#there are 4 possible states in terms of what is on screen
def switchStatesAndDrawBackground(barHeight, showIllusion, illusionName):

    if showIllusion == True and illusionName == "White":
        title.setText('White illusion')
        for i in range(-6, 7, 2):
            blackBar.setPos([0, barHeight * i])
            blackBar.draw()
    elif showIllusion == True and illusionName == "SBC":
        title.setText('Simultaneous Brightness Contrast')
        blackSquare.draw()
        whiteSquare.draw()
    elif showIllusion == False and illusionName == "White":
        title.setText('White illusion - OFF')
    elif showIllusion == False and illusionName == "SBC":
        title.setText('Simultaneous Brightness Contrast - OFF')

#six grey rectangles, three on the left three on the right
def drawRectangles(barHeight):

    xPos = 120

    grayRectangleLeft.setPos([-xPos, barHeight * -3])
    grayRectangleLeft.draw()
    grayRectangleLeft.setPos([-xPos, barHeight * -1])
    grayRectangleLeft.draw()
    grayRectangleLeft.setPos([-xPos, barHeight * 1])
    grayRectangleLeft.draw()

    grayRectangleRight.setPos([xPos, barHeight * -2])
    grayRectangleRight.draw()
```

```
    ⟶ grayRectangleRight.setPos([xPos, barHeight * 0])
    ⟶ grayRectangleRight.draw()
    ⟶ grayRectangleRight.setPos([xPos, barHeight * 2])
    ⟶ grayRectangleRight.draw()

#the main loop
def mainLoop():

    ⟶ finished = False
    ⟶ illusionName = "White"
    ⟶ showIllusion = True
    ⟶ barHeight = 25
    ⟶ grayRectangleLeft.setHeight(barHeight)
    ⟶ grayRectangleRight.setHeight(barHeight)
    ⟶ blackBar.setHeight(barHeight)

    ⟶ while not finished:

    ⟶  ⟶ switchStatesAndDrawBackground(barHeight, showIllusion, illusionName)
    ⟶  ⟶ drawRectangles(barHeight)
    ⟶  ⟶ information.draw()
    ⟶  ⟶ myScale.draw()
    ⟶  ⟶ title.draw()
    ⟶  ⟶ myWin.flip()

    ⟶  ⟶ if myScale.noResponse == False: #some new value has been selected with the mouse
    ⟶  ⟶  ⟶ gray = myScale.getRating()
    ⟶  ⟶  ⟶ grayRectangleLeft.setFillColor(gray)
    ⟶  ⟶  ⟶ grayRectangleRight.setFillColor(-gray)
    ⟶  ⟶  ⟶ information.setText(str(gray))
    ⟶  ⟶  ⟶ myScale.reset()

    ⟶  ⟶ pressedList = event.getKeys(keyList = ['escape','a','s'])
    ⟶  ⟶ if len(pressedList) > 0:
    ⟶  ⟶  ⟶ if pressedList[0] == 'escape': #pressing ESC quits the program
    ⟶  ⟶  ⟶  ⟶ finished = True
    ⟶  ⟶  ⟶ elif pressedList[0] == 'a':
    ⟶  ⟶  ⟶  ⟶ if illusionName == 'White': illusionName = 'SBC'
    ⟶  ⟶  ⟶  ⟶ elif illusionName == 'SBC': illusionName = 'White'
    ⟶  ⟶  ⟶ elif pressedList[0] == 's':
    ⟶  ⟶  ⟶  ⟶ showIllusion = not showIllusion
    ⟶  ⟶  ⟶ event.clearEvents()

mainLoop() #enters the main loop
myWin.close() #closes the window
core.quit() #quits
```

Let's execute the program. Try using the scale to adjust the grey levels so that they appear perfectly matched to you. After you achieve a satisfactory result, press 's' on the keyboard to remove the context. You will probably be surprised by how different the two greys are. You can do the same with each of the two effects. The key 'a' will switch between Simultaneous brightness contrast and White illusion.

Extra Programming Challenge for Extra Fun

You can change the value of barHeight. Thin bars or maybe thick bars may work best for you and produce a stronger effect. For me the effect is strong with thick bars, but in that case the whole configuration drawn by the program is rather small. As an exercise, make the bars thin but also increase the number from 7 black bars to 14.

Chapter 10

Neon Colour Spreading

This chapter introduces colour! When lines change colour, a boundary may be perceived and the surface defined by such boundary takes on a colour that is different from the outside colour. This phenomenon has been called Neon colour spreading because the colour of the lines inside the surface spread to the whole surface. The program introduces two now techniques. One is the use of a stencil, which in PsychoPy is created using visual.Aperture(). This allows drawing just inside, or just outside, a region. The second technique is a loop that picks random numbers so that a very large number of different patterns can be produced. To do so we will use for the first time the module random.

In the previous chapter we have seen three cases of changes in perceived brightness: the Simultaneous brightness contrast, the White illusion, and the Benary cross. In this chapter we will look at an illusion of colour. The illusion is not about the brightness or the hue, but about how colour spreads to fairly large regions of an image. The phenomenon is known with the descriptive term *Neon colour spreading* or *Neon-like colour spreading*. It is good to start by looking at some examples, provided in Fig. 10.1.

This illusion does not take the name of a person. Nevertheless I want to mention the scientists that have published the original demonstrations. The Italian Dario Varin (1971) published a monograph about what he called "chromatic contrast and diffusion", but this work in Italian is not well known. Independently of Varin, the Dutch Harrie van Tuijl described the same effect with different stimuli in 1975. To this author we owe the name of "Neon-like colour spreading" (for a review and discussion see Bressan et al. 1997).

The essence of the effect is that a whole surface appears to assume a colour, and this colour is provided by other elements, usually lines. The colour that spreads to the surface, like the disk in Fig. 10.1, may be rather subdued and muted, and therefore different from that of the inducing elements (the lines), but the surface appears to have a uniform colour.

As we said, the colour appears to spread out to the whole surface, but only under certain conditions. As we will see in our program, an abrupt change of colour along the lines is necessary. For example in the first image in Fig. 10.1 the line goes abruptly from red to black, and in the second image it goes from blue to black. This means that coloured lines do not always spread their colour to the surround, they do so only when there is a certain boundary that creates an illusory surface.

Figure 10.1. These are three different examples of *Neon colour spreading*. On the top left we see spreading in a very simple configuration. The disk is known as *Ehrenstein disk* and we have seen it in Fig. 1.5, but here you may see that the disk take on a reddish or pinkish colour. In the second and third examples we see a larger surface that follows the shape of a set of lines. In this case the surface (not just the lines) may appear blueish, or greyish. I included the image on the right to show that grey levels can work just as well as colour. To verify the role of the black lines you can compare the examples above to the ones below, which have the same colour but should not show any Neon colour spreading

There are other beautiful illusions in which colour appears to spread or form unexpected patterns. In Message 10.1 Akiyoshi Kitaoka mentions coloured grid illusions from Prandtl (1927), Schachar (1976) and Redies et al. (1984). He also provides a new variation with yellow lines within a grid.

There is also an illusion in which colour spreads to a whole surface, called the Watercolour illusion (Pinna et al. 2001; Pinna et al. 2003). An example was already in Fig. 1.5 but a larger one is in Fig. 10.2. Compared to Neon colour spreading here the spreading is even more long range, in the sense of very large surfaces.

One final observation links these colour illusions with the colour afterimage that we have seen in Chapter 1. As you remember after observing a colour patch for a while, adaptation leads to perception of a patch of the opposite colour. It has been observed recently that stronger colour afterimages are produced if there is a well-defined surface with borders in which the afterimage can be seen (van Lier et al. 2009). Specifically, providing closed contours after adaptation leads to a stronger afterimage. Van Lier et al. conclude that the filling-in of afterimage colours resembles the filling-in of *real* colours. Or in other words colours may always be subject to some kind of spreading and filling-in.

Message 10.1. "Coloured ray illusion" by Akiyoshi Kitaoka

Humans are the only species who see visual illusions. It is true that many animals might see perceptual distortions like us, but only humans are curious about them.

Here I propose an illusion that I call the "Coloured ray illusion" (2001). Illusory yellow lines appear to run obliquely over the homogeneously white background. This is part of a family of illusions in which lines appear within a grid. An early report was called Spider's web (Prandtl 1927), and more recent examples include the Pincushion grid illusion (Schachar 1976), and the Neon flanks (Redies et al. 1984).

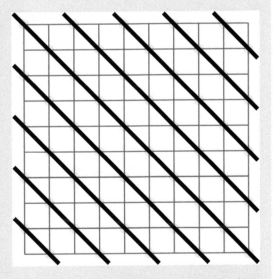

Akiyoshi Kitaoka received a BSc in Biology, University of Tsukuba, Japan in 1984, and a PhD in 1991. He was awarded the Gold Prize of the 9th L'ORÉAL Art and Science of Colour Prize (2006), and the Award for Original Studies from the Japanese Society of Cognitive Psychology (2007). He studies visual illusions including geometrical illusions, colour and lightness illusions, motion illusions and other phenomena including visual completion and perceptual transparency. He works in the Department of Psychology, Ritsumeikan University, Kyoto/Osaka, Japan. http://www.ritsumei.ac.jp/~akitaoka/index-e.html

The NeonColourSpreading.py Program

Let's write a program that shows Neon colour spreading. You can download the file NeonColourSpreading.py from *www.programmingvisualillusionsforeveryone.online* (as for all programs).

We will draw a novel configuration for this effect. It uses a large number of lines that are drawn within a square region. We will use 24 lines and the square will have a side of 400 pixels (from –200 to 200). These lines will be black, but at one point they change

Figure 10.2. An example of the *Watercolour illusion*. There is an orange colouring of the inside of the shape. More beautiful examples can be seen at *http://www.scholarpedia.org/article/Watercolor_illusion*

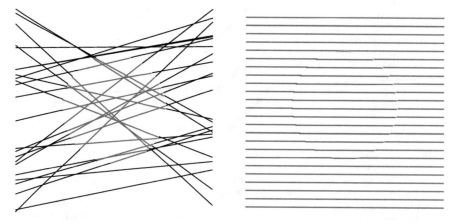

Figure 10.3. An example of *Neon colour spreading* with 24 lines and a circular region. The configuration on the left is what is drawn in our program. The orientation of the lines will be chosen randomly and thus many different patterns can be produced. The example on the right has evenly spaced lines

from black to red. The change will take place so as to describe a circle, in the sense that within a circular region the lines are red and outside they are black. This is shown in Fig. 10.3 and you should be able to see a reddish colour that spreads to the whole circle.

At first sight this configuration may look like something complicated to program. Do we need to compute when the line crosses the boundary of the circle? That would be one way to do it, but there is a useful technique that will make things very easy. This program will not be very long, thanks to this technique, but I need to introduce a couple of new ideas.

When we draw in our windows we have been thinking of a process similar to drawing on paper, or in some case gluing pieces of paper on top of each other. Now what if we could also help ourselves to other drawing tools like a ruler, a rubber, or a stencil? Because we live in a digital world you may not be too familiar with a stencil. It is a piece of plastic or cardboard with a cut-out. By drawing or painting on top of a stencil we get the lines or paint just inside the cut-out.

In PsychoPy we can use a stencil thanks to a type of object called visual.Aperture() (from the visual module). We create an aperture with a certain shape and this will be our cut-out. Then we place this object in our window and whatever drawing we do will only be effective inside that aperture. An illustration of the way the aperture works is provided in Fig. 10.4.

The aperture tool is part of the visual module, so we already have everything we need. However, nice examples of Neon colour spreading include some complex pattern like in Fig. 10.1 and 10.2. To create these patterns I decided to show you another new tool. We will see how to pick random numbers, so we can draw lines that vary randomly in orientation.

Figure 10.4. The visual.Aperture() class creates a *stencil*. Here you can see the effect of having a stencil during drawing. The stencil is called **myStencil** and for illustration is shown in red here. You will never see the stencil as an object on the screen. It was created with a circular shape (many other shapes are possible). As you can see the rectangle is only drawn within the circular cut-out. The same drawing of a rectangle with the inverted stencil gives a very different result

The module to generate random number is already imported, because as you recall we started off with all the necessary modules from the beginning. It is called random.

```
import math, numpy, random #to have handy system and math functions
from psychopy import core, event, visual, gui #these are the PsychoPy modules
```

The two new lines create the window and the clock. I had to add one parameter to the window. Because we want to use a stencil we need to say allowStencil = True. Without this parameter we would get an error when trying to use visual.Aperture().

```
myWin = visual.Window(color = 'white', units = 'pix', size = [1000, 1000], allowStencil = True,
                      allowGUI = False, fullscr = False) #creates a window
myClock = core.Clock() #this creates and starts a clock which we can later read
```

After that we set up new objects.

```
line = visual.Line(myWin, start = [-200, 0], end = [200, 0])
myStencil = visual.Aperture(myWin, size = 100, shape = 'circle')

myScale = visual.RatingScale(myWin, pos = [0, -360], low = 1, high = 400, textSize = 0.5, lineColor = 'black',
                             tickHeight = False, scale = None, showAccept = False, singleClick = True)
information = visual.TextStim(myWin, pos = [0, -385], text = '', height = 18, color = 'black')
title = visual.TextStim(myWin, pos = [0, 305], text = 'Neon Colour Spreading', height = 24, color = 'green')
```

The controller will change the size of the disk. This disk starts off with a radius of 100 pixels and the controller will change the radius between 1 and 400 pixels.

The lines will be drawn using the object line, of type visual.Line. The disk instead will be created by using an aperture, called myStencil. Notice how inside visual.Aperture we set the size of this stencil (100 pixel) and its shape (circle). By the way, other stencil shapes are possible, for example we could set up an irregular polygon to be used as shape, or we could even use an image, like a photo of a cat saved as an image.

The logic is that we will draw a set of 24 red lines with random orientation. However, we will have a stencil (called myStencil) on our window. This stencil has a circular cut-out (radius 100). The nature of a stencil is that the lines will not be actually seen anywhere except inside the cut-out in the stencil. This is a circular region in which red lines will therefore be drawn.

The next step uses a special property of our stencil. A normal stencil just has a cut-out and that is what we can use. On a computer the same stencil can be used to only draw **inside** the cut-out or to only draw **outside** the cut-out. To do that we invert the stencil object by changing the variable myStencil.inverted from False to True.

These steps are illustrated in Fig. 10.4. and in the lines below. You can see the use of the stencil and its inverted version, the first drawing of the lines uses myStencil with inverted set to False, the second uses the myStencil with inverted set to True. The actual drawing of the lines is done by a function called drawLines and we will describe this function a bit later.

```
myStencil.inverted = False
line.setLineColor('red')
line.setLineWidth(2)
drawLines(yLeft, yRight, number)

myStencil.inverted = True
line.setLineColor('black')
line.setLineWidth(1)
drawLines(yLeft, yRight, number)
```

Note that in the first case the colour is red and in the second black. These are the same lines so they will form lines that change colour when they cross the boundary of the circular aperture. I have also changed the thickness of the lines. The red ones will be thicker. This is not strictly necessary for the effect but should make it stronger. Feel free to try different values for width (in pixels) including decimal values such as 1.5.

It may take a bit of time to grasp the trick, meaning the way that a stencil works. But after that I think you will realise that it can be a useful technique, and not just to draw the Neon colour spreading illusion.

The drawing of the lines is done by a combination of two functions, one called drawLines() and one called chooseYPositions(). We need to look at how we choose the y-positions first.

```
#pick randomly N vertical positions on the left and N vertical positions on the right
def chooseYPositions(n):

    yLeft = []
    yRight = []
    for index in range(n):
        yLeft.append(random.randint(-200, 200))
        yRight.append(random.randint(-200, 200))

    return yLeft, yRight
```

This is a function that selects n vertical positions on the left and n vertical positions on the right. Vertical positions for the start and end of our lines are positions along the y-axis (the vertical). These values are therefore stored in two lists called yLeft and yRight.

The first two lines create two empty lists:

```
yLeft = []
yRight = []
```

We start with empty lists because we are going to use a loop that adds numbers to them. We cannot add anything if first we do not create a list. It is the first time we are doing this and also the first time that we treat a list as an object with its own .append() function.

The append function increases the length of the list by one element. The new number in this case comes from generating a random integer. This is also something new that we have not seen before. We have a module called random, and from that module we call random.randint(). This function takes two parameters and returns an integer that is a value between the two numbers given.

Here is an example of how to generate a random number between 0 and 100.

```
random.randint(0, 100)
```

In the program we are picking random numbers between –200 and 200. This is because we want our lines to be within a square with a side of 400 pixels. For now what you should note is that we are creating two lists with *n* elements each, and these are integers between –200 and 200. The value of *n* will be 24 because we will draw 24 lines, but this is something that we may want to change at some point. The function will work fine for any value of *n*.

So we are learning a few new things in this chapter. With respect to random numbers you can explore more of the commands available from the random module. For example you can import it in the Shell panel in PsychoPy (see Chapter 2), and then use random.randint() with different arguments. It is particularly interesting in this case to write the same line more than once.

```
>>> import random
>>> random.randint(0, 100)
32
>>> random.randint(0, 100)
6
>>> random.randint(0, 100)
100
```

Again using the Shell panel try to type the following two lines.

```
>>> import random
>>> random.choice(['Sheba', 'Simba', 'Smudge'])
'Simba'
```

As you can see the random.choice() is a way of picking one element from a list. If you execute the same command again you may get 'Simba' again or a different name. The main functions from the module are listed in Box 10.1.

On the last line of the function chooseYPositions() for the first time we see one of our own functions return some values.

```
return yLeft, yRight
```

Note how simple it is to make a function return something, and note also that what we are returning are two lists. Therefore when we will call this function in the program we will store what will be returned in two lists by writing something like this:

```
yLeft, yRight = chooseYPositions(24)
```

Box 10.1. A list of the main functions from the *random* module

- random()

 returns a float between 0.0 and 1.0 (excluding 1.0).

- randint(min, max)

 returns an integer between the min and the max value, including both min and max. The values of min and max can also be negative as in randint(−100, 50).

- choice(list)

 returns one random element from the list.

- randrange(start, stop, step)

 returns a randomly selected element from a range. Equivalent to choice(range(start, stop, step)).

- shuffle(list)

 shuffle randomly the elements of the list. After called this function the list itself is changed. It does not create a new list.

- sample(list, n)

 returns a new list with *n* elements selected at random from the list. If the original list contains repeats, then each occurrence is a possible selection in the sample.

In the examples above I have described the behaviour in terms of lists. To be more precise any sequence can be used in these cases. For example shuffle or sample can take a string instead of a list (each character is one element) or a sequence generated by range().

In this example the name of the variables is the same as the name inside the function, but this is not necessary. It would work equally well in the following way:

```
myYLeft, myYRight = chooseYPositions(24)
```

This is because what happens inside the function is local to that function, and what is returned can be stored in any new variable with the same or different names.

The second function that we need to write is called drawLines() and it uses the lists created by chooseYPositions(). This is the reason I am describing them one after the other.

In drawLines() we have a loop over all the lines that we want to draw (*N*), that is between 0 and 23 (thus 24 lines). For each line we set the starting and the ending locations as *x,y*-pairs. The *x*-value is fixed, so the line will always cross the screen from −200 (on the left) to 200 (on the right). The *y*-value is whatever value we have in the yLeft and yRight lists.

```
#draw N lines that go from -200 to 200 horizontally, and from yLeft to yRight vertically
def drawLines(yLeft, yRight, n):

    for index in range(n):
        line.start = [-200, yLeft[index]]
        line.end = [200, yRight[index]]
        line.draw()
```

This is a simple function that does just one specific job, it draws *N* lines using the coordinates that were created by chooseYPositions(). We can call this function repeatedly to refresh the drawing of the lines. These lines will remain the same unless we decide to have a different pattern and pick new random positions. This is achieved by called again chooseYPositions() before drawLines().

We need to decide what to do in response to the user actions. The scale will vary the radius of the disk. This will help in getting the strongest effect. As always ESC will close the program. In addition we will use the key 'a' to call again the function chooseYPositions(n). This way we can see many different patterns. Some will look nicer than others.

Remember that chooseYPositions(n) is where we pick random numbers for the vertical positions of the lines. Calling this function again means that the pattern will change. Finally, it is important to show how the presence of the black lines is important to get the spreading of the colour. Therefore with the key 's' we will switch off the black lines and leave only the red ones.

```
pressedList = event.getKeys(keyList = ['escape','a','s'])
if len(pressedList) > 0:
    if pressedList[0] == 'escape': #pressing ESC quits the program
        finished = True
    elif pressedList[0] == 'a':
        yLeft, yRight = chooseYPositions(number)
    elif pressedList[0] == 's':
        showIllusion = not showIllusion
event.clearEvents()
```

Let's write all the lines of the NeonColourSpreading.py program. But let's add one more change with respect to previous programs. We have seen that some key variables can be set with a specific value at the beginning of the function. The idea is that these are values that you can change and try out different patterns. So we could have written number = 24 at the start of the main loop. Instead we have set number as a parameter, with a default value of 24.

```
def mainLoop(number = 24):
```

This means that we can still call mainLoop without parameters (because there is a default value anyway) or we can call it with a different value. In the script below the mainLoop is called without any parameters.

```
import math, numpy, random #to have handy system and math functions
from psychopy import core, event, visual, gui #these are the PsychoPy modules

myWin = visual.Window(color = 'white', units = 'pix', size = [1000, 1000], allowStencil = True,
                allowGUI = False, fullscr = False) #creates a window
myClock = core.Clock() #this creates and starts a clock which we can later read

line = visual.Line(myWin, start = [-200, 0], end = [200, 0])
myStencil = visual.Aperture(myWin, size = 100, shape = 'circle')

myScale = visual.RatingScale(myWin, pos = [0, -360], low = 1, high = 400, textSize = 0.5, lineColor = 'black',
                tickHeight = False, scale = None, showAccept = False, singleClick = True)
```

```
information = visual.TextStim(myWin, pos = [0, -385], text = '', height = 18,  color = 'black')
title = visual.TextStim(myWin, pos = [0, 305],  text = 'Neon Colour Spreading', height = 24, color = 'green')

#pick randomly n vertical positions on the left and n vertical positions on the right
def chooseYPositions(n):

    yLeft = []
    yRight = []
    for index in range(n):
        yLeft.append(random.randint(-200, 200))
        yRight.append(random.randint(-200, 200))

    return yLeft, yRight

#draw n lines that go from -200 to 200 horizontally, and from yLeft to yRight vertically
def drawLines(yLeft, yRight, n):

    for index in range(n):
        line.start = [-200, yLeft[index]]
        line.end = [200, yRight[index]]
        line.draw()

#the main loop
def mainLoop(number = 24):

    finished = False
    yLeft, yRight = chooseYPositions(number)
    myStencil.enabled = True
    showIllusion = True

    while not finished:

        myStencil.inverted = False
        line.setLineColor('red')
        line.setLineWidth(2)
        drawLines(yLeft, yRight, number)

        myStencil.inverted = True
        line.setLineColor('black')
        line.setLineWidth(1)
        if showIllusion == True:
            drawLines(yLeft, yRight, number)

        title.draw()
        information.draw()
        myScale.draw()
```

```
→ → myWin.flip()

→ → if myScale.noResponse == False: #some new value has been selected with the mouse
→ → → c = myScale.getRating()
→ → → information.setText(str(c))
→ → → myStencil.size = c
→ → → myScale.reset()

→ → pressedList = event.getKeys(keyList = ['escape','a','s'])
→ → if len(pressedList) > 0:
→ → → if pressedList[0] == 'escape': #pressing ESC quits the program
→ → → → finished = True
→ → → elif pressedList[0] == 'a':
→ → → → yLeft, yRight = chooseYPositions(number)
→ → → elif pressedList[0] == 's':
→ → → → showIllusion = not showIllusion
→ → → event.clearEvents()

→ → myStencil.enabled = False

mainLoop() #enters the main loop
myWin.close() #closes the window
core.quit() #quits
```

Now let's execute the program. Keep pressing the 'a' key to see many different configurations. Press the 's' key to see how the illusory spreading of colour requires the full configuration of lines.

Extra Programming Challenge for Extra Fun

The program draws lines that have y-values chosen at random between −200 and 200, so the y-values are picked randomly but the x-values are fixed. Change the program so that the lines form an evenly spaced set of horizontal lines. This is the pattern shown in Fig. 10.3 (right). To do that you will need to set 24 y-values that move in regular steps from −200 to 200.

Chapter 11

Honeycomb Illusion

We are aware of looking directly at things when we want to attend to them, or when we want to read text. However the rest of the visual scene remains complete and stable. Yet illusory objects in the periphery may appear, as in the case of the Hermann grid, or features may disappear as in the case of the Honeycomb illusion. The Honeycomb illusion is an illusion showing that things do **not** necessarily stay uniform, even though the texture is uniform and therefore it is unclear where the evidence of non-uniformity is coming from. In the program we can see a honeycomb with hexagons and additional lines. This is the basic image where the hexagons remain visible but the lines are only visible at fixation. We can also see just the hexagons or just the lines. Finally, changing the lines from black to red is quite interesting as it separates two textures, the hexagons and the red lines. This makes everything easier to see.

The *Honeycomb illusion* is the most recent of the illusions included in this book. It was described by Marco Bertamini in 2016 (Bertamini et al. 2016). You may notice a curious coincidence in that the name is the same as the name of the author of this book. Well, OK, so maybe it is not a coincidence. I noticed this effect while working on something completely different. I was exploring the available built-in textures within an application, and thought that a texture was strange because it did not extend to the whole screen. In reality the texture was uniform but it did not appear uniform.

Let us start by looking at the effect in Fig. 11.1. Unlike many other illusions for this effect we need a large surface. The page of the book is just about big enough when seen from a natural reading distance. For the same reason the program will fill the whole window.

Look at the texture in Fig. 11.1 and choose one particular hexagon. It does not matter which one, say one in the middle. The next bit requires some care and effort. Try and describe the whole image that you see without moving your eyes. The reason this is difficult is that it is natural to move our eyes. You will probably see that the hexagons have lines in a region around fixation, but that they look like plain hexagons (without lines) in the periphery.

Figure 11.1. Here the *Honeycomb illusion* is shown with white lines over a grey background. A normal reading distance from the page should be OK (about 40 cm). Choose one location and without moving the eyes try to describe the full texture. The hexagons in the periphery will appear as regular hexagons without lines at the intersections. Try moving your gaze to a different location, the features that you had just been looking at the previous location disappear immediately

By the way there is nothing magical about hexagons, a similar (and simpler) configuration could be made with squares for example. Hexagons just form a nice pattern.

The Honeycomb illusion may remind you of the Hermann grid that we have seen in Chapter 1 (and Fig. 1.3) because it uses a large and regular pattern. But the effect is the opposite. In the Hermann grid we see things in the periphery that disappear when we look directly, in the Honeycomb illusion we do not see things in the periphery and they appear only when we look at them directly.

Vision in the centre of the visual field is much more accurate and detailed than vision in the periphery. We know that by testing vision in the periphery (Levi et al. 1985). However we do not experience a field of view that becomes blurry and colourless in the periphery. This may be a kind of illusion in itself.

One possibility is that when we see a natural and therefore large field of view (much larger than just the central fixation area) we have an illusion that our perception of the whole visual scene is of a high resolution and colourful. The illusion may be based on memory (because we sample the scene by moving the eyes and make many fixations over time) or on an assumption that, if there is no reason to believe otherwise, what is in the centre is also present in the periphery (Otten et al. 2016). We have seen examples of spreading of colour in the case of the Neon colour spreading and the Watercolour illusion (Chapter 10). Therefore we know that in some cases the visual system extrapolates colour to large surfaces.

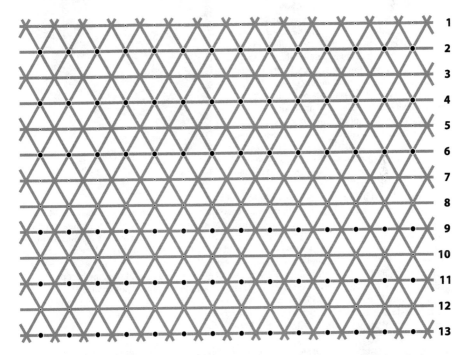

Figure 11.2. In the context of variations on the *Hermann grid*, Ninio and Stevens (2000) described a case in which disks become invisible in the periphery. They named it the *Extinction illusion*. Lines 9, 11, 13 contain disks on top of lines and these disks are easy to see. Instead the disks on lines 2, 4, 6 are extinguished, irrespective of their size, when they are situated at the crossings. One sees only a few of them at a time, in clusters which move erratically on the page (image by Jacques Ninio)

This context is what makes the Honeycomb illusion fascinating. The texture is uniform, but observers do not see it as uniform. Moving the eyes and therefore sampling many locations does not make any difference either, so there is no memory of what we have just seen (or the memory is replaced immediately by a different representation).

What we can see in the periphery of our filed of view is also affected by clutter. That is, recognition of objects presented away from the centre is impaired by the presence of neighbouring objects, and this interesting phenomenon is called **crowding** (Parkes et al. 2001; Sayim et al. 2010). Note, however, that crowding tends to manifest itself as a mixing together of features, or misreporting of neighbouring objects. Neither of these effects could explain the Honeycomb illusion.

Figure 11.2 shows a related phenomenon, known as *Extinction illusion*. In this case what disappears are objects rather than features, specifically local disks (Ninio and Stevens 2000). Again, you can explore these images for hours but they will still look non-uniform, despite everything we know. We have a message from Jacques Ninio in Message 11.1.

Message 11.1. "From Biology to Visual Perception" by Jacques Ninio

Being luckily in possession of a very wide scientific culture, I managed to contribute to a dozen different scientific fields. In molecular biology, I proposed, with John Hopfield, the popular *kinetic proofreading* concept (1974–1975) that explains how kinetic tricks enhance molecular recognition specificity. In evolutionary genetics, I introduced the well-accepted *transient mutator* concept (1991) explaining how bacteria generate multiple mutations, without an increase in general mutation level, then I extended the concept to higher organisms. In bioinformatics, I described (Dumas and Ninio 1982) an algorithm for comparing DNA sequences that is at the heart of a package called BLAST. The article (Altschul et al. 1990) on BLAST is one of the most quoted scientific articles of all times.

I started working on perception as a hobby, in 1975, first on geometrical illusions, then on stereoscopic vision, and last on visual memory. It was easy for me to produce sophisticated images (for instance, the random curve stereograms in 1981 or the *elastic autostereograms* – see my 2007 review). However, the impact of this work was minor, mostly, I believe, because other workers in the field did not have the tools to produce similar images. Since 1992 I used C++ and OpenGL, but the real skill that limited many of my colleagues was an understanding of geometry, and mainly analytical geometry. In my opinion, my best publication is my 2004 article on visual memory. It still meets with incomprehension in the field.

I produced several visual illusions by serendipity: looking at an image, finding something slightly odd in it, but potentially important, then varying the parameters using analytical geometry and graphical programming until the effect became conspicuous.

Jacques Ninio graduated as an engineer from Ecole Polytechnique, Paris, in 1963. In 1964 he started research in molecular biology at Centre de Génétique Moléculaire, Gif-sur-Yvette, then Institut Jacques Monod, in Paris. In 1972–1974 he worked on the origins of life in Leslie Orgel's laboratory, at the Salk Institue, San Diego. Since 1992, he is within a team of physicists at Ecole Normale Supérieure, and is partly active as an emeritus director of research.

So to appreciate the Honeycomb illusion we have discussed how vision differs in the centre of the field of view and in the periphery, how the impression that we see everything over a large field of view may be an illusion, and how things may be hard to see in clutter. One final interesting phenomenon is what happens if we keep our eyes fixed on one location. Over time objects in the periphery may fade away completely, and you can experience this phenomenon using Fig. 11.3. This fading is called *Troxler fading* (Martinez-Conde et al. 2004; Pessoa and De Weerd 2003). Indeed with prolonged fixation even what is in the centre fades away completely.

You may wonder how is that possible because you have never noticed objects in front of your eyes disappear. The reason is that we are not aware of how often our eyes move.

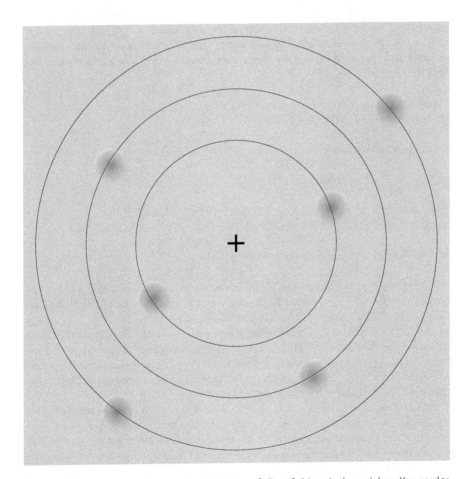

Figure 11.3. This image should allow you to experience *fading* of objects in the periphery. You need to be at a distance of about 40 cm from the image and keep your eyes on (fixate) the black cross. This is not easy to do but if you can manage to maintain your fixation after several seconds some of the red objects will start to disappear. Objects can disappear and then come back, although with time it is possible to make them all disappear. Counter-intuitively it has been found that attended objects fade faster than unattended ones (Lou 1999)

There are not only large movements of gaze direction, but also small and very small movements, these happen even when we are just looking at the same target object.

Can Troxler fading explain the Honeycomb illusion? Not really, because Troxler fading is an adaptation effect that requires long fixations, the Honeycomb effect is instantaneous.

The Honeycomb.py Program

Let's write a program that shows the Honeycomb illusion. You can download the file Honeycomb.py from *www.programmingvisualillusionsforeveryone.online*. The main different with respect to the other programs is that we will not use a controller.

The program will draw something relatively simple, a hexagon and six small lines at the vertices of the hexagon, and we will have to repeat this drawing over the whole of the window. To do so we will need a loop and some maths.

The first few lines are similar to all other programs, after importing the necessary modules and opening a window we create some objects. What is new is that we do not need the controller.

```
import math, numpy, random #to have handy system and math functions
from psychopy import core, event, visual, gui #these are the PsychoPy modules

myWin = visual.Window(color = 'white', units = 'pix', size = [1000, 1000], allowGUI = False,
                       fullscr = False) #creates a window
myClock = core.Clock() #this creates and starts a clock which we can later read

line = visual.Line(myWin, start = [-4, 0], end = [4, 0], lineWidth = 0.4, lineColor = 'black')
hexagon = visual.Polygon(myWin, ori = 30, edges = 6, radius = 50, lineWidth = 0.4, lineColor = 'black',
                          fillColor = None)
title = visual.TextStim(myWin, pos = [0, 305], text = 'Honeycomb illusion', height = 24, color = 'green')
```

The small lines at the vertices of the hexagons will be drawn using a short line of type visual.Line(). This line has been set up as a horizontal line of length 8 pixels (from –4 to 4) and is thin (width of 0.4 pixels).

The hexagon will be drawn using the object called hexagon. The hexagon shape is defined using visual.Polygon(). This is similar to other classes of shapes we have seen, but it creates regular polygons with a given number of edges. So for edges = 3 we get an equilateral triangle, for edges = 4 a square, for edges = 5 a pentagon, and so on. We use it to draw a regular hexagon (six equal sides).

As I said we will need a bit of maths. It is useful at this point to take a piece of paper and work out the relevant distances for a pattern like that shown in Fig. 11.1. I have done that and show the working in Fig. 11.4. There may be more ways to do this, and more ways to draw a pattern, so if you are happy to take a different approach feel free to do so. What Fig. 11.4 shows is one way to describe the distances and we will use them to obtain a honeycomb pattern.

To learn something new we are going to change a bit the structure of the program. There are three functions that do the drawings. One deals with the drawing of the hexagons, one loops over all the hexagons in turn to draw the small lines, and one actually draws the six small lines for one specific hexagon. These are short functions that

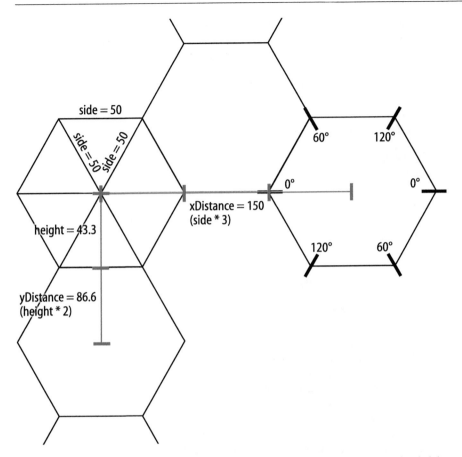

Figure 11.4. We need to carefully look at the position of hexagons in a *honeycomb*. Let us decided the side of the hexagon is 50. A honeycomb can be seen as two columns of stacked hexagons, therefore if we draw one at a time the centre to centre distance between hexagons is three times the side of the hexagon (horizontally) and two times the height (vertically). I called these *xDistance* and *yDistance*. The position of the additional lines for each hexagon is at 60 degree intervals around an imaginary circle with radius 50, and the orientation of the line is as shown: 0, 120, 60, 0, 120, 60 degrees

carry out specific tasks. Instead of setting them up outside the main loop I have written them as functions **inside** a function.

It is the first time we see a function inside another function. What are the differences with respect to just a list of functions all at the same level? The main factor to consider when deciding the position of a function within the program is the logic of what we are doing. If a function is logically only a bit player (a cog in the machine) of a large function then it may belong inside it. There are, however, some important practical implications. Our functions are now private to the mainLoop() and they exist only in that environment. In our program that is just fine, as these functions are not needed as stand-alone functions, they are local to the main loop rather than global to the whole script. In other words there is no use for them outside the main loop.

Here are the first few lines of the main loop. We note first that the colour of the lines is set to black by default (a different value can be passed as a parameter) and the side of the hexagon is 22 pixels (the default value, a different one could be passed as a parameter). As you remember we have done something similar in the previous chapter for the Neon colour spreading main loop.

```
#the main loop
def mainLoop(colorOfLines = 'black', side = 22):

⟶ finished = False
⟶ showLines = True
⟶ showHexagons = True
⟶ hexagon.setRadius(side)

⟶ height = math.sqrt((side**2) - ((side / 2.)**2))
⟶ xDistance = side * 3.
⟶ yDistance = height * 2.
⟶ nHorizontal = int(500. / xDistance)
⟶ nVertical = int(500. / yDistance)
⟶ orientations = [0, 120, 60, 0, 120, 60]
⟶ angles = [0, 60, 120, 180, 240, 300]
```

At the beginning of the main loop we start to figure out some values. These will be available to all inner functions (unlike outside functions that would have to received them as parameters). What in visual.Polygon() is called radius is really the side of the hexagon (it is the radius of a circle in which the hexagon is inscribed). We will call this the side of the hexagon.

A regular hexagon is composed of six equilateral triangles in a flower formation. Therefore we compute the height of an equilateral triangle using Pythagoras theorem (see the *height* marked in red in Fig. 11.4). As a reminder, Pythagoras theorem says that for any right-angled triangle the square of the side opposite the right angle is equal to the sum of the squares of the other two sides.

To take the square root of a number we use math.sqrt() and inside the brackets we have the squared value of the side (side**2) and the squared value of half the side ((side / 2.)**2). You can look back at Box 2.3 to see that **2 is how we write *x* to the power of 2. Note also the use of brackets as the division has to be done first, so (side / 2.**2) would have given us a different (and wrong) result: ((22 / 2.)**2) is 121 but 22 / 2.**2 is 5.5, a massive difference!

To understand these computations visually we also need to look at Fig. 11.4. A honeycomb is made up of two columns of stacked hexagons. If we draw one column at a time the centre-to-centre distance between hexagons is three times the side of the hexagon (horizontally) and two times the height (vertically). We call these xDistance and yDistance.

There are two more parameters to calculate. We want to fill a window (going from −500 to 500) with hexagons that are xDistance apart, so we divide 500 by xDistance. This will be the number of columns and is called nHorizontal (for number horizontally). Similarly 500 divided by yDistance will be the number of rows and is called nVertical

(for number vertically). To use the specific example with side 22, xDistance is 66 and nHorizontal is 7 (on each side of the origin).

Finally, for convenience we store the angles and the orientations that we will need for the small lines. We call these lists orientations and angles.

This may feel a lot like a maths exercise. But hopefully it was not boring because there was a clear application. We have solved the puzzle and found the numbers we needed, so we can move on to the next challenge. Let us look at the three functions that do the drawing.

```
#draw all lines around one specific hexagon
def drawLines(centrex, centrey):

    for index in range(6):
        angle = math.radians(angles[index])
        x = math.cos(angle) * radius
        y = math.sin(angle) * radius
        line.setPos([centrex + x, centrey + y])
        line.setOri(orientations[index])
        line.draw()

#draw all lines around each hexagon in turn by calling drawLines
def drawAllLines():

    for xCounter in range(-nHorizontal, nHorizontal + 1):
        for yCounter in range(-nVertical, nVertical + 1):
            drawLines(xDistance * xCounter, yDistance * yCounter)
            drawLines(xDistance * xCounter + xDistance / 2., yDistance * yCounter + yDistance / 2.)

#draw all hexagons as two sets of columns
def drawHexagons():

    for xCounter in range(-nHorizontal, nHorizontal + 1):
        for yCounter in range(-nVertical, nVertical + 1):
            hexagon.setPos([xDistance * xCounter, yDistance * yCounter])
            hexagon.draw()
            hexagon.setPos([xDistance * xCounter + xDistance / 2., yDistance * yCounter + yDistance / 2.])
            hexagon.draw()
```

The drawHexagons() function draws all hexagons with a loop over the *x*-position and another loop over the *y*-position. The loop is from −nHorizontal to nHorizontal, and from −nVertical to nVertical. We set the position and we draw the hexagon. But then we draw it again. Why?

Well, again we have to look at the honeycomb and at Fig. 11.4. The first drawing is for the columns that are xDistance apart, but then there is the other column that is stuck in the middle of these. The loop is actually designed for the first set of hexagons, and the others are added with the second hexagon.draw(). To position this second set of hexagons we shift both the *x* and the *y* by half the distance between columns. This moves the hexagon up to the right. Effectively the loop is a loop that each time draws a pair of hexagons.

As I said before, to fully understand what our commands do sometimes it is worth experimenting. One easy way to experiment is to comment some lines (and therefore removing them from what the program will do). So try and comment out the second drawing (the last line in the function drawHexagons()) with #. The program will still work but you will see gaps between the columns.

Given that we do not have a controller we can only used a few keys to switch on and off some of the features of the configuration. We will use the 'a' to toggle the lines from black to red. This is interesting because changing colour of the lines makes them visible in the periphery. We will use the 's' to toggle the presence of the lines, and the 'd' to toggle the presence of the hexagons. It is interesting that without the hexagons the lines are seen everywhere. It follows that it is the hexagons that somehow mask the lines in the periphery and make them impossible to see. That also means that there is something more interesting going on that simply poor vision in the periphery.

```
pressedList = event.waitKeys(keyList = ['escape', 'a', 's', 'd'])
if len(pressedList) > 0:
    if pressedList[0] == 'escape': #pressing ESC quits the program
        finished = True
    elif pressedList[0] == 'a':
        if colorOfLines == 'red': colorOfLines = 'black'
        elif colorOfLines == 'black': colorOfLines = 'red'
    elif pressedList[0] == 's':
        showLines = not showLines
    elif pressedList[0] == 'd':
        showHexagons = not showHexagons
```

Let's write all the lines of the Honeycomb.py program. This program will be a bit different from the others. There will not be a controller and the image will fill the whole window. We keep the green title at the top but apart from that the texture will be uniform and fill the whole window.

```
import math, numpy, random #to have handy system and math functions
from psychopy import core, event, visual, gui #these are the PsychoPy modules

myWin = visual.Window(color = 'white', units = 'pix', size = [1000, 1000], allowGUI = False,
                      fullscr = False) #creates a window
myClock = core.Clock() #this creates and starts a clock which we can later read

line = visual.Line(myWin, start = [-4, 0], end = [4, 0], lineWidth = 0.4, lineColor = 'black')
hexagon = visual.Polygon(myWin, ori = 30, edges = 6, radius = 50, lineWidth = 0.4, lineColor = 'black',
                         fillColor = None)
title = visual.TextStim(myWin, pos = [0, 305], text = 'Honeycomb illusion', height = 24, color = 'green')

#the main loop
def mainLoop(colorOfLines = 'black', radius = 22):
```

```
⟶ #draw all lines around one specific hexagon
⟶ def drawLines(centrex, centrey):

⟶ ⟶ for index in range(6):
⟶ ⟶ ⟶ angle = math.radians(angles[index])
⟶ ⟶ ⟶ x = math.cos(angle) * radius
⟶ ⟶ ⟶ y = math.sin(angle) * radius
⟶ ⟶ ⟶ line.setPos([centrex + x, centrey + y])
⟶ ⟶ ⟶ line.setOri(orientations[index])
⟶ ⟶ ⟶ line.draw()

⟶ #draw all lines around each hexagon in turn by calling drawLines
⟶ def drawAllLines():

⟶ ⟶ for xCounter in range(-nHorizontal, nHorizontal + 1):
⟶ ⟶ ⟶ for yCounter in range(-nVertical, nVertical + 1):
⟶ ⟶ ⟶ ⟶ drawLines(xDistance * xCounter, yDistance * yCounter)
⟶ ⟶ ⟶ ⟶ drawLines(xDistance * xCounter + xDistance / 2., yDistance * yCounter + yDistance / 2.)

⟶ #draw all hexagons as two sets of columns
⟶ def drawHexagons():

⟶ ⟶ for xCounter in range(-nHorizontal, nHorizontal + 1):
⟶ ⟶ ⟶ for yCounter in range(-nVertical, nVertical + 1):
⟶ ⟶ ⟶ ⟶ hexagon.setPos([xDistance * xCounter, yDistance * yCounter])
⟶ ⟶ ⟶ ⟶ hexagon.draw()
⟶ ⟶ ⟶ ⟶ hexagon.setPos([xDistance * xCounter + xDistance / 2., yDistance * yCounter + yDistance / 2.])
⟶ ⟶ ⟶ ⟶ hexagon.draw()

⟶ finished = False
⟶ showLines = True
⟶ showHexagons = True
⟶ hexagon.setRadius(radius)

⟶ height = math.sqrt((radius**2) - ((radius / 2.)**2))
⟶ xDistance = radius * 3.
⟶ yDistance = height * 2.
⟶ nHorizontal = int(500. / xDistance)
⟶ nVertical = int(500. / yDistance)
⟶ orientations = [0, 120, 60, 0, 120, 60]
⟶ angles = [0, 60, 120, 180, 240, 300]

⟶ while not finished:

⟶ ⟶ line.setLineColor(colorOfLines)
⟶ ⟶ if showHexagons == True:
```

```
            drawHexagons()
         if showLines == True:
            drawAllLines()
         title.draw()
       myWin.flip()

       pressedList = event.waitKeys(keyList = ['escape','a','s','d'])
       if len(pressedList) > 0:
          if pressedList[0] == 'escape': #pressing ESC quits the program
             finished = True
          elif pressedList[0] == 'a':
             if colorOfLines == 'red': colorOfLines = 'black'
             elif colorOfLines == 'black': colorOfLines = 'red'
          elif pressedList[0] == 's':
             showLines = not showLines
          elif pressedList[0] == 'd':
             showHexagons = not showHexagons
       event.clearEvents()

myWin.setMouseVisible(False)
mainLoop() #enters the main loop
myWin.setMouseVisible(True)
myWin.close() #closes the window
core.quit() #quits
```

In the last five lines we have added something new. In this program we do not use the controller, and therefore the mouse is not necessary and the cursor may be in the way of the illusion. Therefore we have set the mouse to be invisible (and then reset that back to be visible after we come out of the main loop). This is done by using a function of the class .Window called .setMouseVisible().

Let's execute the program. You will notice that the drawing will be slower compared to other programs. There is more work to do, and even when you press one of the keys ('a', 's', or 'd') you may have to wait a bit to see the image change. Exactly how slow the change will be depends on the computer on which you are working. You may need to be a bit patient.

Extra Programming Challenge for Extra Fun

Is it important that the lines are placed at the corners of the hexagons? It seems likely but you can test this by changing the position of the lines. You need to change the list called angles because this is used to place the lines around the hexagon. However, as you change the angles you may also need to change the orientations if you want the lines to make right angles with the sides of the hexagons. The challenge is really to find the right values. Another modification, relatively easier, is to change the lines into circles to see what happens to circles placed at the corners of hexagons. To do this a new object of the class visual.Circle() needs to be created and then placed at the same locations as the lines.

Chapter 12

Breathing Square Illusion

The Breathing square is an illusion of movement, therefore in this chapter for the first time we will program an animation. In it, a red square rotates but some parts may be hidden from view. As a consequence the rigid rotation of the square become hard to see and instead the object appears to deform. We will learn how to show an animation on screen, with every image updated every new frame. We set the frame rate to 60 frames per second. This will be done by reading the clock and then waiting without doing anything until the correct amount of time has elapsed (1/60 of a second).

The next four chapters all deal with motion. We see objects in motion all the time and we generally do not have problems with recognising where they are going to and how fast they are travelling. However, it is a huge challenge to reach such representation starting from the visual information generated by multiple objects moving in a three-dimensional environment. Ordinarily, these multiple motions are interpreted correctly, but occasionally strange and interesting things can happen.

Let us consider what happens when an object moves but we only see a few parts of it, for instance a cat walking behind some tall grass. If we know that all those features belong to a cat we can put them together and find information not about the foot or the tail but about the cat as a whole. In particular we can see that the cat is moving in particular direction. Now let's make this even simpler, we have a square and it is rotating. Surely we should be able to see that it is a square even when some parts are hidden.

The illusion we are going to program is broadly based on the stimuli described by Meyer and Dougherty (Meyer and Dougherty 1990). A square will rotate in the centre of the screen, but because we will cover up four corners of the scene the square will not appear like a rigid object. As it says in the title of the paper by Meyer and Dougherty we will see "diamonds that ooze". Another term that has been used to describe the percept is that of "Breathing squares" and "breathing illusions" (as you might have guessed, there are many other displays that produce similar effects; for a review see Bruno 2001b).

This lack of rigidity for a simple rigid object is surprising. The topic fits in an older literature on the complex motion of objects that rotate. If you were to rotate an ellipse for instance even without any hidden parts, it will soon start to appear like a disk moving in three-dimensional space. Basically it will look like a coin that is spinning on a table. Both the ellipse and the disk are rigid objects, but during the observation of what happens people also notice at least for a few seconds deformations and non-rigid motions (Musatti 1924; Vallortigara et al. 1988; Wallach and O'Connell 1953).

Returning to our Breathing square. It is surprising as we said that something rigid appears to deform. This has generated much interest because in general rigidity is a useful assumption to interpret motion. Shiffrar and Pavel (1991) have suggested that the problem is in a misperception of the centre of rotation. However, adding texture to the square should solve this problem of ambiguity, but when texture is added the breathing is still perceived (Bruno 2001b).

There is a fundamental problem at the root of this and other illusions of motion. The problem is that to know that something is moving is relatively easy, but to know **how** something is moving is difficult. To detect motion one has to notice a change over time; most people have burglar detectors in their homes, and they are simple devices that respond to motion. To know what is moving and how requires solving the ambiguity of motion.

This ambiguity is best known under the name of the **aperture problem**. The name comes from the fact that local motion by definition is motion seen only in one place. Think of a situation in which you are looking at the world though an aperture, like a hole in a cardboard. What you see within the hole is limited by the aperture itself, and different physical motions are indistinguishable. For example a vertical line moving

Figure 12.1. The *aperture problem*. A T is moving diagonally from top left to bottom right. An L is moving diagonally from bottom left to top right. Inside the circular aperture a line appears and moves to the right, this is the same motion generated by the T and by the L. So within the aperture the motion does not correspond to either of the two physical motions

down diagonally can produce the same image within the aperture as a vertical line moving up diagonally. I tried to show this situation in Fig. 12.1 using a T and an L. Because the stems of the letters are vertical, within the aperture one can only see a displacement of a line from left to right.

What makes the example of the aperture in a cardboard particularly interesting is that in a sense a neuron in the early part of the visual system responds to information from a small region of the image, so it has its own aperture. In early visual areas neurons have small receptive fields. The consequence is that motion-sensitive neurons in the primary cortex will respond to a moving edge, but shape of the whole object and direction of motion do not make any difference to the response.

Much research has been done on the problem of how to perceive motion of objects (Hildreth 1984; Bertamini et al. 2004; Braddick 1993). The aperture problem can be demonstrated even with just a piece of cardboard and a hole, and the first person credited with describing the aperture problem was Pleikart Stumpf in 1911. His only paper on the subject is available in a translation by Todorović (1996).

The BreathingSquare.py Program

We will set up the program to show the Breathing square illusion. We start as usual (and you can download it from *www.programmingvisualillusionsforeveryone.online*).

```
import math, numpy, random #to have handy system and math functions
from psychopy import core, event, visual, gui #these are the PsychoPy modules

myWin = visual.Window(color = 'white', units = 'pix', size = [1000, 1000], allowGUI = False,
                      fullscr = False) #creates a window
myClock = core.Clock() #this creates and starts a clock which we can later read

movingSquare = visual.Rect(myWin, width = 200, height = 200, fillColor = 'red', lineColor = None)
occludingSquare = visual.Rect(myWin, width = 200, height = 200, fillColor = 'black', lineColor = None)
myScale = visual.RatingScale(myWin, pos = [0, -360], low = 100, high = 180, textSize = 0.5, lineColor = 'black',
                             tickHeight = False, scale = None, showAccept = False, singleClick = True)
information = visual.TextStim(myWin, pos = [0, -385], text = '', height = 18, color = 'black')
```

Message 12.1. "Breathing illusions" by Nicola Bruno

My interest in breathing illusions did not originate from computer-animated displays, but from actual surfaces on a turntable. In certain conditions a rigid surface appears to deform during the rotation. I knew the surface was rigid, because I had cut it from a piece of cardboard, so the deformation had to be an illusion. I therefore created computer-animated variants to identify the conditions that produced this illusion. This became the basis for my PhD thesis and several publications – perhaps not surprisingly, one of them in collaboration with the author of this wonderful book (Bruno and Bertamini 1990). I ended up proposing an explanation that accounts for the results I got from the animation studies as well as the earlier observations with real objects.

One of the fundamental problems in vision research is understanding how the brain combines many local motion signals into the global motion of a unitary object. The brain does this very efficiently most of the times – if it did not, we would not see moving objects correctly and we would be in trouble. Discovering limiting cases when the brain makes mistakes can be very instructive to understand how all of this happens and how it can happen so efficiently. I am proud to have made a small contribution to this literature.

Nicola Bruno received a PhD in experimental psychology from Cornell University in 1990. He has taught courses in perception and cognition at Cornell, at the University of Virginia, at the University of Southampton, and for several years at the University of Trieste, Italy. In 2008 he moved to the University of Parma, where he coordinates a master program in Psychobiology and Cognitive Neuroscience and continues to pursue his research interests in multisensory and sensorimotor processes.

As you can see we have a movingSquare, which is created as a red square with side 200, and an occludingSquare. This will be placed on top of the moving square and it will partly occlude it from view. We have only one implementation of the occluding square but we will draw this over the four corners of the moving square.

The controller will change the location of the occluding squares, so that they can cover more or less of the moving object. When moved out of the way the moving object will be fully visible and it will appear to rotate rigidly. As we move the occluding squares over the object we will start to lose rigidity. That is we will perceive the object as "breathing" despite the fact that we can remember seeing it just a few seconds before as a square. As is often the case with illusions knowing the correct answer does not mean that we become immune to the effect.

Let us write a function to draw the four black objects. This function is called drawOccluders and it takes a parameter distance. This is the variable that will be changed by the controller. This distance defines a square in the sense that the four objects will be places at the vertices of this imaginary square. Therefore the positions will be [-distance, -distance], [distance, -distance], [distance, distance], and [-distance, distance]. These are located in the four quadrants (see Fig. 3.2). We can write these values, or we can obtain these four combinations with a loop within a loop, with x taking on the values distance and -distance and the same for y.

```
#draw four occluders at a distance 'distance'
def drawOccluders(distance = 120):

    for xposition in [distance, -distance]:
        for yposition in [distance, -distance]:
            occludingSquare.setPos([xposition, yposition])
            occludingSquare.draw()
```

I gave the parameter distance a default value. This is for illustration purposes because we will always pass a value to this function and therefore the default will never be used.

We now move on to the main loop, there we will enter as usual a loop that will only end when the variable finished will become True. From within that loop we will call the drawOccluders() function to draw the four black squares.

For the moving square we have the new challenge of rotating the object. We can do that by continuously changing its orientation.

PsychoPy has a very neat way to change a variable based on an operation. We are going to use .setOri() as we have done before to set the orientation, but we use now two parameters instead of one. The first is the angle that we want to add to the current orientation. We used the number 2 so the angle will increase by 2 degrees every time setOri is called. To make it so that this 2 is added to whatever orientation the object has we use the second parameter, called operation. This could be one of a few different operations: +, -, *, /. This value is given to the parameter operation as a string. In our case we use "+".

```
movingSquare.draw()
movingSquare.setOri(2, operation = "+")
drawOccluders(distanceOfOccluders)
```

```
information.draw()
myScale.draw()
myWin.flip()
```

As you can see the moving square is drawn first and then we draw the occluding squares. This will make sure the occluding squares are on top. After the drawing we call myWin.flip().

I deliberately called the value of the distance distanceOfOccluders here to show that this could have the same name as the distance variable inside the drawOccluders function, but it can also have a completely different name. This way you can see that distance is a variable local to the function and takes whatever value is passed to the function.

The value of orientation will continue to increase over time, and these values are still meaningful as degrees, even after we go above 360. However, just to make the loop return to zero after 358 we can add a check for that. This is so that we force this loop to go from zero to 358 and then back to zero (which is equivalent to 360). The value 360 will be reached but not used as such (because we don't want to use both 360 and 0).

```
if movingSquare.ori >= 360:
⟶ movingSquare.ori = 0
```

In this case we are reading and setting the variable ori instead of using .setOri(). I hope this is not confusing. This is a case were there are two equivalent ways to do something. Here I show the two one after the other. The first is a function with a parameter and the function will do the job of changing the variable, the second is an assignment to a variable.

```
movingSquare.setOri(45)
movingSquare.ori = 45
```

In this program we have a rotating square on the screen. But if this is an animation how fast will our square rotate? This is the next issue to consider when we are drawing an animation on the screen. In part the speed that we can achieve will depend on the hardware that we are using. In particular monitors vary in terms of how quickly they can change the image. But for our purpose of showing a smooth animation we do not need to explore in too much detail the hardware problem. We want to write a program that will work well on most if not all computers and monitors. Let us decide that the square will rotate by 2 degree on every new frame and we will show 60 frames per second.

The best way to think about the smoothness of the animation is in terms of **frames per seconds.** Most movie projectors show images at 48 or 72 frames per second. Most standard computer monitors show images at 60 frames per second. That means one frame every 1/60 of a second, which means that a frame lasts 0.01666 seconds. Therefore, an animation shown at 60 frames per second changes the image every 0.01666 seconds. The division gives a recurring decimal, meaning that we have an

infinite list of 6 in the number but in our program we don't need to worry about that level of precision.

You will find this information presented often in terms of **hertz** (Hz). This is the unit of frequency in the International System of Units and refers to cycles per second. The name honours a physicist, Heinrich Hertz (1857–1894). Therefore on a monitor that operates at 60 Hz the image changes 60 times per second.

To make sure we see a new image at the right time we use the clock we have created. We have had the myClock object in all our programs, finally we have a use for it. We check what time it is at the end of the loop using myClock.getTime(). Then we add 1/60 seconds (0.01666) to the current time.

```
waitUntil = myClock.getTime() + 1 / 60. #one second divided by 60 (most monitors are 60 Hz), which is 0.016
```

For example, if it is noon, and therefore exactly 12 o'clock, the waitUntil variable will be set at exactly 0.016 seconds after noon. Then we have a loop that does nothing until we reach that time. To do nothing we use the special command called pass.

```
while myClock.getTime() < waitUntil:
⟶ pass
```

This program is not very long. It turns out that creating an animation using Python® and PsychoPy is not difficult. We already knew how to enter a loop that keeps drawing an image, now we have added two things, an increment to the orientation of the square, and a while loop that waits for 1/60 of a second. Let's write all the lines of the BreathingSquare.py program.

```
import math, numpy, random #to have handy system and math functions
from psychopy import core, event, visual, gui #these are the PsychoPy modules

myWin = visual.Window(color = 'white', units = 'pix', size = [1000, 1000], allowGUI = False,
                fullscr = False) #creates a window
myClock = core.Clock() #this creates and starts a clock which we can later read

movingSquare = visual.Rect(myWin, width = 200, height = 200, fillColor = 'red', lineColor = None)
occludingSquare = visual.Rect(myWin, width = 200, height = 200, fillColor = 'black', lineColor = None)
myScale = visual.RatingScale(myWin, pos = [0, -360], low = 100, high = 180, textSize = 0.5, lineColor = 'black',
                tickHeight = False, scale = None, showAccept = False, singleClick = True)
information = visual.TextStim(myWin, pos = [0, -385], text = '', height = 18, color = 'black')

#draw four occluders at a distance 'distance'
def drawOccluders(distance = 120):

⟶ for xposition in [distance, -distance]:
⟶ ⟶ for yposition in [distance, -distance]:
⟶ ⟶ ⟶ occludingSquare.setPos([xposition, yposition])
⟶ ⟶ ⟶ occludingSquare.draw()
```

```
#the main loop
def mainLoop(distanceOfOccluders = 120):

    finished = False

    while not finished:

        movingSquare.draw()
        movingSquare.setOri(2, operation = "+")
        drawOccluders(distanceOfOccluders)

        information.draw()
        myScale.draw()
        myWin.flip()

        if movingSquare.ori >= 360:
            movingSquare.ori = 0

        if myScale.noResponse == False:
            distanceOfOccluders = myScale.getRating()
            information.setText(str(distanceOfOccluders))
            myScale.reset()

        if event.getKeys(keyList = ['escape']): #pressing ESC quits the program
            finished = True

        waitUntil = myClock.getTime() + 1 / 60. #1 second divided by 60 (most monitors are 60 Hz), which is 0.016
        while myClock.getTime() < waitUntil:
            pass

mainLoop() #enters the main loop
myWin.close() #closes the window
core.quit() #quits
```

Note how the distance of the black squares is set to 120 by default. This is a default value for the main loop, and again a default value for the drawOccluders function. At this distance there should be a clear breathing effect, but the value can also be adjusted using the controller. Now let's execute the program.

If everything works the BreathingSquare.py program should show you an interactive demonstration of a rotating square that deforms. This chapter was not long, and we have time to add something new. Remember that we mentioned one interesting fact about the illusion: if the problem is that it is hard to locate the red square and see where is its centre, then the illusion should go away with a texture.

How do we add a texture to the moving square? To do so we need to replace the visual.Rect() with a different type of object called visual.GratingStim(). This is an object that can show different textures and when these textures repeat they form patterns and

gratings. But we do not need to learn all the features of visual.GratingStim() for now, and we do not need gratings. We will use a texture of darker and lighter grey cells, a bit like a chequerboard.

Let us go back to the line that creates the red square:

```
movingSquare = visual.Rect(myWin, width = 200, height = 200, fillColor = 'red', lineColor = None)
```

and replace it with the new object.

```
movingSquare = visual.GratingStim(myWin, tex = myTexture, size = [200, 200])
```

We are using only three parameters, the first is the window, the second is new and is called tex, and the third is size in pixels. The key parameter is the second in which we have placed a variable called myTexture. This texture needs to be created (before we can use it). We can do that using a function from the numpy module.

The numpy module provides many useful functions that work with numbers, and with arrays in particular. An array is very similar to a list, but it can also have more dimensions, so a two-dimensional numpy array is a matrix. Although we have included this module in all our programs this is the first time we make use of it. Numpy has a function to generate random numbers and place them in an array.

```
myTexture = numpy.random.rand(16, 16) * 0.1
```

This line generated a numpy array full of random numbers. The array (matrix) is 16 elements by 16 elements. It is important to understand that the parameters for this function are the size of the array. The values within the array by default will be between 0 and 1. We multiply each of them by 0.1 because we want all the grey levels to be dark. Note that values in this case specify colour, so the smaller the number the darker the colour. Therefore as the largest possible value was 1, and it is then multiplied by 0.1, the largest value will be 0.1.

The use of dark squares in the chequerboard is necessary to keep the rotating object looking like a solid object. If we had just black and white squares the illusion would be destroyed because there would not be a big square but just individual elements.

We have mentioned in Chapter 3 that numpy arrays are very similar to lists. They are but here you can see that they have additional properties. One is that we can create a two-dimensional array (a matrix). The other is that we can multiply this object by a number (0.1 in our case) and all the values inside will be multiplied by that number. This would not have worked with a list.

The order of our commands is important, the creation of the texture comes first and the creation of the grating using that texture second.

```
myTexture = numpy.random.rand(16, 16) * 0.1
movingSquare = visual.GratingStim(myWin, tex = myTexture, size = [200, 200])
```

These two new lines are enough to show a rotating square that is not red but is made up of a texture of 16 × 16 smaller squares, each of them with a random grey level.

Breathing square illusion

100 180

Figure 12.2. A version of the *Breathing square illusion* in which we have used a texture for the moving square. The breathing effect may be less compelling, but it is still present

You can see an image of this animation in Fig. 12.2. The breathing effect may be weaker but it will not disappear completely. The program is available for download and is called BreathingSquareTexture.py.

Extra Programming Challenge for Extra Fun

We have increased orientation by 2 degrees using the .setOri function with the operation "+". Therefore for every frame the square rotates by 2 degrees. You may want more control on the speed of rotation. To do that you can use the controller to change the amount that is added, in other words instead of 2 degrees this will become a variable, which you can call speed or more precisely rotationIncrement, controlled with the mouse. This may simply replace the other use of the controller. If you want to control both you may need a different approach, perhaps using the keyboard, or a second controller. We will see how to have two controllers in the next chapter (Chapter 13).

Chapter 13

Stepping Feet Illusion

Perception of motion is affected by the contrast between the moving object and the background. When the background has black and white stripes the contrast changes from one stripe to the next. A dark object will have high contrast against the white stripe and low contrast against the black stripe. The opposite is true for a light object. As a result a motion with constant speed may appear to speed up and slow down. We will show this by using black and white stripes and two moving objects, one dark (a dark blue) and one light (a pale yellow). The program also shows that we can have two controllers one on top of the other on the screen.

The *Stepping feet illusion* is fun to watch. The feet in the name are just two simple objects, usually two rectangles, that move across a background with alternating dark and bright stripes. A static image of the configuration is shown in Fig. 13.1. The version that we will program is based on the effect described by Stuart Anstis in 2003, and is therefore relatively recent (Anstis 2003).

The rectangles that move across the screen need to be of very different colours. In our program we will use a dark blue and a bright yellow. While they are moving the observer will notice that they appear to take turns in moving forward, the way that feet alternate their movement when walking. For the best effect the observer should not look directly at the moving rectangles, but rather at the location that is halfway between the two objects. This type of movement is an illusion because the rectangles are aligned with each other and move exactly with the same speed.

The brightness difference (and therefore the contrast) between the moving objects and the background is important for the explanation of the Stepping feet illusion. If there is no background there is no illusion. The contrast is high between the yellow object and the black stripes, and low between the yellow object and the white stripes. But for the dark blue object it is the opposite, there is high contrast with the white and not with the black stripes.

The reason contrast is important is that it affects how easy it is to see motion. Imagine an extreme case in which instead of dark blue we use a black moving rectangle. As a black rectangle moves over a black stripe they merge and there is nothing there to see. Equally, there is no signal when a white rectangle moves over a white stripe.

The black on black is a special case, but more generally it has been found that perceived speed depends on contrast. This is supposed to explain why a car on a foggy day appears to move slower than in a sunny day (Anstis 2004; Krekelberg et al. 2006; Thompson 1982).

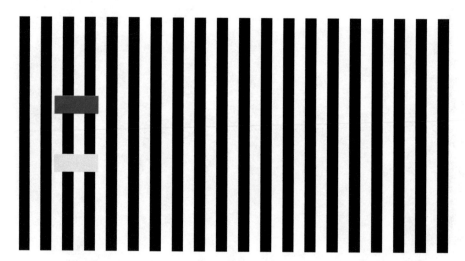

Figure 13.1. The image shows a background with alternating black and white stripes. On top of this background there are two rectangles, one is dark blue and one is yellow. When animated the rectangles move to the right with constant speed but they appear to move in steps, first one and then the other

Message 13.1. "Footsteps" by Stuart Anstis

In the Footsteps illusion, the dark blue and light yellow bars move smoothly together across vertical black and white stripes. Although the bars actually move at constant speed, their perceived speed varies dramatically. When the dark blue bar lies on a background of white stripes, its front and back edges have high contrast and are easy to see, so the motion looks clear and rapid. When it lies on black stripes, its edges have low contrast and are hard to see, so the motion looks slower. The opposite is true for the yellow bar. Conclusion: high-contrast motion looks faster than low-contrast. That is why cars seem to move more slowly during a fog.

Stuart Anstis was born in England and was a scholar at Winchester and Cambridge. Since his PhD at Cambridge with Richard Gregory, he has taught at the Universities of Bristol (UK), York (Toronto), and California, San Diego (UCSD). He is a Visiting Fellow at Pembroke College, Oxford, and a Humboldt Fellow, and received the Kurt-Koffka Medal in 2013.

In 2014 Ono, Tomoeda, and Sugihara entered the Best Illusion of the Year Contest with an illusion called the Pigeon-Neck illusion. You can see the illusion here: *http:// illusionoftheyear.com/2014/05/pigeon-neck-illusion/*

The effect is closely related to the Stepping feet illusion, but it uses shapes that look like pigeons, so the result is particularly amusing.

Because of the importance of contrast in the program we will use a controller to change the back bars from black all the way to white. This idea is adapted from the animation provided online on Michael Bach's website: *http://www.michaelbach.de/ot/mot-feetLin/*

This online demonstration will allow you to change various parameters, more than what we will be able to do inside our program.

The SteppingFeet.py Program

We will set up the program as usual (and you can download it from *http://www.programmingvisualillusionsforeveryone.online*).

```
import math, numpy, random #to have handy system and math functions
from psychopy import core, event, visual, gui #these are the PsychoPy modules

myWin = visual.Window(color = 'white', units = 'pix', size = [1000, 1000], allowGUI = False,
                      fullscr = False) #creates a window
myClock = core.Clock() #this creates and starts a clock which we can later read

movingFoot1 = visual.Rect(myWin, width = 80, height = 30, fillColor = [-1, -1, -0.2], lineColor = None)
movingFoot2 = visual.Rect(myWin, width = 80, height = 30, fillColor = [0.9, 0.9, 0.2], lineColor = None)
verticalBar = visual.Rect(myWin, width = 20, height = 400, fillColor = 'black', lineColor = None)
```

As you can see we have two moving feet. They are small rectangles, the first is dark blue and the second is bright yellow. Remember that we specify colours with numbers for red greed and blue and the values range between –1 (none of that colour at all) to 1. A value of zero is therefore a medium level.

The vertical bar is a black rectangle and we are going to draw many of these to form a pattern of black bars on top of the white background, as shown in Fig. 13.1.

Next we set up our controller. To try something different we are going to have two controllers this time. The first is called myScaleSpeed, and it will control the speed of the movement. The second is called myScaleTransparent because we will use it to change the transparency of the back bars all the way from fully visible to transparent (in which case they will disappear).

```
myScaleSpeed = visual.RatingScale(myWin, pos = [0,-360], low = 1, high = 10, textSize = 0.5, lineColor = 'black',
                    tickHeight = False, scale = None, showAccept = False, singleClick = True)
informationSpeed = visual.TextStim(myWin, pos = [0,-385], text = '', height = 18, color = 'black')

myScaleTransparent = visual.RatingScale(myWin, pos = [0,-255], low = 0, high = 100,
                    textSize = 0.5, lineColor = 'black', tickHeight = False,
                    scale = None, showAccept = False, singleClick = True)
informationTransparent = visual.TextStim(myWin, pos = [0,-280], text = '', height = 18, color = 'black')
```

The last object is something we have used before, a green title at the top of the page.

```
title = visual.TextStim(myWin, pos = [0, 305], text = 'Stepping Feet Illusion', height = 24, color = 'green')
```

Let us write a function to draw the vertical bars. This function is called drawBars and it takes two parameters, the width of the bar, and the number of bars. It is unlikely that these values need changing but as far as the function is concerned it can produce a number of bars of various widths.

```
#draw nBars vertical bars, half black half white
def drawBars(width, nBars):

    left = - width * (nBars - 1) / 2
    for x in range(left, -left, width * 2):
        verticalBar.setPos([x, 0])
        verticalBar.draw()
```

The variable left is the starting position along the horizontal axis. The position is used for the centre of the object, so to use a numerical example, for 40 bars the full distance if 39 times the width of the bar (from the centre of the first to the centre of the last). The reason we divide this number by two is because zero is in the middle so we will go from a negative starting value on the left to a positive value on the right. That is, from left to -left.

In the for loop, range has a step of width * 2 because we want to alternate the black bars with white bars (which we do not draw). In practice this means that we draw a

black bar, then we have a white space with the same width and then we draw another black bar. We do not change the vertical position (the *y*-value) and therefore the bars will all be centred vertically in our window (Fig. 13.1).

The next function moves the two rectangles that we call feet. Here the vertical position stays the same and we increment the horizontal position. These two objects will move on the screen from left to right (if speed has a positive value) or from right to left (if speed has a negative value). In other words their *x*-position will increase or decrease by adding a positive or negative value.

```
#move the rectangles
def animateSteps(speed):

    movingFoot1.setPos([speed, 0], operation = "+")
    movingFoot2.setPos([speed, 0], operation = "+")

    movingFoot1.draw()
    movingFoot2.draw()
```

Note that for the Breathing square we had used the operation "+" to increase the orientation. Here we use the same operation but to increase the position along the *x*-axis. The increase is in pixels and exactly how far we are moving is determined by the variable called speed. Higher speed will displace the object farther forward on every frame.

We now move on to the main loop, here we start with some default values for the width and number of bars, and the speed of the movement. The xMargin is the starting position on the left for the two moving rectangles.

Inside the main loop we draw the background and the moving feet by calling the functions. Then we use the same delay as in the Breathing square program to achieve a smooth animation. To see the new image (with a new position of the feet) at the right time we use the clock. We check what time it is using myClock.getTime(). Then we add 0.016 seconds to the current time. This is so that we get 60 frames every second. This way of controlling the animation is the same that we have already used in Chapter 11.

```
waitUntil = myClock.getTime() + 1 / 60. #one second divided by 60 (most monitors are 60 Hz), which is 0.016
while myClock.getTime() < waitUntil:
    pass
```

In this program we are going to try something new compared to the other programs, but it is not something revolutionary. We have used a controller using visual. RatingScale in most of our programs, now we can see that we can have two of these on the screen at the same time.

At the top we have already seen that we have called one myScaleSpeed and the second myScaleTransparent. We will set up a few lines that use the information from the first controller to change speed, and then a set of lines that are very similar but that allow the user to control the transparency of the vertical bars.

```
if myScaleSpeed.noResponse == False: #some new value has been selected with the mouse
→ speed = myScaleSpeed.getRating()
→ informationSpeed.setText(str(speed))
→ myScaleSpeed.reset()
```

Speed is the number of pixels that is used to change the position on the *x*-axis. You can look back at the animateSteps function to see where the value of speed is used.

```
if myScaleTransparent.noResponse == False: #some new value has been selected with the mouse
→ transparent = myScaleTransparent.getRating()
→ verticalBar.setOpacity(1 - transparent / 100.)
→ informationTransparent.setText(str(transparent) + "%")
→ myScaleTransparent.reset()
```

The variable called transparent is used to set the opacity, which is a property of the verticalBar object. The opacity variable can take values between 0 and 1. Note that for PsychoPy this variable controls opacity, which is the exact opposite of transparency. An opaque object is not transparent at all, and a transparent object is not opaque.

We have decided to let the user change transparency so 0 transparency will have to become 1 in opacity (fully visible) and 1 in transparency will have to become 0 in opacity (completely transparent). There is just one final thing to consider. On this occasion inside our program we like to think of transparency as varying between 0% and 100%, rather than between 0 and 1.

Therefore, we take from the controller a value between 0 and 100. That is how the low and high values were set up for myScaleTransparent. Then we divide this number by 100. (with a decimal point to make sure we get a float). We now have a value between 0 and 1, which is what PsychoPy expects. As this is the transparency we want, to set the opacity we take 1 minus this value. That turns 1 into 0 and 0 into 1. Try with a few values to see what happens.

You may ask why we change opacity instead of colour. We could have changed the colour from black to white in a similar way, but there is an advantage in using opacity. Imagine that you change the program so that the bars are blue, or green, or any other colour. The part of the program that deals with opacity does not need changing, 0 will make these bars invisible (same as background), and 1 will show them with the original colour.

Note that for the information to be shown on the screen we use the value between 0 and 100. That is because we like to think of this as the percentage of black. To make it clear that this should be thought of as a percentage we add the string "%" before displaying this information on the screen.

Let's write all the lines of the SteppingFeet.py program.

```
import math, numpy, random #to have handy system and math functions
from psychopy import core, event, visual, gui #these are the PsychoPy modules

myWin = visual.Window(color = 'white', units = 'pix', size = [1000, 1000], allowGUI = False,
                        fullscr = False) #creates a window
myClock = core.Clock() #this creates and starts a clock which we can later read
```

```
movingFoot1 = visual.Rect(myWin, width = 80, height = 30, fillColor = [-1, -1, -0.2], lineColor = None)
movingFoot2 = visual.Rect(myWin, width = 80, height = 30, fillColor = [0.9, 0.9, 0.2], lineColor = None)
verticalBar = visual.Rect(myWin, width = 20, height = 400, fillColor = 'black', lineColor = None)

myScaleSpeed = visual.RatingScale(myWin, pos = [0, -360], low = 1, high = 10, textSize = 0.5,
                            lineColor = 'black', tickHeight = False, scale = None,
                            showAccept = False, singleClick = True)
informationSpeed = visual.TextStim(myWin, pos = [0, -385], text = '',  height = 18, color = 'black')
myScaleTransparent = visual.RatingScale(myWin,  pos = [0, -255], low = 0, high = 100, textSize = 0.5,
                            lineColor = 'black',  tickHeight = False, scale = None, showAccept = False,
                            singleClick = True)
informationTransparent = visual.TextStim(myWin, pos = [0, -280], text = '', height = 18,  color = 'black')
title = visual.TextStim(myWin, pos = [0, 305], text = 'Stepping Feet Illusion', height = 24, color = 'green')

#draw nBars vertical bars, half black half white
def drawBars(width, nBars):

    left = - width * (nBars - 1) / 2
    for x in range(left, -left, width * 2):
        verticalBar.setPos([x, 0])
        verticalBar.draw()

#move the rectangles
def animateSteps(speed):

    movingFoot1.setPos([speed, 0], operation = "+")
    movingFoot2.setPos([speed, 0], operation = "+")

    movingFoot1.draw()
    movingFoot2.draw()

#the main loop
def mainLoop(width = 20, nBars = 40, speed = 4):

    finished = False
    verticalBar.setWidth(width)
    xMargin = width * nBars / 2 - width
    movingFoot1.setPos([-xMargin, 50])
    movingFoot2.setPos([-xMargin, -50])

    while not finished:

        drawBars(width, nBars)
        animateSteps(speed)
        if movingFoot1.pos[0] > xMargin or movingFoot1.pos[0] < -xMargin:
            speed = -speed
        title.draw()
```

```
⟶ ⟶ myScaleSpeed.draw()
⟶ ⟶ informationSpeed.draw()

⟶ ⟶ myScaleTransparent.draw()
⟶ ⟶ informationTransparent.draw()
⟶ ⟶ myWin.flip()

⟶ ⟶ if myScaleSpeed.noResponse == False: #some new value has been selected with the mouse
⟶ ⟶ ⟶ speed = myScaleSpeed.getRating()
⟶ ⟶ ⟶ informationSpeed.setText(str(speed))
⟶ ⟶ ⟶ myScaleSpeed.reset()

⟶ ⟶ if myScaleTransparent.noResponse == False: #some new value has been selected with the mouse
⟶ ⟶ ⟶ transparent = myScaleTransparent.getRating()
⟶ ⟶ ⟶ verticalBar.setOpacity(1 - transparent / 100.)
⟶ ⟶ ⟶ informationTransparent.setText(str(transparent) + "%")
⟶ ⟶ ⟶ myScaleTransparent.reset()

⟶ ⟶ if event.getKeys(keyList = ['escape']): #pressing ESC quits the program
⟶ ⟶ ⟶ finished = True

⟶ ⟶ waitUntil = myClock.getTime() + 1 / 60. #1 second divided by 60 (most monitors are 60 Hz), which is 0.016
⟶ ⟶ while myClock.getTime() < waitUntil:
⟶ ⟶ ⟶ pass

mainLoop() #enters the main loop
myWin.close() #closes the window
core.quit() #quits
```

Now let's execute the program. Remember the strongest effect is when you do not look directly at the moving rectangle; instead you should try to look in between the two rectangles.

Extra Programming Challenge for Extra Fun

Something easy to try is to change the blue and yellow of the moving rectangles to another pair of colours. Remember the most important parameter is the contrast so as long as you use a very dark colour and a very bright one the effect will be present. You can also make the interface more informative by printing the meaning of the controllers next to them. For one of them you should print a sentence saying that it controls transparency (as a percentage) and for the other that it controls speed (in pixles / frame). For something more challenging you could replace the rectangle with a pigeon (see the Pigeon-Neck illusion for an illustration of how to draw a simple pigeon made of rectangles).

Chapter 14

Lilac Chaser Illusion

As discussed in Chapter 1, afterimages of colour have been known for a long time. When a colour is present at a particular location the system adapts to it and afterwards on a neutral background one sees the complement of that colour. This effect usually takes several seconds. In the dynamic case of the Lilac chaser illusion each location is adapted for most of the time, and the neutral background is only visible for a fraction of a second when the gap is present. In addition the afterimage is seen at neighbouring locations so it is perceived as moving. To achieve good apparent motion we have created an animation that is updated nine times per second.

The *Lilac chaser illusion* was described by Jeremy L. Hinton in 2005 and it was shown by Michael Bach on his website in the same year. Imagine a set of coloured dots forming a circle. A good colour to use is lilac, which is a pinkish-violet colour, but other colours can be used, and in our animation we will use two different colours in two concentric rings.

The dots are placed at twelve fixed positions around the circle. Twelve positions works well but the number is not critical, they just have to make a nice circular ring. One of the twelve dots is always missing but this gap changes from one position to the next over time. This is illustrated in Fig. 14.1. If the gap changes position at the right speed these jumps are perceived as motion.

It is important to fixate in the centre of the image, and pay attention to the circle of dots. After a while where the gap is you will start to see a colour. This will be the complement of the colour of the dot, so from pinkish-violet we get greenish.

As discussed in Chapter 1, we have known for a long time about colour afterimages. In this illusion there is a colour afterimage that is generated briefly at different locations. As a consequence the greenish dot appears to move around the circle.

Figure 14.1. This is the image of lilac disks on a grey background that we will use in our program. Here the gap is shown at the top, but over time this gap will move around the circle

Although the Lilac chaser is relatively new, it relies on a combination of three factors, some of which have been known for some time. Let us mention them as a list.

1) Afterimages of colour. As I have already mentioned there are opponent channels that determine the colour that we perceive. These channels are sensitive to blue/yellow and red/green and their response is affected by adaptation. We have demonstrated colour afterimages in Chapter 1.
2) Troxler fading. At the same time when the greenish dot becomes visible, all the lilac dots fade and become invisible. This may take some time, and is due to the fact that we are maintaining fixation in the centre so the lilac dots are stationary and in the visual periphery. We have described this effect, known as Troxler fading, in Chapter 11 (see Fig. 11.3).
3) Apparent motion. When an object jumps a fairly large distance, if the timing is within a specific range we perceive the displacement as **apparent motion** (Exner 1875; Wertheimer 1912). Apparent motion is interesting in its own right, here we use it to move the colour afterimage around the circle. Apparent motion can also lead us to see motion between objects that are not the same. In that case we may perceive a morphing of the first object into the second (Kolers 1972).

The Lilac chaser illusion demonstrates all three of these effects. However, note that both the afterimage and the fading require some time, so the observer needs to fixate a central spot. We will provide something to look at using a cross, which is a good target for fixation.

The Lilac.py Program

We will set up the program as usual (and you can download it from *www.programmingvisualillusionsforeveryone.online*).

```
import os, math, numpy, random #to have handy system and math functions
from psychopy import core, event, visual, gui #these are the PsychoPy modules

myWin = visual.Window(color = [0, 0, 0], units = 'pix', size = [1000, 1000], allowGUI = False,
                fullscr = False) #creates a window
myClock = core.Clock() #this creates and starts a clock which we can later read

movingLilac = visual.Circle(myWin, radius = 26, fillColor = [0.15, 0, 0.15], lineColor = None)
movingGreen = visual.Circle(myWin, radius = 26, fillColor = [0, 0.12, 0], lineColor = None)
fixation = visual.TextStim(myWin, text = ' + ', height = 18, color = 'black')
```

The window has a grey rather than a white colour. We have used zero as the middle grey level because RGB values vary from −1 to 1. We wrote this explicitly although grey is actually the default background colour for the window, so this was not strictly necessary.

The two moving disks are circles with radius 26 pixels. Here we set the colours by adding some deviations away from zero to the RGB values, but they are small deviations because we want these disks to be faint. The lilac colour is a mix of red and blue ([0.15, 0, 0.15]), and the green colour is just a bit more green than the background ([0, 0.12, 0]).

Message 14.1. "Illusions on-line" by Michael Bach

Every vision scientist sooner or later encounters visual illusions – for me it was sooner, in my first vision textbook where the Craik-O'Brien-Cornsweet illusion was topical. That hooked me. But it took more than a decade until I could marry that to one of my other interests, programming. Finally, on the first Mac® model (a temporary loan), using the Pascal compiler that came with it, I programmed an interactive Müller-Lyer. Another decade would pass until it became possible to implement interactive illusion demos in web pages. I had several up, at *http://michaelbach. de/ot/* when I received an e-mail from Jeremy Hinton, asking "Do you take submissions?". I responded "it depends", only to be blown away by the reply containing his "Lilac chaser". I wrote some explanatory text and put it up. Both of us were somewhat naïve in that respect then, and I was flabbergasted seeing it being copied all over the internet within 3 days without any source attribution … oh well.

Vision scientists are a close-knit group of lovable people. I'm proud of having made friends with great scientists there while adding an interactive spin to perceptual phenomena on my site, creating mini on-line vision experiments. I would hope that they entice some visitors to proceed from the "wow" stage to the joys of scientific understanding (which sure doesn't take the wonder out of it). I've written about the programming background, easily accessible from the "Built with …" buttons.

Michael Bach studied Physics, Computer Science and Psychology. His PhD work dealt with multiunit neuron recordings. Over three decades he ran the electrophysiology clinic and vision research lab at the Eye Center, University of Freiburg, Germany. He was President of the International Society for Clinical Electrophysiology in Vision (ISCEV) and is interested in life and all aspects of vision.

The cross that we will use to be the target of fixation is a black + character. This is simpler to do that drawing two rectangles, although less precise. But a small plus sign is all we need as a fixation cross.

The controller, which we create next, will change slightly the darkness of the background. This is so that the user can optimise the contrast of the image for them and their particular monitor. Probably, for this effect, most people will not need to use the controller.

```
myScale = visual.RatingScale(myWin, pos = [0,-360], low = -20, high = 20, textSize = 0.5, lineColor = 'black',
                tickHeight = False, scale = None, showAccept = False, singleClick = True)
information = visual.TextStim(myWin, pos = [0,-385], text = '', height = 18, color = 'black')
```

Finally we have a title, which is white this time to make it easier to see on a grey background.

```
title = visual.TextStim(myWin, pos = [0, 305], text = 'Lilac Chaser Illusion', height = 24, color = 'white')
```

There is just one function that we need to write. This will draw all the disks. It takes two parameters, the radius of the configuration (the ring of disks) and which one of the twelve disks is missing.

This is a loop over twelve positions, which in degrees go from 0 to 360 in steps of 30. Based on this angle we compute the *x*- and *y*-coordinates of each position. As you remember from previous circular configurations, we get the *x*- and *y*-values using trigonometry. In particular we get the horizontal position using the cosine and the vertical position using the sine. Degrees have to be converted in radians in order to use these functions.

The size of the ring (distance from the centre) is given by the parameter radius. We place lilac disks at this distance (radius) and green disks farther out (at a distance of radius plus 90 pixels). Therefore we will see a ring of lilac disks and a larger ring of green disks.

```
#draw twelve circles but skip one of them (so draw eleven)
def drawDisks(radius, missingOne):

    missingAngle = 30 * missingOne
    for angle in range(0, 360, 30):

        angleR = math.radians(angle)
        x = math.cos(angleR) * radius
        y = math.sin(angleR) * radius
        movingLilac.setPos([x, y])
        x = math.cos(angleR) * (radius + 90)
        y = math.sin(angleR) * (radius + 90)
        movingGreen.setPos([x, y])

        if angle ! = missingAngle:
            movingLilac.draw()
            movingGreen.draw()
```

Within this loop we draw both the lilac and the green disks. The loop would draw twelve of them, but we have an if inside the loop that skips one of them. The position that is not drawn is controlled by the parameter missingOne. This will have values from 0 to 11 to indicate the position. However, the disks are drawn on the basis of the position as an angle in degree, which varies from 0 to 330. We therefore multiply the position by 30 to obtain the missing position in degrees.

The main loop will start with a default value of radius of 160 pixels, and it initialises some starting values for a set of variables. We are familiar with the finished variable, set to False. The missingOne will go from 0 to 11 and when it reaches 12 is reset to 0. This is going to create a gap in the circular configuration.

```
def mainLoop(radius = 160):

    finished = False
    missingOne = 0
    showOnlyIllusion = False
    movingGreen.opacity = 0
```

We will use showOnlyIllusion and movingGreen.opacity as a way to control two other aspects of the display. By pressing the 's' key on the keyboard the user will remove the title and the controller. We provide this possibility because a cleaner screen may help the observer to focus on just the disks.

By pressing the 'a' key on the keyboard the user will add or remove the green disks. This is useful because the basic Lilac chaser illusion has just the lilac disks. I have added the green ones as a second ring following an idea of Sebastiaan Mathôt, which you can see here: *http://www.cogsci.nl/illusions/colour-after-effect*

I recommend that you first get the basic Lilac chaser to work for you, with the moving green disk and the fading of the lilac disks. This will take several seconds of fixation. After that you can switch on the second ring using the 'a' key.

Let us take a look at the controller.

```
if myScale.noResponse == False:
    backColour = myScale.getRating()
    rgb = [backColour / 100., backColour / 100., backColour / 100.]
    myWin.color = rgb
    information.setText(str(backColour))
    myScale.reset()
```

The variable backColour takes values between –20 and 20 because that is how we set up the scale. These are used to create a colour as a RGB list. As these values have to be expressed between –1 and 1 we divide the value by 100, giving values between –0.2 and 0.2. All three RGB values are the same because we want to keep the background colour as grey. The change will therefore only be a change in overall brightness of the grey background.

To switch the green disks on and off we have used the setting of opacity for the movingGreen object. We have seen in the previous chapter that opacity can make objects fade into the background, whatever is the colour of the background. Here we use only the two extreme values, 1 for visible disks, and 0 for invisible disks. Next we can look at the way that the 'a' and 's' keys are used.

```
pressedList = event.getKeys(keyList = ['escape', 'a', 's'])
if len(pressedList) > 0:
    if pressedList[0] == 'escape': #pressing ESC quits the program
        finished = True
    elif pressedList[0] == 'a':
        movingGreen.opacity = abs(movingGreen.opacity - 1)
    elif pressedList[0] == 's':
        showOnlyIllusion = not showOnlyIllusion
    event.clearEvents()
```

Note that we have used a trick to toggle opacity from 0 to 1 and vice versa. We take the value, subtract 1 and then take the absolute value of the result. The absolute value is simply the value without the sign. So starting with 1 we get 1 – 1 and therefore 0, and for 0 we get 0 – 1, which is –1 but thanks to the abs function it becomes 1. If you prefer you can achieve the same result with a pair of if and elif.

For showOnlyIllusion we can use the negation, because this is a variable with a Bollean value that can only be True or False. This will toggle the content of the variable between these two possible values.

You may not like this way of programming, as it is not very explicit. Feel free to replace these lines with a set of if statements that change True to False and False to True if you prefer.

Finally we control the frame rate, as we have done for the other animations.

```
waitUntil = myClock.getTime() + 0.166
while myClock.getTime() < waitUntil:
⟶ pass
```

We are not showing 60 frames per second this time. That would be too fast. We want a timing that leads to perception of apparent motion, and the literature suggests a value around 60 milliseconds is ideal, but certainly below 200 milliseconds (Kolers 1972). Therefore we use a value of 0.166 seconds, which is 166 milliseconds.

This is a nice number because it means 6 frames per second. If our monitor is set to work at 60 frames per second, the best we can do is change the image every 0.0166 seconds, as we have seen when we programmed our first animation (Chapter 12). Therefore if we wait 0.166 seconds instead of 0.0166 seconds we update the screen 6 times per second instead of 60 (10 times as slow).

To elaborate on this choice, if the minimum unit of time that the screen can cope with is 0.0166 then it makes sense to choose delays that are multiples of this minimum. This is why 0.166 (0.0166×10) is better than 170 (which is not a multiple). However, we could have used 0.15 (which is 0.0166×9).

There are twelve positions, so to go around the full circle the gap takes 2 seconds (0.166×12 is 2). When you drive a car you usually have information about revolutions per minute of the pistons (**rpm**). If you like to think in terms of rpm we need to think of how many seconds are in a minute (60) and divide that by 2 seconds. Our gap is making 30 revolutions per minute.

There is one slightly annoying aspect of this program. In all our previous programs the loop repeats very quickly and within the loop mouse and keyboard are monitored. In particular when the ESC button is pressed we turn finished to True. This is still the case here, but we get into a new step of the loop only after 0.166 seconds. You will notice that the program will be less responsive, and there may be slight delay before the program quits.

Let's write all the lines of the Lilac.py program.

```
import os, math, numpy, random #to have handy system and math functions
from psychopy import core, event, visual, gui #these are the PsychoPy modules

myWin = visual.Window(color = [0, 0, 0], units = 'pix', size = [1000, 1000], allowGUI = False,
                      fullscr = False) #creates a window
myClock = core.Clock() #this creates and starts a clock which we can later read

movingLilac = visual.Circle(myWin, radius = 26, fillColor = [0.15, 0, 0.15], lineColor = None)
movingGreen = visual.Circle(myWin, radius = 26, fillColor = [0, 0.12, 0], lineColor = None)
```

```
fixation = visual.TextStim(myWin, text = ' + ', height = 18, color = 'black')

myScale = visual.RatingScale(myWin, pos = [0, -360], low = -20, high = 20, textSize = 0.5, lineColor = 'black',
                             tickHeight = False, scale = None, showAccept = False, singleClick = True)
information = visual.TextStim(myWin, pos = [0, -385], text = '', height = 18, color = 'black')
title = visual.TextStim(myWin, pos = [0, 305], text = 'Lilac Chaser Illusion', height = 24, color = 'white')

#draw twelve circles but skip one of them (so draw eleven)
def drawDisks(radius, missingOne):

    missingAngle = 30 * missingOne
    for angle in range(0, 360, 30):
        angleR = math.radians(angle)
        x = math.cos(angleR) * radius
        y = math.sin(angleR) * radius
        movingLilac.setPos([x, y])
        x = math.cos(angleR) * (radius + 90)
        y = math.sin(angleR) * (radius + 90)
        movingGreen.setPos([x, y])

        if angle != missingAngle:
            movingLilac.draw()
            movingGreen.draw()

#the main loop
def mainLoop(radius = 160):

    finished = False
    missingOne = 0
    showOnlyIllusion = False
    movingGreen.opacity = 0

    while not finished:

        drawDisks(radius, missingOne)
        missingOne = missingOne + 1
        if missingOne == 12:
            missingOne = 0
        fixation.draw()
        if showOnlyIllusion == False:
            title.draw()
            myScale.draw()
            information.draw()
        myWin.flip()

        if myScale.noResponse == False:
            backColour = myScale.getRating()
```

```
→ → → rgb = [backColour / 100., backColour / 100., backColour / 100.]
→ → → myWin.color = rgb
→ → → information.setText(str(backColour))
→ → → myScale.reset()

→ → pressedList = event.getKeys(keyList = ['escape', 'a', 's'])
→ → if len(pressedList) > 0:
→ → → if pressedList[0] == 'escape': #pressing ESC quits the program
→ → → → finished = True
→ → → elif pressedList[0] == 'a':
→ → → → movingGreen.opacity = abs(movingGreen.opacity - 1)
→ → → elif pressedList[0] == 's':
→ → → → showOnlyIllusion = not showOnlyIllusion
→ → → event.clearEvents()

→ → waitUntil = myClock.getTime() + 0.166
→ → while myClock.getTime() < waitUntil:
→ → → pass

mainLoop() #enters the main loop
myWin.close() #closes the window
core.quit() #quits
```

Now let's execute the program. Remember to try and keep your eyes on the cross in the middle until something interesting starts to happen.

Extra Programming Challenge for Extra Fun

A very interesting variation on the basic Lilac chaser illusion is to have more than one gap. Try and show 10 instead of 11 disks on every frame. The two missing disks could be next to each other, or could be at different positions along the ring. A separate aspect that you can explore is apparent motion. We said that 166 milliseconds is a good choice for apparent motion, but you can experiment with shorter or longer delays. If your monitor works at 60 frames per second, then the examples in Table 14.1 would work nicely.

Table 14.1. Let us assume that your monitor can only change the image every 0.0166 seconds (thus 60 times per second). The table shows some options for animations in terms of delays

Interval (s)	Change every how many frames	Changes per second
0.0166	1	60
0.0333	2	30
0.0500	3	20
0.1000	6	10
0.2000	12	5

Chapter 15

Hierarchical Motion Organisation

This is one of my favourite illusions. It may not be the one that jumps out and is immediately obvious, but the implications of this effect are important. Any given motion can be interpreted in different ways based on the frame of reference. We will move a dot on the screen, and depending on the frame of reference it will be seen to move counter-clockwise (relative to the static background) or along a line (relative to its own motion up and down) or clockwise (relative to a bigger system that includes all the dots). In the program we will also learn how to set up some clickable buttons. These will replace the controller and we learn therefore how to do the monitoring of the mouse directly.

We have seen three interesting illusions of motion, the *Breathing square*, the *Stepping feet*, and the *Lilac chaser*. In this chapter we consider a situation where motion is ambiguous, and an object moving along a path can be seen to move very differently (when it groups with other moving objects).

We start by explaining the title of the chapter: *hierarchical motion organisation*. The word organisation refers to the visual system applying a structure, or grouping, to the information in the stimulus. Just like the Kanizsa square is organised into a square and some occluded circles (Chapter 1) even in the case of motion we can have some motions separated from other motions. This idea of **perceptual organisation** is central to Gestalt theory, and grouping by moving together (common fate) was one of the principles of perceptual organisation in the classic work by Wertheimer (1923).

To use an example of a system of motion within a system, consider the Moon. It moves around the Earth and both (together as a system) move around the Sun. This is the meaning of the word hierarchical: there is a system within a system. The hierarchy can have many levels, after all Moon, Earth and Sun rotate also around the centre of our Galaxy. Depending on what we take as the frame of reference it may or it may not be correct to say that the Earth has an elliptical path (it does only if we take the Sun as the reference).

The Swedish psychologist Gunnar Johansson (1911–1998) was a pioneer in the study of motion organisation. He used simple lights and showed how we perceive motion by separating a common motion (maybe all the lights move to the right) and a relative motion (at the same time as moving to the right one of them may also move upwards) (Johansson 1950). A simple point-light display can be seen as a simplified version of what happens in real life, a person walking on a train has a motion common to the train, and an individual motion unique to that person.

Johansson (1973) also had a brilliant idea of placing point-lights on the body of people and filming them in darkness so that only the lights were visible. When the person does not move all one can see is a random configuration of point-lights. However, as soon as the person moves observers recognise the human form and can see exactly what the person is doing. In one demonstration people were walking, climbing steps, doing push-ups or dancing (Mass et al. 1971). These displays are famous for good reasons: the effect is striking, and it is a beautiful demonstration of the power of motion to disambiguate a scene. This type of display is known as **point-light walker** and the area as **biological motion** perception.

Many examples of biological motion can be found online. On the website of the Biomotion lab (Queen's University in Kingston, Ontario) there are interactive demos in which you can alter the characteristics of the walker (for example more male or more female), and take part in studies: *https://www.biomotionlab.ca/html5-bml-walker/*

Much work has followed the pioneering studies by Johansson. For example Cutting and Kozlowski (1977) demonstrated that observers could recognise their friends in point-light walker displays. Cutting and Proffitt (1982) studied wheel motion, and Bertamini and Proffitt (2000) compared displays in which the common motion was a translation, a rotation, or an expansion (or contraction). Observers were asked to see what was the movement of a dot within these different moving frames of reference. Unlike the others, rotation failed to provide a strong frame of reference.

We will program an animation with three dots, related to the displays described by Johansson, but more specifically we will use an example described in a paper by Frank Restle (1979).

Restle described various configurations in his figures. He used dashed lines to show paths of motion and clouds to show that some dots form groups, or systems. If three dots are a single system, they are shown within a cloud and they will appear to move with a motion that is common to all of them. This common motion provides a frame of reference and some dots may have a motion relative to this frame of reference.

Figure 15.1 shows the situation that we will program, and is my redrawing of figure 14 in Restle. Following Restle's approach to illustrate systems with clouds I have

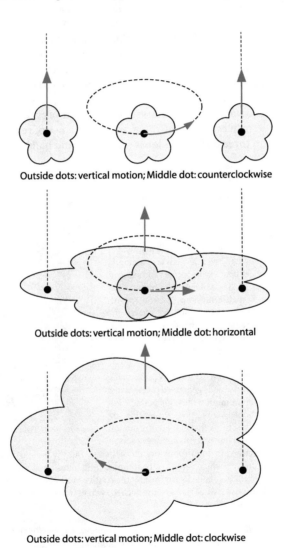

Outside dots: vertical motion; Middle dot: counterclockwise

Outside dots: vertical motion; Middle dot: horizontal

Outside dots: vertical motion; Middle dot: clockwise

Figure 15.1. This is a display described in Restle (1979, figure 14). The motion on the screen is shown by dashed lines and is always the same: two dots move vertically up and down (they are the two on the outside) and one dot moves in an ellipse counter-clockwise. I have highlighted three possible motion organisations using clouds. Our program will show this animation and allow observers to experience these different percepts

highlighted three possible motion organisations. The motion on the screen is always the same: two dots move vertically up and down (they are the two on the outside) and one dot moves along an ellipse counter-clockwise.

In the first motion organisation the frame of reference is the white background, which is static. What we have described as motion of the dots is what one perceives. In the second motion organisation the two outside dots move together up and down. The dot in the middle moves up and down but also left and right. When its elliptical motion is divided into these two components no curved path is perceived. This dot is now moving left and right while at the same time it also moves up and down.

In the third motion organisation the three dots form a single system. The dot in the middle moves within the frame of reference provided by the whole configuration. Because the path of the outside dots is twice as long as the height of the ellipse, the dot in the middle will appear to move in an ellipse but this time the motion is clockwise instead of counter-clockwise.

This is very hard to imagine with a static image, but our program will show exactly this situation and to help establish the three different frames of reference we will use moving rectangles of three different colours (red, green and blue).

Message 15.1. "Hierarchical motion organisation" by Arthur Shapiro

Middle school science teachers can be very influential. When I was 12, my science teacher assigned our class the task of building a science museum. The students divided into groups, chose topics, and, over the course of a month, created exhibits to be viewed mostly by parents and siblings. My group chose to work on "visual illusions". Our museum exhibit consisted of geometric illusions, glowing paints, and blacklights – it was the 1970s – and we offered the best explanation of the visual effects that we could muster.

Nowadays, my laboratory typically starts with an idea about how the visual system will respond when presented with visual stimuli, and then we write computer programs to create images and movies to test our ideas. We refer to the resulting visual illusions as research-generated phenomena.

There are many different motion illusions perhaps because our intuitions about how we perceive motion are relatively poor. Most people think that we perceive motion when an object moves from one place to another – sort of like how motion is described in an introductory physics class. But the brain's triggers for motion perception can be set off by a whole variety of conditions. In the illusion in this section (based on Restle 1979), the perceived motion is determined by the relative motion of the objects in the scene. It is almost as if the brain has a set of tricks to produce the perception of motion and another set of tricks to organise the elements.

Arthur Shapiro received his PhD in Psychology from Columbia University and did postdoctoral research in the Department of Vision Science and Ophthalmology at the University of Chicago. He is on the faculty of American University in Washington, D.C., where he is Professor of Psychology, Chair of the Department of Computer Science, and Co-Director of AU's Collaborative for Applied Perceptual Research and Innovation. His research primarily concerns motion, colour and clinical vision, but he is also interested in all things that can be classified as an illusion.

The HMO.py Program

We will set up the program as usual and you can download it from *www.programmingvisualillusionsforeveryone.online.*

```
import math, numpy, random #to have handy system and math functions
from psychopy import core, event, visual, gui #these are the PsychoPy modules

myWin = visual.Window(color = 'white', units = 'pix', size = [1000, 1000], allowGUI = False,
                       fullscr = False) #creates a window
myClock = core.Clock() #this creates and starts a clock which we can later read

frame1 = visual.Rect(myWin, lineWidth = 3, lineColor = [1, 0, 0], fillColor = None)
frame2 = visual.Rect(myWin, lineWidth = 3, lineColor = [0, 1, 0], fillColor = None)
frame3 = visual.Rect(myWin, lineWidth = 3, lineColor = [0, 0, 1], fillColor = None)
box1 = visual.Rect(myWin, pos = [-200, -300], width = 20, height = 20, lineWidth = 3, lineColor = [1, 0, 0],
                    fillColor = None)
box2 = visual.Rect(myWin, pos = [0, -300], width = 20, height = 20, lineWidth = 3, lineColor = [0, 1, 0],
                    fillColor = None)
box3 = visual.Rect(myWin, pos = [200, -300], width = 20, height = 20, lineWidth = 3, lineColor = [0, 0, 1],
                    fillColor = None)
dot = visual.Circle(myWin, radius = 6, fillColor = 'black', lineColor = None)

title = visual.TextStim(myWin, pos = [0, 305], text = 'Hierarchical Motion Organisation', height = 24, color = 'green')
myMouse = event.Mouse()
```

We have three frames (frame1, frame2 and frame3), which are rectangles of three different colours. If you look at the RGB values you can see that they are red, green and blue respectively. The size of the rectangles is not specified here because it will be set later.

We also have three boxes. They are used to let the user click with the mouse inside these boxes and use them as buttons to turn on the different frames. They are small (20 × 20 pixels) and placed low on the screen (–300 pixels). They match the three colours of the three frames.

The moving dot is a simple black dot with a radius of 6 pixels. And we have a green title placed high on the screen (305 pixels).

The last object is new. It is a mouse and is called myMouse. It is created using event. myMouse() and we will see how to use it to let the user press buttons with the mouse.

The first function that we will write computes coordinates for a motion along an ellipse. These are 240 steps and the *x,y*-coordinates are stored in a list called coordsMiddle. The name refers to the fact that this is the motion of the dot in the middle. We will also have two dots on the outside. We go around the ellipse (360 degrees) in steps of 1.5 degrees, and that is how we get 240 steps.

You are familiar by now with the necessary transformation of the angle from degrees to radians. The use of cosine and sine also should be familiar for the horizontal and vertical positions. We have used similar steps to set positions along a circle, and cosine and sine values were multiplied by the radius of the circle. Here everything is

the same, except that an ellipse has two axes instead of just a radius; the y-value is obtained by multiplying the cosine by one axis (a) and the x-value is obtained by multiplying the sine by the other axis (b).

We are not drawing anything at this stage, only storing the x,y-coordinates in a list. When we finish the list will have 240 elements (x,y-pairs).

The coordsMiddle uses the parameters a and b (as axes of the ellipse). When we compute the coordsOutside we use two new axes called aOutside and bOutside. The first is the double of a, so this movement will go father, but we set the other axis, bOutside, to zero. What will happen to an ellipse when one axis set to zero and therefore it has no width? You can think of this situation as if the ellipse can turn around and we end up looking at it sideways. The dot is (in a sense) still moving along an ellipse but we only see it from the side and therefore we see a linear motion.

This outside motion is therefore a vertical motion, but remember that because this is still an ellipse the dot will appear to slow down at the top and bottom and it will appear to speed up in the middle.

```
#set up coordinates for an ellipse (with axes a and b) and a second ellipse (with axes 2 * a and 0)
def prepareCoordinates(a, b):

    angle = 0.
    coordsMiddle = []
    coordsOutside = []

    while angle < 360:
        angle = angle + 1.5
        angleR = math.radians(angle)
        y = math.cos(angleR) * a
        x = math.sin(angleR) * b
        coordsMiddle.append([x, y])

    aOutside = a * 2.
    bOutside = 0.
    angle = 0.

    while angle < 360:
        angle = angle + 1.5
        angleR = math.radians(angle)
        y = math.cos(angleR) * aOutside
        x = math.sin(angleR) * bOutside
        coordsOutside.append([x, y])

    return coordsMiddle, coordsOutside
```

At the end of the function we return these two lists. They will be used in the animation, which is done inside the next function. But we need to use the prepareCoordinates function only once.

```
#draws the animation of the three dots, and also the frames based on the selection made with the mouse
def drawAnimation(coordsMiddle, coordsOutside, a, b):

    finished = False
    frame1on = False
    frame2on = False
    frame3on = False
```

The first few lines set the starting values that make the three frames not visible. The visibility is controlled by frame1on, frame2on and frame3on, and they are all set to False.

After that we enter a familiar while loop that will continue until finished becomes True. This, as always, will happen when the ESC button is pressed.

```
while not finished:
    buttonWas = 'up'
    for i in range(len(coordsMiddle)):
        if frame1on: #this is the static frame of reference - counter-clockwise motion
            frame1.draw()
        if frame2on: #this is the dots frame of reference - clockwise motion
            frame2.setPos([0, coordsOutside[i][1]])
            frame2.draw()
        if frame3on: #this is the horizontal frame of reference
            frame3.setPos([0, coordsMiddle[i][1]])
            frame3.draw()

        box1.draw()
        box2.draw()
        box3.draw()
        title.draw()

        x1 = coordsMiddle[i][0]
        y1 = coordsMiddle[i][1]
        dot.setPos([x1, y1])
        dot.draw()

        x1 = coordsOutside[i][0]
        y1 = coordsOutside[i][1]
        dot.setPos([x1 + b * 2, y1])
        dot.draw()
        dot.setPos([x1 - b * 2, y1])
        dot.draw()
```

Within the loop there is a second loop, this time over all the coordinates that we have prepared thanks to the prepareCoordinates function. So this second loop moves the dot along the full ellipse (240 steps), and after that it will start again and in the animation there will not be any break between one cycle and the next.

The frames are drawn if the variables that control their visibility are set to True. The three boxes and the title are always drawn. One dot is drawn using the coordinates in coordsMiddle, and two other dots are drawn using the coordinates in coordsOutside. They would appear in the middle of the screen but they are shifted one to the right (by adding b*2) and one to the left (by subtracting b*2). We prefer to use multiple of the basic parameters that set the size of the ellipse because if the change a and b we like our program to behave intelligently and move other elements accordingly.

Let us look at the three frames in terms of their coordinates. For the first frame the position does not depend on anything: this will be a static frame of reference. For the second frame the vertical position is taken from coordsOutside: this frame will move vertically together with the outside dots. For the third frame the vertical position is taken from coordsMiddle: this frame will move vertically together with the dot in the middle.

We come now to the part of the program that monitors the mouse. As we are not using a controller object we have to do a bit more work. First we store the information about which mouse buttons are pressed. This is a list and we call it buttons.

```
buttons = myMouse.getPressed()
```

We are only interested in the left button, which is the first in the list, and therefore we check if buttons[0] is True. However, when we press a mouse button it stays down for more than just a few milliseconds, so within the loop this is likely to be true more than once. This is a problem because we don't want to treat the second time we see that the left button is down as a second mouse click. To solve this problem we keep track of the position of the button in a variable called buttonWas.

When the left button has been pressed (buttons[0] is True) and buttonWas is 'up', then we have detected a mouse click and we continue to process it. After we have done what, it is necessary that we switch buttonWas to 'down' and next time we arrive here in the loop we do not process a new mouse click because we know that the button is already down. However, next time that buttons[0] is not True we reset buttonWas to 'up' and we are ready to process a new mouse click.

```
if buttons[0]:
    if buttonWas == 'up':
        if box1.contains(myMouse):
            if frame1on:
                box1.setFillColor(None)
                frame1on = False
            else:
                box1.setFillColor('black')
                frame1on = True
        elif box2.contains(myMouse):
            if frame2on:
                box2.setFillColor(None)
                frame2on = False
```

```
→ → → else:
→ → → → box2.setFillColor('black')
→ → → → frame2on = True
→ → elif box3.contains(myMouse):
→ → → if frame3on:
→ → → → box3.setFillColor(None)
→ → → → frame3on = False
→ → → else:
→ → → → box3.setFillColor('black')
→ → → → frame3on = True
→ buttonWas = 'down'
else:
→ buttonWas = 'up'
myWin.flip()
```

Note that dealing with the mouse requires a slightly different approach than dealing with the keyboard. This is because once pressed the mouse will signal the new state (which button has been pressed) for an extended period of time. We have used the mouse in most of our programs, from the very beginning. You may wonder why we discuss these aspects only now. The reason is that before the mouse clicks were dealt with entirely within the class visual.RatingScale(). We had taken advantage of the properties of the controller without having to study the content of the class. This is an advantage of object-oriented programming, or more generally of using powerful functions that have been set up by other programmers. The only downside is that some things are hidden from us. But remember that you have the option to go and study the commands inside any PsychoPy class.

By the way, while writing this particular part of the program I got stuck and I had to ask for a bit of help from Jon Pierce. If you are learning to program it is important to stress that asking for help from other programmers is absolutely fine. There is a stereotype out there of programmers as antisocial and solitary individuals, people who work at night and only eat cold pizza. I have met some programmers that do work at night and sleep during the day, but the idea that all programmers are solitary and shun society is wrong. Quite the opposite, programming can be a very social activity, with plenty of sharing of ideas, people willing to help each other and even social gatherings. It can also be a hobby that you can practice together with friends.

In the specific case of PsychoPy there is a very active forum, with over a thousand users (*https://discourse.psychopy.org*). This is a place in which people can ask questions, offer and receive help and support. There are also platforms for more general programming questions (for example *https://stackoverflow.com*). Here people can ask and answer questions, then edit the answers and even vote questions and answers up or down.

Let us return to our program. We still need to look at how we use the mouse clicks. With respect to the location of the mouse we have a convenient function that can be used with objects in PsychoPy. We use box1.contains(myMouse). This a beautifully elegant way of asking whether the coordinates of the cursor are within the shape.

When we have an object like a rectangle, a circle and so on, the .contains() function checks if a given location is inside that shape. The obvious way to use this function is with a pair of *x,y*-coordinates. The results will be either True or False. For example we can write:

```
box1.contains([20, 25])
```

We could check the location of the cursor and then see if it is inside the box.

```
cursorPosition = myMouse.getPos()
box1.contains(cursorPosition)
```

However the .contains() function, in addition to a *x,y*-pair, can accept an object. The important point is that this has to be an object with a .getPos() function that returns *x,y*-coordinates, such as the mouse object. These following two lines have the same effect, and we will use the second.

```
box1.contains(myMouse.getPos())
box1.contains(myMouse)
```

In summary, we use the .contains() function to check whether the user has clicked inside each of the three boxes. Each box is associated with a frame, so when it is selected it toggles that frame from invisible to visible or vice versa. Whether each frame is visible is specified by frame1on, frame2on and frame3on.

When the user clicks inside box1, in addition to changing the value of frame1on the mouse click also fills box1 with black colour (and the same for each of the three boxes). This is a way to provide feedback to the user. The black inside the boxes is a signal that the switch is on or off.

Figure 15.2 shows the program running without any of the frames visible.

Let's write all the lines of the HMO.py program.

```
import math, numpy, random #to have handy system and math functions
from psychopy import core, event, visual, gui #these are the PsychoPy modules

myWin = visual.Window(color = 'white', units = 'pix', size = [1000, 1000], allowGUI = False,
                      fullscr = False) #creates a window
myClock = core.Clock() #this creates and starts a clock which we can later read

frame1 = visual.Rect(myWin, lineWidth = 3, lineColor = [1, 0, 0], fillColor = None)
frame2 = visual.Rect(myWin, lineWidth = 3, lineColor = [0, 1, 0], fillColor = None)
frame3 = visual.Rect(myWin, lineWidth = 3, lineColor = [0, 0, 1], fillColor = None)
box1 = visual.Rect(myWin, pos = [-200, -300], width = 20, height = 20, lineWidth = 3,
                   lineColor = [1, 0, 0], fillColor = None)
box2 = visual.Rect(myWin, pos = [0, -300], width = 20, height = 20, lineWidth = 3,
                   lineColor = [0, 1, 0], fillColor = None)
box3 = visual.Rect(myWin, pos = [200, -300], width = 20, height = 20, lineWidth = 3,
                   lineColor = [0, 0, 1], fillColor = None)
```

Hierarchical motion organisation

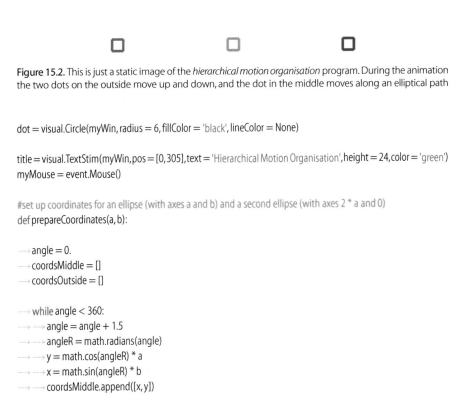

Figure 15.2. This is just a static image of the *hierarchical motion organisation* program. During the animation the two dots on the outside move up and down, and the dot in the middle moves along an elliptical path

```
dot = visual.Circle(myWin, radius = 6, fillColor = 'black', lineColor = None)

title = visual.TextStim(myWin, pos = [0, 305], text = 'Hierarchical Motion Organisation', height = 24, color = 'green')
myMouse = event.Mouse()

#set up coordinates for an ellipse (with axes a and b) and a second ellipse (with axes 2 * a and 0)
def prepareCoordinates(a, b):

    angle = 0.
    coordsMiddle = []
    coordsOutside = []

    while angle < 360:
        angle = angle + 1.5
        angleR = math.radians(angle)
        y = math.cos(angleR) * a
        x = math.sin(angleR) * b
        coordsMiddle.append([x, y])
```

```python
        aOutside = a * 2.
        bOutside = 0.
        angle = 0.

        while angle < 360:
            angle = angle + 1.5
            angleR = math.radians(angle)
            y = math.cos(angleR) * aOutside
            x = math.sin(angleR) * bOutside
            coordsOutside.append([x, y])

        return coordsMiddle, coordsOutside

#draws the animation of the three dots, and also the frames based on the selection made with the mouse
def drawAnimation(coordsMiddle, coordsOutside, a, b):

    finished = False
    frame1on = False
    frame2on = False
    frame3on = False

    while not finished:
        buttonWas = 'up'
        for i in range(len(coordsMiddle)):
            if frame1on: #this is the static frame of reference - counter-clockwise motion
                frame1.draw()
            if frame2on: #this is the outside dots frame of reference - clockwise motion
                frame2.setPos([0, coordsOutside[i][1]])
                frame2.draw()
            if frame3on: #this is the middle dot frame of reference - horizontal motion
                frame3.setPos([0, coordsMiddle[i][1]])
                frame3.draw()

            box1.draw()
            box2.draw()
            box3.draw()
            title.draw()

            x1 = coordsMiddle[i][0]
            y1 = coordsMiddle[i][1]
            dot.setPos([x1, y1])
            dot.draw()

            x1 = coordsOutside[i][0]
            y1 = coordsOutside[i][1]
            dot.setPos([x1 + b * 2, y1])
            dot.draw()
```

```
            dot.setPos([x1 - b * 2, y1])
            dot.draw()

            buttons = myMouse.getPressed()
            if buttons[0]:
                if buttonWas == 'up':
                    if box1.contains(myMouse):
                        if frame1on:
                            box1.setFillColor(None)
                            frame1on = False
                        else:
                            box1.setFillColor('black')
                            frame1on = True
                    elif box2.contains(myMouse):
                        if frame2on:
                            box2.setFillColor(None)
                            frame2on = False
                        else:
                            box2.setFillColor('black')
                            frame2on = True
                    elif box3.contains(myMouse):
                        if frame3on:
                            box3.setFillColor(None)
                            frame3on = False
                        else:
                            box3.setFillColor('black')
                            frame3on = True
                    buttonWas = 'down'
            else:
                buttonWas = 'up'
            myWin.flip()

            if event.getKeys(keyList = ['escape']): #pressing ESC quits the program
                finished = True
                break

            waitUntil = myClock.getTime() + 1 / 60.
#line above: one second divided by 60 (most monitors are 60 Hz), which is 0.016
            while myClock.getTime() < waitUntil:
                pass

#the main loop
def mainLoop():

    a = 60.
    b = 120.
    frame1.setWidth(b * 2 + a)
```

```
⟶ frame1.setHeight(b * 2 + a)
⟶ frame2.setWidth(b * 4)
⟶ frame2.setHeight(b * 2)
⟶ frame3.setWidth(b * 2)
⟶ frame3.setHeight(b * 2)

⟶ coordsMiddle, coordsOutside = prepareCoordinates(a, b)
⟶ drawAnimation(coordsMiddle, coordsOutside, a, b)

mainLoop() #enters the main loop
myWin.close() #closes the window
core.quit() #quits
```

Now let's execute the program. Use the buttons to control the visibility of the frames.

Extra Programming Challenge for Extra Fun

In this program the user sees an animation with three dots. Below them there are three small boxes (red, green and blue). We check whether the left mouse button has been pressed. If it has (and the button was not already down) we toggle on or off one of three frames of reference (red, green and blue). To create this set of clickable buttons we had to use a type of object that we had not used before, from the class event.Mouse(). To explore more features of this new object you can try and use myMouse.setPos(). This will allow you for example to make the cursor follow the dot in the middle. Note, however, that if you set the mouse position within the loop to be always on the dot you will not be able to use the mouse to click on the boxes. Therefore you need to think of how to make the mouse follow the dot, and also how to make the mouse stop following the dot.

A different development that you may want to try has to do with the management of the mouse clicks. As you see we monitor the mouse and then apply a set of commands using if and elif. These commands are similar for each of the three boxes. I am referring to anything that follows the line:

```
buttons = myMouse.getPressed()
```

Therefore the management of the mouse clicks could be done in a specific function. This could be called once for every iteration of the loop, or every time a mouse event has been detected. As there is more than one way to do this I have provided one example in a program called HMOfunction.py and you can download it from *www.programmingvisualillusionsforeveryone.online.*

Chapter 16

And More: Files, Irregular Polygons and Images

This final chap- ter does not introduce any new illusion. Instead it shows some additional features of Python and of PsychoPy. In particular we will see how to open a text file, write something and then close it again. We will see how to create complex polygons using a list of vertices. We will see how to create a dialogue box that collects some information from the user, and how to use images from files, including how to save an image that we have created to a file.

Some illusions are very strong, as in the case of the colour afterimage in Chapter 1. Others are subtle and you or a friend may have found the Ponzo illusion underwhelming perhaps. As we have seen in Chapter 1 there are different types of illusion, and there are many ways to draw the images. Now we have reached the last chapter of the book, I hope you appreciate how useful it is to be able to program a computer to display images. Thanks to this new skill you can explore the parameters that make an illusion strong for you, and for other people, because you can program different illusions and set parameters such as size, colour, position and more.

In Chapter 1 I also claimed that everybody sees illusions the same way, more or less. If you want to know more about this general question of how different people respond to illusions, there is a lot of relevant work you can study. Various factors can affect how illusions are experienced, although these are mainly subtle modulations. For the record I include here a list of factors (in alphabetical order) with some key references.

- **Age.** We have mentioned the work by Piaget in the chapter on the Delbœuf illusion (Piaget et al. 1942). There is also more recent work (for instance, Doherty et al. 2010).
- **Anatomy and physiology.** Strength for illusions of size (Ponzo and Ebbinghaus) correlates with the size of the primary visual cortex (Schwarzkopf et al. 2011). Other physiological differences between individuals may be relevant as well (Peterzell 2016). An obvious example may be colour blindness.
- **Autism spectrum.** There are many studies about this, in particular the hypothesis that individuals with autism spectrum disorder have weak global processing and therefore see local elements more accurately (a famous study is by Happé 1996; recent reviews are in Simmons et al. 2009, and Gori et al. 2016).
- **Culture.** Several important studies have looked at the role of culture. The famous Russian psychologist Luria studied people in non-urban Uzbekistan and found that they were less prone to illusions such as the Müller-Lyer illusion (Luria 1979). The Himba in Namibia (nomadic people who have limited access to modern technology and no formal education) experience weaker illusions, because they focus more on local information (de Fockert et al. 2007). In a comparison between Asians and Westerners, Asians show greater sensitivity to context in size illusions (Doherty et al. 2008). This also has been interpreted as a focus on global rather than local information.
- **Developmental dyslexia.** Slaghuis et al. (1996) used an apparent motion display known as the *Ternus stimulus*, and found a reduction of group motion (elements do not appear to move as a whole). This has been followed by many studies focusing especially on motion perception.
- **Migraine.** Individuals with migraine experience strong tilt and motion aftereffects (Shepherd 2001).
- **Schizophrenia and schizotypy.** There seems to be decreased susceptibility to visual illusions in schizophrenia (for a recent review see Notredame et al. 2014). But individuals high in positive schizotypy have an increased response bias toward seeing something that is not there (Partos et al. 2016).
- **Sex.** Some subtle differences exist (Rasmjou et al. 1999; Roalf et al. 2006) that relate to males having a stronger hemispheric lateralisation (McGlone 1980).

A different question is whether any given person will experience all illusions strongly and another person may be almost immune to illusions. This seems like a reasonable hypothesis. Recently Grzeczkowski et al. (2017) investigated the existence of common factors for visual illusions in a sample of over one hundred people. They tested how strongly six illusions correlate with each other, which they should do if a person susceptible to one illusion is susceptible to other illusions as well. They did not find any correlations except for an association between the Ebbinghaus and Ponzo illusions. In a second experiment, they investigated mental imagery and again found a link only between mental imagery and the strength of the Ponzo illusion. Overall they concluded that each individual is unique as far as visual perception is concerned.

Clearly visual illusions can be a tool to study many aspects of perception.

A Bit More PsychoPy

In this chapter I will mention a few additional aspects of Python® and in particular of PsychoPy. What we have seen in the 12 programs that we have developed is that Python is a powerful and easy to read language. We have used Python together with PsychoPy to create visual illusions in which we have manipulated size, orientation, colour, brightness, opacity (transparency), and more. We have also seen how to create smooth motion animations.

Thanks to PsychoPy we have created objects to manipulate simple geometrical shapes, like squares and circles, but also other types of objects, such as a clock, a mouse, and a rating scale.

Box 16.1. List taken from the PsychoPy API showing all modules that are part of PsychoPy

- psychopy.core basic core functions (for example a clock)
- psychopy.visual visual stimuli including the window
- psychopy.data functions for storing/saving/analysing data
- psychopy.event functions to process keypresses and mouse clicks
- psychopy.filters helper functions for creating filters
- psychopy.gui functions that create dialogue boxes
- psychopy.hardware specific hardware interfaces
- psychopy.info functions for getting information about the computer
- psychopy.iohub ioHub event monitoring framework
- psychopy.logging controls what gets logged
- psychopy.microphone functions to capture and analyse sound
- psychopy.misc miscellaneous routines for converting units etc.
- psychopy.monitors controls features of the monitor (alternative to Monitor Center)
- psychopy.parallel functions for interacting with the parallel port
- psychopy.preferences getting and setting preferences
- psychopy.serial functions for interacting with the serial port
- psychopy.sound plays various forms of sound
- psychopy.tools miscellaneous tools
- psychopy.voicekey real-time sound processing
- psychopy.web functions to deal with the web

The names of the modules that we have used is at the beginning of each program:

```
import math, numpy, random #to have handy system and math functions
from psychopy import core, event, visual, gui #these are the PsychoPy modules
```

There are many other modules that you could use. Box 16.1 has the full list of the PsychoPy modules. There are also many other modules not related to PsychoPy. For example if you need to work with files and directories you can use a module called os (for operating system).

```
import os
```

Suppose you want to save some data in a folder called data. You could start by checking whether the folder exists, and if it does not exist already you can create it.

```
if not os.path.isdir('data'):
  ⟶ os.makedirs('data')
```

Here we have used two functions, both of them from the os module. The first is called os.path.isdir and it checks that a directory exists. The second is called os.makedirs and it creates a directory with a name provided as the argument.

Now that we know how to create a directory you may want to open a file in it. The standard way to open a file is by using open() which returns an object. In the following example we called this newly created object myFile.

```
myFile = open('data/file.txt', 'w')
```

The first parameter is a filename that can include also a path. The second parameter is a single character. The possible values for this parameter are 'w' (for writing in the file) 'r' (for reading) 'a' (for appending new data to data that is already in the file).

Once this object exists and is open for writing ('w' or 'a') we can write something in the file. Remember to write strings or to convert anything else (like numbers) to strings to write them in the file. We have seen in Chapter 2 how to convert numbers to strings.

```
myFile.write('The content to be stored')
myFile.write(str(2017))
```

Note that some conventions on how to specify a path may differ on different operating systems (Mac®, Windows®, Unix®). I work on a Mac® and if the data directory is in the home directory then we can write the name of the file as follows: /Users/myusername/data/file.txt. On Windows® the path might be: C:\Users\myusername\data\file.txt. Also there may be slight differences in how to write an end of line in a text file.

There is a lot more that can be done with files. Here I will stop and just mention that at the end after working with a file you need to finish with a function that closes what you have opened.

```
myFile.close()
```

There are also ways in which PsychoPy offers solutions to read and write data that do not require you to do the work of opening and closing files. I will not describe them here because they are specific to collecting data from experiments and storing these data in a format that is useful for analysis. I am referring in particular to the module data within PsychoPy. If you are interested in using PsychoPy to create experiments, then I suggest you follow some of the suggested links in Chapters 2 and 3 for tutorials on the use of PsychoPy in research.

With respect to capturing the image from the screen and saving that to a file, we will see later in this chapter how to use PsychoPy to deal with images.

Irregular Polygons

We have drawn lines, circles, rectangles and regular polygons using specific classes from the visual module (Line, Circle, Rect, Polygon). They are all part of a family in the sense that they are special cases of a more general class called visual.ShapeStim().

The circles for example are made with many sides so that they look smooth. By default the number of sides is 32. But this can be changed with the edges parameter. If you were to go back to a program that draws a circle and change the parameter edges you would see a different shape. Here is an example of a change to the way we have created the circle in the Lilac.py program, starting with the command as it is in the program.

```
movingLilac = visual.Circle(myWin, radius = 26, fillColor = [0.15, 0, 0.15], lineColor = None)
```

This is a circle because the default number of edges is 32. If we change it to 4 we obtain squares and you can run this modified version to see the result.

```
movingLilac = visual.Circle(myWin, radius = 26, fillColor = [0.15, 0, 0.15], lineColor = None, edges = 4)
```

Using the ShapeStim class we can also create more complex shapes like for instance irregular polygons. The vertices of the polygon need to be stored in a list. Here is an example of a loop that creates a list of *x,y*-pairs. These are 36 locations around a circle with radius of 150 pixels.

```
radius = 150
vertices = []
for a in range(0, 360, 10):
    x = radius * math.cos(math.radians(a))
    y = radius * math.sin(math.radians(a))
    vertices.append([x, y])
```

If we were to use these locations we would draw a regular polygon with 36 sides, which is pretty similar to a circle. A more interesting shape is one in which the radius is not fixed, and for every step it can take a value between 100 and 200. This creates a very irregular shape.

Here is the code with the change in radius, and structured as a function.

```
def selectVertices():
    radius = 150
    vertices = []
    for a in range(0, 360, 10):
        newradius = radius + random.randint(-50, 50)
        x = newradius * math.cos(math.radians(a))
        y = newradius * math.sin(math.radians(a))
        vertices.append([x, y])
    return vertices
```

We have stored these 36 vertices is a list called vertices. Next we can use these locations for a shape.

```
myShape = visual.ShapeStim(myWin, lineColor = 'black', fillColor = 'red')
vertices = selectVertices()
myShape.setVertices(vertices)
myShape.draw()
```

You can see the resulting drawing in Fig. 16.1. These are nine examples that come from a loop. Although the commands inside the loop are exactly the same at every iteration, we have used random.randint to pick different random numbers, and therefore we get different vertices and nine different shapes.

```
myShape = visual.ShapeStim(myWin, lineColor = 'black', fillColor = 'red')

for index in range(9):

    vertices = selectVertices()
    myShape.setVertices(vertices)
    myShape.draw()

    myWin.flip()
    core.wait(1) #a delay of 1 second so we can see the shape
```

The filled colour is red and in Fig. 16.1 we see that it stays always nicely inside the contour. Unfortunately you cannot be certain that the colour will work as expected for complex shapes. This is a limitation of the graphical interface we are using (called OpenGL, see Box 4.1). It can only guarantee to fill shapes that are convex.

Our shapes are not convex, and everything is working fine, the problem is that it is not something we can rely on. For an even more complex shape the solution is to draw it not as a single shape, but as a combination of smaller filled regions so that each of these is convex.

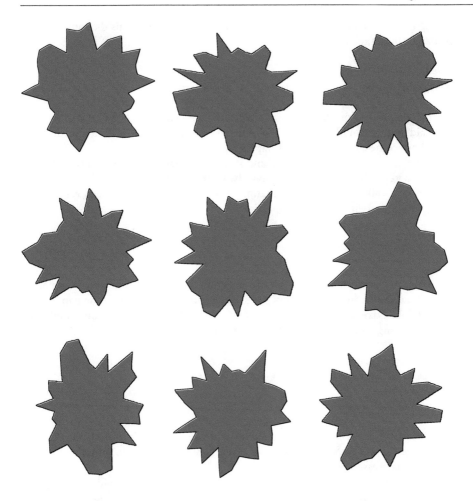

Figure 16.1. Nine examples of *irregular polygons* with 36 vertices created using visual.ShapeStim(). Selecting locations along the circumference of a circle creates the shape. However, the radius of the circle is chosen for every location as a random value between 100 and 200 pixels, making this a complex and irregular polygon

Dialogue Boxes

A PsychoPy module that we have included in our programs but not used is called gui (for graphical user interface) and it allows the use of dialogue boxes.

```
from psychopy import gui
```

A dialogue is a very useful way to collect responses from a user. For example we may want to collect some information before starting our program. We can do this by

setting up a dictionary to store the information and then pass this dictionary to the gui.DlgFromDict() function.

```
info = {'name':'Sheba', 'age':4}
dlg = gui.DlgFromDict(dictionary = info, title = 'Please answer the questions')
```

I had mentioned the dictionary as a type of variable in Chapter 2 (Table 2.1). I had also said that we would not use it. Well, OK, so we have not used it until now. But you and I have come a long way since Chapter 2.

A dictionary uses curly brackets, and it has information stored always as pairs: a key and a value. In our example we have two keys: name and age. Think of the key as the way you will retrieve the information. The following is how we can retrieve the string 'Sheba' and the number 4 respectively.

```
info['name']
info['age']
```

In Fig. 16.2 you can see the result of a program that uses the following commands. As you can see the title is the title of the dialogue box. The fields have the name of the keys and the boxes have in them the string 'Sheba' and the number 4. Importantly the user can change these values when we run the program.

```
info = {'name':'Sheba', 'age':4}
dlg = gui.DlgFromDict(dictionary = info, title = 'Please answer the questions')
if dlg.OK == False:
   → core.quit() #user pressed cancel
```

The last two lines check that the user has pressed the 'ok' button. If they did the dlg.OK variable will have the value True. If this is not the case then it must mean that the user has pressed the 'cancel' button.

We do not need default values and the following commands would have provided a similar results but with empty boxes.

Figure 16.2. A dialogue box created using PsychoPy. The user can type information in the boxes and these values are stored in a dictionary. The user can click on the 'ok' button to continue, or on 'cancel' to quit

```
info = {'name':'', 'age':''}
dlg = gui.DlgFromDict(dictionary = info, title = 'Please answer the questions')
if dlg.OK == False:
⎯→ core.quit() #user pressed cancel
```

I have added these lines to our first program, and called the new version KanizsaDialog.py. You can download it from *www.programmingvisualillusionsforeveryone.online*. The dialogue collects name and age from the user and then saves these values into two new variables, called name and age. However, nothing is then done with these. They are there if you want to use them.

```
name = info['name']
age = info['age']
```

Images

We have learned a lot about drawing shapes, but we may also like to be able to display an image saved to a file. We can create a new object from the class visual.ImageStim() to open a file.

```
myFace = visual.ImageStim(myWin, image = 'marco.png')
```

In this case I have used an image saved in the .png format. This file is available on *www.programmingvisualillusionsforeveryone.online*. Its size is 68 × 80 pixels. However, you can use the parameter size in ImageStim to rescale the image. You can also use a large range of formats, for example I could have used a marco.jpg file (a jpeg file).

Once the object has been created you can apply to it many of the commands that we are already familiar with to change its position, size, orientation and opacity.

As an example let's go back to the hierarchical motion organisation program of Chapter 15. The moving dot was created using this object:

```
dot = visual.Circle(myWin, radius = 6, fillColor = 'black', lineColor = None)
```

If we keep the same name (dot) but replace the circle with an image we can leave the rest of the program exactly the same and what will be moving on the screen will be the new image.

```
dot = visual.ImageStim(myWin, image = 'marco.png')
```

The result is shown in Fig. 16.3. The animation is now using a face instead of a circle. This version is available online and is called HMOface.py. The image marco.png needs to be present in the same directory.

Sometimes when we have done a lot of work in creating a nice image on the screen we would like to save that image as a .png or .jpg file. To do so we can use a combination

Hierarchical motion organisation

Figure 16.3. The *hierarchical motion organisation* program (HMO.py) will work with any object that can be drawn using the .draw() command. In this case we are using an image uploaded from a file

of functions in PsychoPy that belong to the class window. The first thing to do is flip the buffer so we see the image, followed by .getMovieFrame().

```
myWin.flip()
myWin.getMovieFrame()
```

Here I am showing two lines in which just after a call to .flip() there is a call to .getMovieFrame(). I am using the name myWin for the window because this is the name we have used in our programs. If you call the window with a different name you need to use that name.

The word *Movie* in .getMovieFrame() does not mean that this will be a movie. It can be but this function can also capture a single frame and therefore an image of what is on the screen. It makes sense to get the frame immediately after a .flip() because we will capture exactly what we have just shown on the front buffer of the screen. However, there is a parameter called buffer that can be used to capture the back buffer.

```
getMovieFrame(buffer = 'back')
myWin.flip()
```

Box 16.2. File formats

You can save images in any of these raster formats, and they have different characteristics. This is not the full list.

- .bmp Bitmap image file (large non-compressed file)
- .eps Encapsulated Postscript
- .gif Graphics Interchange Format
- .jpeg, .jpg Joint Photographic Experts Group (can compress to very small size, but with some loss of information)
- .pdf Portable Document Format
- .png Portable Network Graphics
- .tiff Tagged Image File Format

The image is now stored. To save it to a file we need another function.

myWin.saveMovieFrames('myScreen.png')

In this example I am saving the image to a file with extension .png. This is a standard format but many other formats can be used. The more important are listed in Box 16.2. PsychoPy understands what format you want to use from the extension. The size of the image is determined by the size of the window. That is, the size that was specified when myWin was created.

You can use .saveMovieFrames() just after .getMovieFrame() but you can also save a number of images and use the command to save them only once at the end. This is very convenient if you are generating many images, and also if you want to save the frames of an animation.

How exactly the multiple images will be saved depends on which format you have chosen. For an image type like .png multiple static frames are saved. They will have a number added to the name, for example myScreen01.png, myScreen02.png and so on.

If the type is .gif then an animated gif image is created (because this format allows to save an animation in a single file). On OS X .mov files can be created for movies, but this does require that additional optional software be installed. Consult the *www.psychopy.org* website for more detailed information if you are interested in creating movies. In general, it is always possible and usually preferable to save a number of images, one for each frame, and then combine them later into an animation.

New Illusions

Imagine reading a book, or walking down the street towards a restaurant, or crossing a river on a horse and noticing something strange. These are the situations in which the Hermann grid (see Fig. 1.3), the Café wall illusion (see Chapter 8), and the motion aftereffect (see Chapter 1) were observed. You never know, it is still possible, even after centuries of work on visual illusions, to discover new effects or new versions of old illusions. Knowing how to program illusions on a computer is a wonderful tool to explore and create images that may turn out to illustrate new visual effects.

Since 2005 there is a Best Illusion of the Year Contest in which everybody can enter an illusion (*http://illusionoftheyear.com*). It is run by the Neural Correlate Society, a non-profit organisation chaired by Susana Martinez-Conde (Message 16.1). A panel of judges rate all submissions and narrow them down to the Top 10. Then, online voters rate them and there are even cash prizes. Feel free to consider entering the context in the future.

Message 16.1. "Illusions, Science and Art" by Susana Martinez-Conde

My interest in illusions predates my work in vision research by quite a few years. I remember being fascinated, growing up in Spain, with Calderón de la Barca's play "La Vida es Sueño" (Life is a Dream) and Prince Segismundo's powerlessness to tell apart dream from reality. I was even more captivated, as a teen, when I learned about Plato's cave, and about Descartes' postulate that our whole experience of reality may be the work of an *evil demon* intent on deceiving us. (I don't think I ever took the evil demon notion much too seriously, but the difficulty of telling apart perception from reality stuck with me). It was perhaps due to these early influences that I later set out to pursue a neuroscience career, and that I chose to focus my work on the visual system – perhaps the sensory system where the potential discrepancy between the physical world and our perception of it is most extreme. My research into the neural bases of illusion started in earnest during my time as postdoc in the laboratory of the late Nobel Laureate David Hubel. For one of my projects I studied a series of illusions by Victor Vasarely, the founder of Op Art (short for *optic art*) movement. In studying Vasarely's art, I discovered some novel perceptual phenomena, and I was hooked. After leaving the Hubel lab, I directed laboratories at University College London (UK), the Barrow Neurological Institute in Phoenix, Arizona, and most recently at the State University of New York, where I am currently Professor in Ophthalmology. My research has never strayed too far from illusory perception, and I have often turned to illusions that painters and other artists noticed or developed before scientists did. For the last ten years, I have also studied the cognitive illusions developed by magicians – also known as magic tricks. During this time, I have also come to realise that illusions not only bring art and science together, but also serve as a stimulating bridge between researchers and the public. Many non-experts are intrigued and delighted by illusions, just as I myself was as a teenager, without a formal training in perception or neuroscience. In fact, illusions are one of the most wonderful and powerful ways to communicate exciting scientific discoveries about perception to society. Thinking along these lines led me to create, in 2005, the Best Illusion of the Year Contest: an annual event (in its 13th edition at this writing) that brings together scientists, artists and the public, to recognise and celebrate the year's best illusions. [photo by Marcos Lainez, Courtesy of SUNY Downstate]

Susana Martinez-Conde's research bridges perceptual, oculomotor, and cognitive neuroscience. Her work with Parkinsonian patients was honoured with the EyeTrack Award, a global science prize given annually to a single cutting-edge publication in eye movement research. She has also received the 100 Spaniards Prize, and the Empire Innovator Award from the State of New York. Martinez-Conde complements her award-winning research with extensive science communication, education, and public outreach. She is the 2014 recipient of the Science Educator Award, given by the Society for Neuroscience to an outstanding neuroscientist who has made significant contributions to educating the public.

The final words for me to say are that I hope this brief introduction to programming and to illusions have started something for you. If you enjoyed the programming, then this is a skill (and a hobby) that can provide you with great rewards. If you enjoyed the illusions, then there are more effects to explore and a lot of research still to carry out. Throughout the book I have provided links to resources online and to books and articles. My guess, and my hope, is that you enjoyed both!

Visual Perception Glossary

Amodal perception
The part of an object that is not visible because occluded can be amodally perceived. Amodal perception is different and one step removed from modal perception of real or illusory contours.

Apparent motion
When an object is presented at two different locations after a brief time interval observers perceive motion. The first empirical investigation was carried out by Sigmund Exner. His aim, as well as the subsequent work by Max Wertheimer, was in establishing that motion was a basic sensation.

Attention
Refers to the selective processing of some aspect of information, while ignoring other information. The sudden onset of a stimulus can capture attention, but people can also exert some control on where they direct their attention.

Bi-stable stimulus
A particular stimulus that can produce two percepts over time, even though it is unchanged as a stimulus. An example is the Necker cube.

Brightness
Brightness refers to perception of how much light is coming from a given surface or object. A brighter objects reflects more light than a less bright object. However perception of brightness is not fully determined by luminance (see *Illusory contours*).

Cerebral lobe

The cerebral cortex of the human brain is divided into four main lobes. *Frontal* (at the front), *occipital* (at the back), *temporal* (on the sides) and *parietal* (at the top).

Consciousness

Sorry this is too hard, your guess is as good as mine.

Cortex

The cortex is the outer layer of the brain. In most mammals the cortex is folded and this allows the surface to have a greater area given in the confined space available inside the skull.

Figure-ground organisation

Perceptual organisation separates regions of an image into figures, which belong to the foreground, and ground, which is shapeless. Figures are not necessarily familiar objects.

Gestalt

With the term Gestalt school we refer to a group of scientists who had a great influence on psychology. The best-known members are Max Wertheimer, Kurt Koffka, and Wolfgang Köhler. The word Gestalt comes from German and refers to a "whole form" (but it is hard to find a good translation). A central principle is that the mind organises information into global wholes. Many illusions such as apparent motion provide examples of such process of perceptual organisation.

Illusion

It is hard to define properly what is an illusion. In general it is an event in which observers have a surprising percept, often at odds with what they know and what they expect. Other times the surprise is only possible after studying the physical stimulus and comparing the information in the stimulus (for example luminance) with the percept (for example brightness).

Illusory contours

Contours that are seen and therefore exist as percepts in locations where there is no change in luminance in the stimulus. They are sometimes also called subjective contours.

Luminance

Luminance is a measure of light intensity. More specifically it is the amount of light that is reflected from a particular object within a particular angle. The unit of measure is the candela per square metre (cd m^{-2}).

Neuroscience

Neuroscience is a profoundly multidisciplinary field of study. The scope is the study all aspects of the nervous system. It can be divided in a series of subfields such as clinical neuroscience, computational neuroscience, molecular neuroscience, visual neuroscience and many more.

Percept

We use this term for a specific perceptual experience, such as one of the two interpretations of a Necker cube. It is an English word although you need a pretty good dictionary to find it.

Psychology

It is the study of behaviour and mental processes, including perception, attention, emotion, intelligence, personality and more. This is therefore a very broad range of subjects, what all psychologists share is the use of empirical methodologies.

Psychophysics

A scientific field that investigates the relationship between physical stimuli on the one hand, and sensations and perceptions on the other using a series of psychophysical methods. Psychophysics tries to describe the relationship quantitatively. The founder of Psychophysics was Gustav Theodor Fechner (1801–1887) who published a book titled *Elements of Psychophysics* in 1860.

Sensory modalities

This term is for the different senses. Traditionally we list five sensory modalities: sight (vision), hearing (audition), taste (gustation), smell (olfaction), and touch (somatosensation).

Stimulus error

Titchener used this term to refer to a pitfall. People often describe what they perceive in terms of what they know of the stimulus, instead of drawing on their perceptual experiences.

Subjective contours

See *Illusory contours*.

V1

This term refers to the primary visual cortex. This is an area of the brain located in the occipital lobe and is the first area of the cortex to receive visual information. It is also called striate (meaning stripy) cortex, and Broadband area 17.

V2

This is an area in the visual cortex next to V1. In general, neurons in both V1 and V2 are sensitive to edges, orientation, size and colour. V2 is part of a set of extra-striate areas that include V2, V3, V4 and V5.

Visual illusion

See *Illusion* for a definition. In the case of visual illusions we know of many famous examples involving shape, size, colour, motion and more.

Visual system

The human visual system is the part of the central nervous system that processes visual information. This system includes the primary visual cortex but also a number of higher areas in both the temporal and the parietal lobes. In humans the visual areas in the broader sense extend to a majority of the cortex.

Programming Glossary

Algorithm
A step-by-step procedure to arrive at a solution given a well-defined problem.

API
An acronym for application programming interface. It provides a set of clear definitions and methods of communication between various software components. Well-written and documented the API and its documentation can serve as a manual for a specific programming environment.

Argument
A value provided to a function with parameters. Therefore the value of a parameter.

BASIC
Written with capitals it is an acronym (Beginner's All-purpose Symbolic Instruction Code) for a general-purpose, high-level programming language. It was created in 1964 by students at Dartmouth College under the supervision of John G. Kemeny and Thomas E. Kurtz.

Boolean
A type of data that can only have two values: True or False. Named after the English mathematician George Boole (1815–1864).

Bug
An unexpected fault, flaw, or error in a program. Finding and eliminating bugs is called debugging. There are many stories about the origin of the term, often referring to the early history of computing and a programmer who found a beetle or a moth inside the computer.

C++
C++ (pronounced cee plus plus) is a general-purpose programming language created in 1983 by Bjarne Stroustrup. Unlike Python® it is a compiled language.

Class
In object-oriented programming, objects are instances of classes, and classes define their type. The API typically provides a large collection of predefined classes, but most object-oriented programming languages also offer to the user the possibility to create user-defined classes.

Comment
Within a program a comment is a text that is added to make the program easier for humans to understand. It is therefore an annotation that is not part of the commands to the computer. Usually it is clearly marked as a comment (with special characters and with a different font/colour). In Python anything after # till the end of the line is a comment.

Compiler
A program that transforms commands written in a programming language into another language, often a lower-level machine language. The result of the relevant compilation process is an executable program. C, C++ and Pascal are examples of compiled languages (see also *Interpreter*).

CPU
This acronym (Central Processing Unit) refers to the processor inside a computer that carries out the instructions of a program.

Data type
A particular kind of data. Different data types can take different values, and different operations can be performed with them. In Python examples of built-in data types are integers, float and strings.

Dictionary (Python)
In Python a dictionary is a type of variable with keys and values. The values inside a dictionary can be of any type. In a dictionary definition, each key is separated from its value by : and the whole thing is enclosed in curly brackets.

Float
In programming and in Python in particular, float is short for "floating point real value". This is a computer representation of a real number written with a decimal point that divides the integer and fractional parts. Example: 3.14159. Float is also a built-in data type in Python.

Function
A block of commands that perform a specific task. In Python functions are defined with def nameOfFunction():. They can have parameters inside the brackets and therefore take arguments (i.e. values) for these parameters. Functions can also return values, for example total = sum(list).

GPU
This acronym (Graphics Processing Unit) refers to specialised circuitry inside a computer that carries out instructions relative to what is displayed on the monitor. Its function is to accelerate the creation of images in a frame buffer in a way that is more efficient than the general-purpose CPU.

Instance
When we create an object based on a type (a class) we say that the object is an instantiation of that class.

Integer
Integers are signed whole numbers, therefore numbers without decimals. Computers can only store a finite subset of all integers. In Python int is the way to specify a variable that is only allowed to holds integer values in a finite range (defined by the particular version of Python).

Interpreter
A program that directly executes commands written in a programming language, without previously compiling them into machine language. BASIC, MATLAB®, Perl®, Python and R are examples of interpreted languages (see also *Compiler*).

List
In Python a list is a type of variable that holds an ordered collection of values. The values inside a list can be of any type. Example: [1, 2, 3, "four"]. Repeated values are allowed and are distinguished by the position they occupy in the data structure.

Loop
A control structure within a computer program that allows the repeated execution of a block of instructions, possibly subject to a certain Boolean condition being met.

Module
In Python a module is a collection of functions and other data that can be imported into a program. Example: import math.

Monty Python
A comedy group including: Graham Chapman, John Cleese, Terry Gilliam, Eric Idle, Terry Jones, and Michael Palin. They became famous thanks to the Monty Python Flying Circus TV series, aired by the BBC between 1969 and 1974. This was followed by several films including Holy Grail (1975), Life of Brian (1979) and The Meaning of Life (1983). The programming language Python is named after Monty Python, not a snake.

Parameter
Parameters pass a value to a function every time the function is called. A parameter can just have a position (first parameter, second parameter) or it can have a name. For example range can be called with two parameters: range(2,10). The values passed are also called arguments, in this example they are 2 and 10.

Pixel
The word pixel was created by combining "picture" and "element". It is the basic unit that can be controlled on a computer display by a program. Its colour is usually defined by three values: red, green, blue.

Python
On a computer, Python is an interpreted programming language that emphasises easy to read code. It was created in the late 1980s by Guido van Rossum. Unlike other languages (for instance C++) Python is an interpreted language. This means that every command is executed directly, without first compiling the full program into machine-language instructions.

Source code
A list of commands written as a text document, forming a script or program.

String
In Python a string is a type of variable that stores characters. It is defined using single or double quotes. Example: "Shiba" or 'Simba'. Characters are indexed, so if the string contains "Shiba", string[0] contains the character 'S'.

Tuple
In Python a tuple is a type of variable that holds an ordered collection of values. The values inside a tuple can be of any type. Example: $(1, 2, 3, "four")$. Unlike a list a tuple cannot be modified.

Variable
A variable is used to hold some information. The name of the variable is a label making it easy to understand what we have stored and how we can use it. Values are assigned to variables using the = operator. Variables have a scope (part of the program), determining where we can use them. Outside its scope the variable is invisible and has no meaning. An example would be a variable local to a function.

Bibliography

Every paper and book that was cited in the text is listed here. I used a standard format for these references and when the title was not in English I have provided a translation. Many of these papers are old. You may find it hard to actually find them in a library or obtain an electronic copy. However, access to old documents is improving all the time so you may be able to track down even some very old articles.

Aglioti S, DeSouza JFX, Goodale MA (1995) Size-contrast illusions deceive the eye but not the hand. Curr Biol 5:679–685

Altschul SF, Gish W, Miller W, Myers EW, Lipman DJ (1990) Basic local alignment search tool. J Mol Biol 215(3):403–410

Anstis SM (2003) Moving objects appear to slow down at low contrasts. Neural Net 16:933–938

Anstis SM (2004) Factors affecting footsteps: Contrast can change the apparent speed, amplitude and direction of motion. Vision Res 44:2171–2178

Arnheim R (1974) Art and visual perception: A psychology of the creative eye. University of California Press, Berkeley Los Angeles London

Bach M, Poloschek CM (2006) Optical illusions. Adv Clin Neurosci Rehabil 6:20–21

Benary W (1924) Beobachtungen zu einem Experiment über Helligkeitskontrast [Observations from an experiment on brightness contrast]. Psychol Forsch 5:131–142

Bertamini M, Proffitt DR (2000) Hierarchical motion organization in random dot configurations. J Exp Psychol Hum Percept Perform 26:1371–1386

Bertamini M, Latto R, Spooner A (2003) The Venus effect: People's understanding of mirror reflections in paintings. Perception 32:593–599

Bertamini M, Bruno N, Mosca F (2004) Illusory surfaces affect the integration of local motion signals. Vision Res 44:297–308

Bertamini M, Lawson R, Jones L, Winters M (2010a) The Venus effect in real life and in photographs. Atten Percept Psychophys 72:1948–1964

Bertamini M, Masala L, Meyer GF, Bruno N (2010b) Vision, haptics, and attention: New data from a multisensory Necker cube. Perception 39(2):195–207

Bertamini M, Herzog MH, Bruno N (2016) The Honeycomb illusion: Uniform textures not perceived as such. Iperception 7(4)

Boring EG (1930) A new ambiguous figure. Am J Psychol 42:444

Bourdon B (1902) La perception visuelle de l'espace [Visual perception of space]. Schleicher Frères, Paris

Braddick O (1993) Segmentation versus integration in visual motion processing. Trends Neurosci 16(7):263–268

Bravo M, Blake R, Morrison S (1988) Cats see subjective contours. Vision Res 28:861–865

Bressan P, Mingolla E, Spillmann L, Watanabe T (1997) Neon color spreading: A review. Perception 26:1353–1366

Briggs JR (2012) Python for kids: A playful introduction to programming. No Starch Press, San Francisco

Bruce V, Green PR, Georgeson MA (2003) Visual perception: Physiology, psychology, and ecology, 4th ed. Psychology Press, Hove New York

Bruno N (2001a) Breathing illusions and boundary formation in space-time. In: Shipley T, Kellman PJ (eds) From fragments to objects: Segmentation and grouping in vision. Elsevier, Oxford

Bruno N (2001b) When does action resist visual illusions? Trends Cogn Sci 5(9):379–382

Bruno N, Bertamini M (1990) Identifying contours from occlusion events. Percept Psychophys 48:331–342

Bruno N, Bertamini M, Domini F (1997) Amodal completion of partly occluded surfaces: Is there a mosaic stage. J Exp Psychol Hum Percept Perform 23:1412–1426

Bruno N, Jacomuzzi A, Bertamini M, Meyer G (2007) A visual-haptic Necker cube reveals temporal constraints on multisensory interactions during perceptual exploration. Neuropsychologia 45:469–475

Corballis PM, Fendrich R, Shapley RM, Gazzaniga MS (1999) Illusory contour perception and amodal boundary completion: Evidence of a dissociation following callosotomy. J Cogn Neurosci 11:459–466

Coren S, Girgus JS, Erlichman H, Hakstian AR (1976) An empirical taxonomy of visual illusions. Percept Psychophys 20:129–137

Cornsweet TN (1970) Visual perception. Academic Press, New York

Cutting JE, Kozlowski LT (1977) Recognizing friends by their walk: Gait perception without familiarity cues. B Psychonomic Soc 9:353–356

Cutting JE, Proffitt DR (1982) The minimum principle and the perception of absolute, common, and relative motions. Cognit Psychol 14:211–246

Delbœuf FJ (1865) Note sur certaines illusions d'optique: Essai d'une théorie psychophysique de la manière dont l'oeil apprécie les distances et les angles [Note about certain optical illusions: Essay on a psychophysical theory of how the eye appreciates distances and angles]. Bull Acad R Sci Lettr Beaux-Arts Belg 34:195–216

Doherty M, Tsuji H, Phillips WA (2008) The context sensitivity of visual size perception varies across cultures. Perception 37:1426–1433

Doherty M, Campbell NM, Tsuji H, Phillips WA (2010) The Ebbinghaus illusion deceives adults but not young children. Dev Sci 13(5):714–721

Dumas JP, Ninio J (1982) Efficient algorithms for folding and comparing nucleic acid sequences. Nucleic Acids Res 10(1):197–206

Ehrenstein W (1941) Über Abwandlungen der L. Hermannschen Helligkeitserscheinung [Modifications of the brightness phenomenon of L. Hermann]. Translated by Hogg A, in: Petry S, Meyer GE (eds) The perception of illusory contours. Springer, New York, pp 35–39. Z Psychol 150:83–91

Exner S (1875) Über das Sehen von Bewegungen und die Theorie des zusammengesetzten Auges [On the perception of movement and the theory of the composite eye]. Sitzungsberichte der Kaiserlichen Akademie der Wissenschaften. Mathematisch-Naturwissenschaftliche Classe. Abt. 3, Physiologie, Anatomie und theoretische Medicin 72:156–190

Fantoni C, Bertamini M, Gerbino W (2005) Contour curvature polarity and surface interpolation. Vision Res 45:1047–1062

Finger FW, Spelt DK (1947) The illustration of the Horizontal-vertical illusion. J Exp Psychol 37: 243–250

Fiorentini A (1972) Mach band phenomena. In: Jameson D, Hurvich LM (eds) Visual psychophysics. Springer, Berlin Heidelberg, pp 188–201

Fockert J de, Davidoff J, Fagot J, Parron C, Goldstein J (2007) More accurate size contrast judgments in the Ebbinghaus illusion by a remote culture. J Exp Psychol Hum Percept Perform 33:738–742

Franz VH (2001) Action does not resist visual illusions. Trends Cogn Sci 5(11):457–459

Frith CD, Frith U (1972) The Solitaire illusion: An illusion of numerosity. Percept Psychophys 11(6): 409–410

Fuss T, Bleckmann H, Schluessel V (2014) The brain creates illusions not just for us: Sharks (*Chiloscyllium griseum*) can 'see the magic' as well. Front Neural Circuits 8:24

Galilei G (1632) Dialogo sopra i due massimi sistemi del mondo [Dialogue concerning the two chief world systems]. Translated by Drake S (1967) University of California Press. Also online: *http://law2.umkc.edu/faculty/projects/ftrials/galileo/dialogue.html*

Geier J, Bernáth L, Hudák M, Séra L (2008) Straightness as the main factor of the Hermann grid illusion. Perception 37:651–665

Gerbino W (1978) Some observations on the formation of angles in amodal completion. Ital J Psychol 5:85–100

Giovanelli G (1966) Stati di tensione e di equilibrio nel campo percettivo [States of tension and equilibrium in the perceptual field]. Riv Psicol 60:327–335

Girgus JS, Coren S (1982) Assimilation and contrast illusions: Differences in plasticity. Percept Psychophys 32(6):555–561

Gold JM, Murray RF, Bennett PJ, Sekuler AB (2000) Deriving behavioural receptive fields for visually completed contours. Curr Biol 10:663–666

Goldstein EB (2013) Sensation and perception, 9th ed. Wadsworth Publishing

Goodale M, Humphreys GK (1998) The objects of action and perception. Cognition 67:181–207

Gori S, Molteni M, Facoetti A (2016) Visual illusions: An interesting tool to investigate developmental dyslexia and autism spectrum disorder. Front Hum Neurosci 10:175

Gregory RL (1963) Distortion of visual space as inappropriate constancy scaling. Nature 199(4894): 678–680

Gregory R (1966) Eye and brain: The psychology of seeing. Weidenfeld and Nicolson, London

Gregory RL (1997) Visual illusions classified. Trends Cogn Sci 1:190–194

Gregory RL (2004) Illusions. In: Gregory RL (ed) The Oxford companion to the mind. Oxford University Press, pp 426–443

Gregory RL, Heard P (1979) Border locking and the café wall illusion. Perception 8(4):365–380

Grzeczkowski L, Clarke AM, Francis G, Mast FW, Herzog MH (2017) About individual differences in vision. Vision Res, https://doi.org/10.1016/j.visres.2016.10.006

Hamburger K (2016) Visual illusions based on processes: New classification system needed. Perception 45(5):588–595

Happé FG (1996) Studying weak central coherence at low levels: Children with autism do not succumb to visual illusions. A research note. J Child Psychol Psychiatry 37:873–877

Heard P, Phillips D (2015) What's up with witch rings? Perception 44:103–106

Helmholtz H von (1866) Handbuch der physiologischen Optik (Part III) [Handbook of physiological optics]. Voss, Leipzig

Hering E (1861) Beiträge zur Physiologie. I. Zur Lehre vom Ortssinne der Netzhaut [Contributions to physiology. I. The doctrine of the locality of the retina]. Engelmann, Leipzig

Hering E (1907) Vom simultanen Grenzkontrast [On simultaneous boundary contrast]. In: Saemisch T (ed) Graefe-Saemisch Handbuch der gesamten Augenheilkunde, 2nd ed. Engelmann, Leipzig, pp 135–141

Heydt R von der, Peterhans E, Baumgartner G (1984) Illusory contours and cortical neuron responses. Science 244:1260–1262

Hildreth EC (1984) The measurement of visual motion. MIT Press, Cambridge, MA

Hoffman DD (2000) Visual intelligence: How we create what we see. W. W. Norton & Company, New York

Humphrey NK, Morgan MJ (1965) Constancy and the geometric illusions. Nature 206(4985):744–745

Ittersum K Van, Wansink B (2012) Plate size and color suggestibility: The Delbœuf illusion's bias on serving and eating behavior. J Consum Res 39(2):215–228

Jastrow J (1892) Studies from the Laboratory of Experimental Psychology of the University of Wisconsin, II. Am J Psychol 4:381–428

Johansson G (1950) Configuration in event perception. Almqvist & Wiksell, Uppsala

Johansson G (1973) Visual perception of biological motion and a model for its analysis. Percept Psychophys 14:210–211

Kanizsa G (1955) Margini quasi-percettivi in campi con stimolazione omogenea [Quasi-perceptual margins in fields with homogeneous stimulation]. Riv Psicol 49(1):7–30

Kanizsa G (1972) Amodal completion and shrinking of visual fields. Stud Psychol 14:208–210

Kanizsa G (1976) Subjective contours. Sci Am 234:48–52

Kanizsa G (1979) Organization in vision: Essays on Gestalt perception. Praeger Publishers, New York

Kellman PJ, Guttman SE, Wickens TD (2001) Geometric and neural models of object perception. In: Shipley TF, Kellman PJ (eds) From fragments to objects: Segmentation and grouping in vision. Elsevier, Oxford, pp 183–245

Kersten D, Knill DC, Mamassian P, Bülthoff I (1996) Illusory motion from shadows. Nature 379:31

Kingdom F (1997) Simultaneous contrast: The legacies of Hering and Helmholtz. Perception 26: 673–677

Kingdom FA (2015) Models of visual illusions. In: Jaeger D, Jung R (eds) Encyclopedia of computational neuroscience. Springer, pp 1–18

Kitaoka A (2001) Illusion designology 7: Illusory light perception that cannot be explained by the Fourier analysis. Nikkei Science 31:66–68 (in Japanese)

Kolers PA (1972) Aspects of motion perception. Pergamon Press, Oxford

Krekelberg B, Wezel RJ van, Albright TD (2006) Interactions between speed and contrast tuning in the middle temporal area: Implications for the neural code for speed. J Neurosci 26:8988–8998

Künnapas TM (1955) An analysis of the Vertical-horizontal illusion. J Exp Psychol 49:134–140

Levi DM, Klein SA, Aitsebaomo AP (1985) Vernier acuity, crowding and cortical magnification. Vision Res 25(7):963–977

Lier RJ van, Wagemans J (1999) From images to objects: Global and local completions of self-occluded parts. J Exp Psychol Hum Percept Perform 25:1721–1741

Lier R van, Vergeer M, Anstis S (2009) Filling-in afterimage colors between the lines. Curr Biol 19(8): R323–R324

Loeb J (1895) Über den Nachweis von Contrasterscheinungen im Gebiete der Raumempfindungen des Auges [On the proof of contrast phenomena in the area of perceptions of the eye]. Arch f d Psych 60:509–518

Lou L (1999) Selective peripheral fading: Evidence for inhibitory sensory effect of attention. Perception 28:519–526

Luria AR (1979) The making of mind. Harvard University Press, Cambridge MA

Mach E (1865) Über die Wirkung der räumlichen Verteilung des Lichtreizes auf die Netzhaut [On the effect of the spatial distribution of the light stimulus on the retina]. Sitzungsberichte der Kaiserlichen Akademie der Wissenschaften. Mathematisch-Naturwissenschaftliche Classe 52: 303–322

Makin ADJ, Wright D, Rampone G, Palumbo L, Guest M, Sheehan R, Cleaver H, Bertamini M (2016) An electrophysiological index of perceptual goodness. Cereb Cortex 26(12):4416–4434

Mamassian P, Montalembert M de (2010) A simple model of the Vertical-horizontal illusion. Vision Res 50:956–962

Martinez-Conde S, Macknik SL, Hubel DH (2004) The role of fixational eye movements in visual perception. Nat Rev Neurosci 5(3):229–240

Mass JB, Johansson G, Janson G, Runeson S (1971) Motion perception I and II [Film]. Houghton Mifflin, Boston, *https://archive.org/details/motionperception2threedimensionalmotionperception*

McCourt ME (1982) A spatial frequency dependent grating-induction effect. Vision Res 22(1): 119–134

McGlone J (1980) Sex differences in human brain asymmetry: A critical survey. Behav Brain Sci 3(02): 215–227

Meyer GE, Dougherty TJ (1990) Ambiguous fluidity and rigidity and diamonds that ooze! Perception 19(4):491–496

Michotte A, Thines G, Crabbe G (1964) Les complements amodaux des structures perceptives [Amodal completion of perceptual structures]. Studia Psychologica. Publications Universitaires de Louvain, Louvain

Milner AD, Goodale MA (1995) The visual brain in action. Oxford University Press, Oxford

Morrone MC, Burr DC, Ross J (1994) Illusory brightness step in the Chevreul illusion. Vision Res 34: 1567–1574

Mruczek RE, Blair CD, Strother L, Caplovitz GP (2015) The dynamic Ebbinghaus: Motion dynamics greatly enhance the classic contextual size illusion. Front Hum Neurosci 9:77

Müller-Lyer FC (1889) Optische Urteilstäuschungen [Optical illusions]. Archiv für Anatomie und Physiologie, Physiologische Abteilung, Suppl, pp 263–270

Munker H (1970) Farbige Gitter, Abbildung auf der Netzhaut und übertragungstheoretische Beschreibung der Farbwahrnehmung [Coloured grids, picture on the net skin and transference-theoretical description of the colour perception]. Postdoctoral Report, Ludwig-Maximilians-Universität, Munich

Münsterberg H (1897) Die verschobene Schachbrettfigur [The raised chessboard figure]. Z Psychol 15:184–188

Musatti CL (1924) Sui fenomeni stereocineti [On the stereokinetic phenomena]. Archivio Italiano di Psicologia 3:105–120

Necker LA (1832) Observations on some remarkable optical phænomena seen in Switzerland; And on an optical phænomenon which occurs on viewing a figure of a crystal or geometrical solid. London and Edinburgh philosophical magazine and journal of science 1:329–337

Nieder A, Wagner H (1999) Perception and neuronal coding of subjective contours in the owl. Nat Neurosci 2(7):660–663

Ninio J (2001) The science of illusions. Cornell University Press, Ithaca

Ninio J (2007) The science and craft of autostereograms. Spat Vis 21(1–2):185-200

Ninio J (2014) Geometrical illusions are not always where you think they are: A review of some classical and less classical illusions, and ways to describe them. Front Hum Neurosci 8:856

Ninio J, Stevens KA (2000) Variations on the Hermann grid: An extinction illusion. Perception 29(10):1209–1217

Notredame CE, Pins D, Deneve S, Jardri R (2014) What visual illusions teach us about schizophrenia. Front Integr Neurosci 8:63

Oppel JJ (1855) Über geometrisch-optische Täuschungen [About geometrical-optical illusions]. Jahresbericht des physikalischen Vereins zu Frankfurt am Main 37–47

Orbison WD (1939) Shape as a function of the vector-field. Am J Psychol 52(1):31–45

Otten M, Pinto Y, Paffen CL, Seth AK, Kanai R (2016) The uniformity illusion: Central stimuli can determine peripheral perception. Psychol Sci 28(1):56–68

Ōuchi H (1977) Japanese optical and geometrical art. Dover Publications Inc., New York

Parkes L, Lund J, Angelucci A, Solomon JA, Morgan M (2001) Compulsory averaging of crowded orientation signals in human vision. Nature Neuroscience 4:739–744

Partos TR, Cropper SJ, Rawlings D (2016) You don't see what I see: Individual differences in the perception of meaning from visual stimuli. PloS one 11(3), e0150615

Peirce JW (2007) PsychoPy – Psychophysics software in Python. J Neurosci Methods 162:8–13

Peirce JW (2008) Generating stimuli for neuroscience using PsychoPy. Front Neuroinform 2:10

Penrose LS, Penrose R (1958) Impossible objects: A special type of visual illusion. Br J Psychol 49:31-33

Pessoa L, Weerd P De (eds) (2003) Filling-in: From perceptual completion to cortical reorganization. Oxford University Press, Oxford

Peterzell DH (2016) Discovering sensory processes using individual differences: A review and factor analytic manifesto. IS&T International Symposium on Electronic Imaging Science and Technology 16:1–11

Phillips D, Wade NJ (2014) The elusive Johann Joseph Oppel (1815–1894). Perception 43:869–872

Piaget J, Lambercier M, Boesch E, Albertini B von (1942) Introduction a l'etude des perceptions chez l'enfant et analyse d'une illusion relative a la perception visuelle de cercles concentriques (Delbœuf) [Introduction to the study of perceptions in children and analysis of an illusion relative to the visual perception of concentric circles (Delbœuf)]. Arch Psychol 29:1-107

Pinna B, Brelstaff G, Spillmann L (2001) Surface color from boundaries: A new 'watercolor' illusion. Vision Res 41:2669–2676

Pinna B, Werner JS, Spillmann L (2003) The watercolor effect: A new principle of grouping and figure-ground organization. Vision Res 43:43–52

Pomerantz JR, Kubovy M (1986) Theoretical approaches to perceptual organization: Simplicity and likelihood principles. In: Boff KR, Kaufman L, Thomas JP (eds) Handbook of perception and human performance. Wiley & Sons, New York, pp 1–45

Ponzo M (1912) Rapports entre quelques illusions visuelles de contraste angulaire et l'appréciation de grandeur des astres à l'horizon [Relation between some visual illusions of angular contrast and the appreciation of the size of celestial bodies on the horizon]. Arch Ital Biol 58:327–329

Ponzo M (1928) Urteilstäuschungen über Mengen [Misperceptions of quantities]. Arch f d Psych 65:129–162

Prandtl A (1927) Über gleichsinnige Induktion und die Lichtverteilung in gitterartigen Mustern [On uniform induction and light distribution in lattice patterns]. Zeitschrift für Sinnesphysiologie 58:263–307

Pressey AW, Butchard N, Scrivner L (1971) Assimilation theory and the Ponzo illusion: Quantitative predictions. Can J Psychol 25:486–497

Prinzmetal W, Shimamura AP, Mikolinski M (2001) The Ponzo illusion and the perception of orientation. Percept Psychophys 63(1):99–114

Rasmjou S, Hausmann M, Güntürkün O (1999) Hemispheric dominance and gender in the perception of an illusion. Neuropsychologia 37(9):1041–1047

Redies C, Spillmann L, Kunz K (1984) Colored neon flanks and line gap enhancement. Vision Res 24:1301–1309

Restle F (1979) Coding theory of the perception of motion configurations. Psychol Rev 86:1–24

Roalf D, Lowery N, Turetsky BI (2006) Behavioral and physiological findings of gender differences in global-local visual processing. Brain Cognit 60:32–42

Rock I (1985) The logic of perception. MIT Press, Cambridge MA

Rosa Salva O, Rugani R, Regolin L, Vallortigara G (2013) Perception of the Ebbinghaus illusion in four-day-old domestic chicks (Gallus gallus). Anim Cogn 16:895–906

Ross HE, Plug C (2002) The mystery of the moon illusion: Exploring size perception. Oxford University Press, Oxford

Sander F (1926) Optische Täuschungen und Physiologie [Optical illusions and physiology]. Neue Psychologische Studien 1:159–166

Sayim B, Westheimer G, Herzog MH (2010) Gestalt factors modulate basic spatial vision. Psychol Sci 21(5):641

Schachar RA (1976) The "pincushion grid" illusion. Science 192:389–390

Schröder HGF (1858) Über eine optische Inversion [About an optical inversion]. Annalen der Physik und Chemie 181:298–311

Schumann F (1900) Zur Schätzung räumlicher Grössen [Estimation of spatial size]. Zeitschrift für Psychologie und Physiologie der Sinnesorgane 24(1):283

Schwarzkopf DS, Song C, Rees G (2011) The surface area of human V1 predicts the subjective experience of object size. Nat Neurosci 14(1):28–30

Seckel A (2007) Masters of deception: Escher, Dalí & the artists of optical illusion. Sterling Press, New York

Sekuler AB, Murray RF (2001) Amodal completion: A case study in grouping. In: Shipley TF, Kellman PJ (eds) From fragments to objects: Grouping and segmentation in vision. Elsevier, Oxford, pp 265–294

Sekuler AB, Palmer SE (1992) Perception of partly occluded objects: A microgenetic analysis. J Exp Psychol Gen 121:95–111

Shapiro AG, Todorović D (eds) (2017) The Oxford compendium of visual illusions. Oxford University Press, Oxford

Shaw ZA (2013) Learn Python the hard way: A very simple introduction to the terrifyingly beautiful world of computers and code. Addison Wesley Press, Reading MA

Shepard RN (1990) Mind sights: Original visual illusions, ambiguities, and other anomalies. W. H. Freeman and Company, New York

Shepherd AJ (2001) Increased visual after-effects following pattern adaptation in migraine: A lack of intracortical excitation? Brain 124(11):2310–2318

Shiffrar M, Pavel M (1991) Percepts of rigid motion within and across apertures. Journal of Experimental Psychology: Human Perception and Performance 17(3):749–761

Shopland JC, Gregory RL (1964) The effect of touch on a visually three-dimensional figure. Q J Exp Psychol 16:66–70

Simmons DR, Robertson AE, McKay LS, Toal E, McAleer P, Pollick FE (2009) Vision in autism spectrum disorders. Vision Res 49:2705–2739

Slaghuis WL, Twell AJ, Kingston KR (1996) Visual and language processing disorders are concurrent in dyslexia and continue into adulthood. Cortex 32:413–438

Snowden RJ, Thompson P, Troscianko T (2012) Basic vision: An introduction to visual perception. Oxford University Press, Oxford

Sowden PT, Watt SJ (1998) A Jittered squares illusion and a proposed mechanism. Perception 27(4):439–454

Spillmann L (1994) The Hermann grid illusion: A tool for studying human perceptive field organization. Perception 23:691–708

Thiéry A (1895) Ueber geometrisch-optische Täuschungen [About geometric-optical illusions]. Philosophische Studien 11:603–620

Thompson P (1982) Perceived rate of movement depends on contrast. Vision Res 22:377–380

Titchener EB (1909) Lectures on the experimental psychology of the thought-processes. MacMillan, New York

Todorović D (1996) A gem from the past: Pleikart Stumpf's (1911) anticipation of the aperture problem, Reichardt detectors, and perceived motion loss at equiluminance. Perception 25:1235–1242

Tolansky S (1964) Optical illusions. Pergamon Press, Oxford London

Tuijl HFJM van (1975) A new visual illusion: Neonlike color spreading and complementary color induction between subjective contours. Acta Psychol 39:441–445

Vallortigara G (2004) Visual cognition and representation in birds and primates. In: Rogers LJ, Kaplan G (eds) Vertebrate comparative cognition: Are primates superior to non-primates? Kluwer Academic/Plenum Publishers, New York, pp 57–94

Vallortigara G, Bressan P, Bertamini M (1988) Perceptual alternations in stereokinesis. Perception 17:31–34

Varin D (1971) Fenomeni di contrasto e diffusione cromatica nell'organizzazione spaziale del campo percettivo [Phenomena of contrast and chromatic diffusion in the spatial organisation of the perceptual field]. Riv Psicol 65:101–128

Verstraten FA (1996) On the ancient history of the direction of the motion aftereffect. Perception 25(10):1177–1187

Vicario GB (2011) Illusioni ottico-geometriche: Una rassegna di problemi. Istituto Veneto di Scienze Lettere e Arti, Venezia

Vicario GB (1978) Another optical-geometrical illusion. Perception 7(2):225–228

Wade N J (2005) Sound and sight: Acoustic figures and visual phenomena. Perception 34(10):1275–1290

Wade N (2016) Art and illusionists. Springer, Cham Heidelberg New York Dordrecht London

Wagemans J (2017) Perceptual organisation. In: Wixted JT, Serences J (eds) The Stevens' handbook of experimental psychology and cognitive neuroscience: vol. 2. Sensation, perception & attention. John Wiley & Sons, Hoboken

Wallach H (1948) Brightness constancy and the nature of achromatic colors. J Exp Psychol 38:310–324

Wallach H, O'Connell DN (1953) The kinetic depth effect. J Exp Psychol 45:205–217

Wallis SA, Georgeson MA (2012) Mach bands and multiscale models of spatial vision: The role of first, second, and third derivative operators in encoding bars and edges. J Vis 18:1–25

Wertheimer M (1912) Experimentelle Studien über das Sehen von Bewegung [Experimental Studies on Motion Vision]. Z Psychol 61:161–265

Wertheimer M (1923) Untersuchungen zur Lehre von der Gestalt, II. [Investigations in Gestalt Theory: II. Laws of organization in perceptual forms]. Psychol Forsch 4:301–350, [available online at: http://psychclassics.yorku.ca/Wertheimer/Forms/forms.htm]

White M (1979) A new effect of pattern on perceived lightness. Perception 8:413–416

White M (1982) The assimilation-enhancing effect of a dotted surround upon a dotted test region. Perception 11:103–106

Wittgenstein L (1953) Philosophical investigations. Blakwell, Oxford

Wolfe U, Maloney LT, Tam M (2005) Distortions of perceived length in the frontoparallel plane: Tests of perspective theories. Percept Psychophys 67(6):967–979

Wyzisk K, Neumeyer C (2007) Perception of illusory surfaces and contours in goldfish. Visual Neurosci 24:291–298

Zanforlin M (1981) Visual perception of complex forms (anomalous surfaces) in chicks. Ital J Psychol 8:1–16

Zöllner F (1860) Über eine neue Art von Pseudoskopie und ihre Beziehungen zu den von Plateau und Oppel beschrieben Bewegungsphaenomenen [On a new kind of pseudoscopy and its relations to the phenomena of movement described by Plateau and Oppel]. Annalen der Physik und Chemie 186:500–525

Zylinski S, Darmaillacq AS, Shashar N (2012) Visual interpolation for contour completion by the European cuttlefish (*Sepia officinalis*) and its use in dynamic camouflage. Proc R Soc Lond B Biol Sci 279(1737):2386–2390

Index

Page numbers in italics refer to figures or tables.

Subject Index

A

Programming Index